HPBooks®

P9-BIE-573

Pro Techniques of Making

HOME VIDEO
MOVIES

Thomas I. Ford

Published by HPBooks
A division of HPBooks, Inc.
P.O. Box 5367, Tucson, AZ 85704 (602) 888-2150
ISBN:0-89586-300-6 Library of Congress Catalog No.86-80600
©1986 HPBooks, Inc. Printed in U.S.A.

2nd Printing

Publisher: Rick Bailey
Executive Editor: Randy Summerlin
Senior Editor: Vernon Gorter
Art Director: Don Burton
Book Assembly: Kathleen Koopman
Drawings: Yi Chen
Managing Editor: Cindy J. Coatsworth
Typography: Michelle Carter
Director of Manufacturing: Anthony B. Narducci

Cover Photo: Balfour Walker

FOREWORD

Tom Ford is an expert in creative TV and this book is a thoughtful and valuable distillation of his 25 years of experience. As an actor and director, I can vouch for the fundamental moviemaking techniques and practical creative methods Tom has described and illustrated.

The book helps you construct an enjoyable home video movie, use your camera skillfully, direct creatively, shoot decisively, and even edit your shots.

So go ahead—Lights, Camera, Action! This time it's your very own lights, camera and action! With his helpful information and guidance, Tom Ford opens for you a new world of fun and enjoyment. I recommend this book and wish it much success.

Charles Nelson Reilly

Charles Nelson Reilly

DEDICATION

To Renée, whose boundless support helped to give life to this book.

Contents

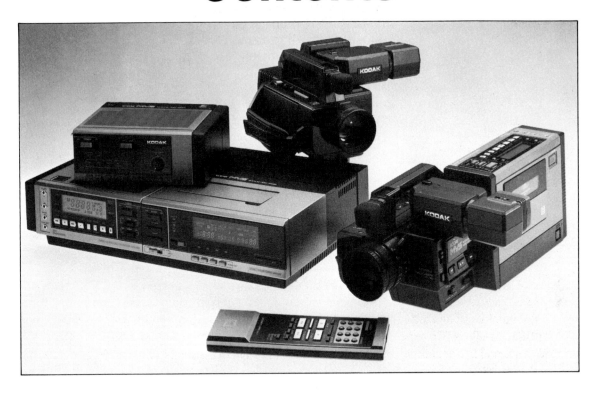

Introduction

We're all aware of the amazing array of electronics gadgetry available today. Among many other things, it provides the fun and excitement of making your own home video movies. Video cameras and recorders are at the same time getting less expensive and more sophisticated. There are even compact all-in-one units called camcorders. As a result, amateur photographers, 8mm-movie fans and many who have never even thought about shooting pictures are taking up electronic moviemaking on videotape.

A video camera extends the pleasures offered by a videocassette recorder (VCR). The VCR can play back TV programs you've recorded off the air and commercially available tapes. By adding a video camera, you can produce your own movies for TV viewing.

A video camera provides immediate reward for your effort. You needn't wait for film to be processed. Instant playback lets you see what you've recorded then and there.

Unlike film, videotape is reusable. If you're not satisfied with what you've shot, you've lost nothing. You can reshoot sections, or the whole production, on the same tape.

After your initial investment in equipment, taping costs are minimal. One cassette costing about $8 can give you up to eight hours of viewing. By comparison, Super-8 film, at about $10 for a three-minute reel—with processing—would cost about $1600 for eight hours of production!

If you're contemplating joining the home-video revolution, this book will help you get the greatest possible enjoyment from this truly exciting and rewarding audio-visual medium.

In many ways video and film moviemaking are similar. The way you use the camera to achieve various visual effects, for example, doesn't differ much between the two. As I've just indicated, however, the video medium offers some special advantages. When I use the term *movie* or *moviemaking* in this book, I'm referring to movies made on videotape unless I specifically tell you otherwise.

Perhaps you'll set out to tape the baby's birthday, the kids' new pup, a school play, the Little League playoff game or a family wedding. Maybe you'll be inspired to try your hand at an original creation—dramatic or documentary. You may plan to shoot simple movies running for just a few minutes or elaborate productions running for an hour or more. Whatever you do, you'll have more pleasure as you shoot, and more satisfaction as you sit back and view your achievement, if you have a fundamental understanding of the video medium and its use.

Eventually, you may even realize business or professional benefits from your video system. This is particularly likely if you have cable TV with public-access facilities in your neighborhood. With cable-TV studio facilities and practical help from the staff of the local system, you can be well on your way to producing programs with a truly professional look.

However, the main purpose of this book is to ensure that you have fun with your video equipment—whether it's VHS, Beta or an 8mm camcorder. It doesn't matter which format or type of equipment you own. The methods and ideas in this book are for everyone. The book can make your home video moviemaking more successful *and* enjoyable.

4

1 The Video System

In this chapter, I'll briefly introduce the tools needed for making home video movies. I'll explain the most important parts and functions of a video camera and videocassette recorder. I'll also discuss the device that makes it all possible—the videotape cassette. The general information I'll provide applies to all videotape formats—VHS, Beta and 8mm. I'll also tell you about important differences in the formats.

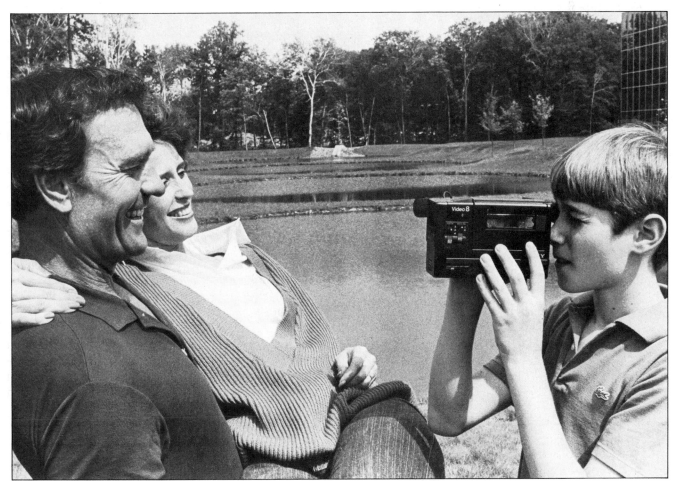

Today's video equipment is so small, lightweight and simple to use, your whole family can participate in making home video movies.

DEFINITION

What does the word *video* mean? It comes from the Latin word meaning *to see*. In recent years, the term *video* has become synonymous with electronic image recording and display. This includes television and the electronic moviemaking discussed in this book.

The word *audio,* derived from the Latin word meaning *to hear,* refers to the sound that accompanies a visual presentation. In general usage, however, the word *audio* has been dropped, and television or electronic image production, complete with sound, is called simply *video.*

Video equipment includes all of the necessary electronic components—including camera, VCR, TV set, microphones, videocassettes and tape editors.

This book is about making home video movies. This includes all the aspects involved in the planning, production and displaying of home movies produced by means of the electronic medium of videotape.

Let's look at the technology and equipment that make home video movies possible. It'll be only a brief look because this book is going to be mainly about *application* rather than *equipment.* I want to tell you how to be creative with your equipment, so you can produce effective and enjoyable "movies." To learn more about equipment, I recommend the latest edition of *Buyer's Guide to Home Video Equipment,* also published by HPBooks. Also, always be sure to read the instruction manuals provided with your video equipment.

A video system has three key parts—camera, videocassette recorder (VCR) and videotape cassette. Let's look at each component separately.

THE CAMERA

A video camera lets you capture color images in motion, with sound—just like a professional movie camera. The esthetics of producing a home video movie aren't very different from regular moviemaking, as you'll see later. However, the technology involved is very different. Many of the major differences are to your advantage, as you'll also learn as you read on.

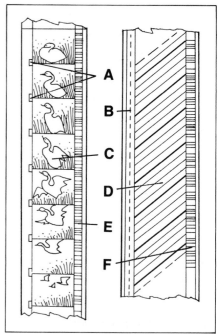

Comparison of a motion-picture-film image (left) with a recording on videotape. The film image can be seen by holding it up to a light. The tape image can be seen only on a TV screen by playing it in a VCR. However, each has a sound track. Each also has a means to ensure exact speed—sprocket holes in film and a control track on tape. A = Sprocket Holes; B = Control Track; C = Picture Area; D = Video Track; E = Audio Track; F = Audio Track.

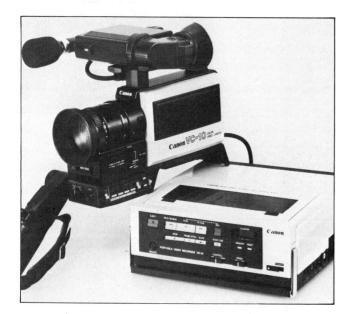

LEFT: Canon's video camera with separate, portable VCR. ABOVE: A Camcorder, using 8mm cassettes, can fit in the palm of your hand—a camera *and* VCR all in one!

ELECTRONIC IMAGE

The first time you pick up a video camera, you may be excused for asking where the film is loaded. The fact is that a video camera uses no film. The image is changed into electronic signals in the camera. The electronic signals representing the image are then transmitted to the VCR. There, they are recorded on magnetic videotape.

In the case of a camcorder, a miniature VCR is combined with the camera into one unit.

Unlike film, the electronic image requires no chemical processing before you can see it. It simply needs playing back through a television set. You can see the image immediately after it is shot. If you don't like what you see, you can simply record a new image in place of the unwanted one, which will be erased automatically as you shoot.

Image Scan—A video camera does not record images frame by frame, as does a movie camera using film. An electronic scanning system scans the scene at a rate of 30 times per second to produce the illusion of moving pictures.

This scanning corresponds to the succession of frames per second a film camera produces on film. Unlike processed film pictures, the electronic images—stored magnetically on videotape—are never visible directly. Only when the videotape is replayed on a TV screen do you see an image. A scanning system in the TV set "paints" the images on the screen, also at the rate of 30 scans per second.

Sound—The video system records sound magnetically on a sound track that runs beside the electronic picture information. When you play back the tape, all the sound you've recorded along with the visual image is played back through the speaker of your TV.

LENS

Physically, a video camera is very similar to a regular film camera. One of its basic parts is a lens that focuses the image on a light-sensitive surface on an imaging device in the camera. The imaging device converts the focused image into electronic signals.

Lens Aperture—Just like other cameras, a video camera has an adjustable lens aperture, also known as the *iris diaphragm*. It controls the light reaching the electronic image-receiving device. This is necessary because, like film, the video system has an inherent sensitivity to light. If the light level reaching the image pickup is too dim, a satisfactory image will be impossible to record. If the light is too bright, the same is true—and some image-receptor

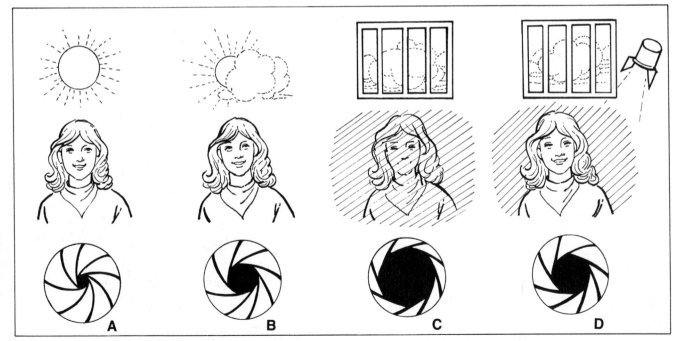

HOW THE IRIS FUNCTIONS:
A. Bright, sunny day. Iris closes down to exclude excessive light.
B. Cloudy day. Iris opens, transmitting more light to the image pick-up.
C. Dark condition, indoors. Iris opens fully but overall light is still insufficient for a satisfactory picture. Low-light warning flashes in the viewfinder.
D. With light added, the iris adjusts for proper picture quality.

types may also be damaged.

A brightly lit subject calls for a relatively small lens aperture, and a dimly lit subject demands a large lens aperture. If the light level on the subject is beyond the range of possible compensation by an aperture adjustment, or other means, described later, the illumination must be adjusted.

If there's too little light, you must add some. If there's too much light, you can either reduce the light intensity by diffusing the lights or moving them farther from the subject. Or, you can use a neutral density (ND) filter on the camera lens. These filters hold back a specific portion of the light striking them without changing the color balance of the illumination. Neutral density filters are available in various strengths.

Auto Iris—In most video cameras, the iris adjustment is made automatically. This, in effect, gives you automatic exposure control and frees you from constant concern about exposure considerations. A light sensor built into the camera does the job for you.

Most cameras have a manual override control, enabling you to set exposure precisely as you want it, regardless of what the sensor indicates. This is important for special creative effects and in unusual lighting conditions.

For example, if the subject has a very bright background, the exposure set by the camera's light sensor will be for the background and, therefore, the main subject will be underexposed. By manually opening the lens aperture, you can ensure correct exposure for the subject—although the background will then be somewhat overexposed.

Backlight Button—This control, found on many cameras, conveniently helps you overcome the backlight problem just described. Pressing the button automatically increases the exposure initially set by the camera's sensor, to compensate for the underexposure of the subject.

Fade In/Fade Out—By slowly and uniformly closing down the lens aperture, you can fade out a scene. By slowly opening the lens aperture, you can fade in a scene. Some cameras have an automatic fade control—which is similar to an automatic iris control—ensuring a uniform transition from light to dark or vice versa in a fade.

Zoom—Almost all home video cameras have a zoom lens. It has a continuously variable focal length, enabling you to frame your scene selectively without changing the camera-to-subject distance.

Many cameras feature *power zoom*, enabling you to change the lens focal length automatically at the push of a button. Besides its convenience, this feature eliminates the danger of jerky, uneven zoom action. However, you can also operate the zoom manually by a lever on the rotating collar on the lens.

Focus—As with any other camera, the lens of a video camera must be focused on the image receptor to provide a sharp image. Many video

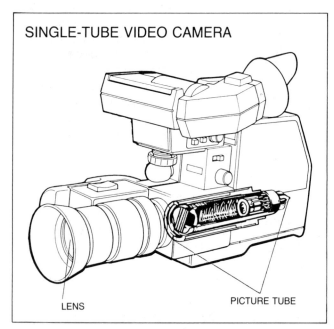

SINGLE-TUBE VIDEO CAMERA

LENS

PICTURE TUBE

The picture tube is a key component in a video camera. Typically, it's a single tube, located behind the lens.

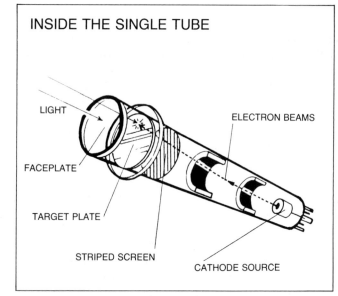

INSIDE THE SINGLE TUBE

LIGHT

FACEPLATE

TARGET PLATE

STRIPED SCREEN

ELECTRON BEAMS

CATHODE SOURCE

A scanning beam, working with a filter, produces individual red, green and blue signals that are sent to the VCR to be recorded as full-color images.

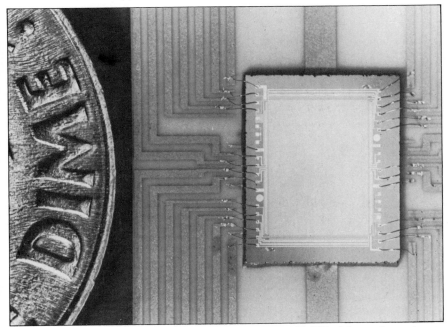

This solid-state image pick-up device contains about 100,000 pick-up elements, arranged in a silicon chip much smaller than a dime.

cameras must be focused manually, usually by adjusting a ring on the lens barrel. However, more and more cameras offer automatic focusing.

Automatic Focusing—The auto-focus feature allows you to simply point the camera at the subject and shoot. The image is focused automatically. This can be particularly helpful when you have to work fast with an active subject.

Camera manufacturers use several different auto-focus methods. Under certain conditions, each of them can be fooled. For example, if you're shooting through a wood or mesh fence with a focusing system using an infrared beam, the lens will focus on the fence material rather than on the subject.

Some auto-focus systems employ prisms and mirrors, somewhat like conventional camera rangefinders. These systems tend to be less accurate in dim light. However, they are not "fooled" by such obstructions as fences.

When using an auto-focus camera, always be on your guard against features in view that can lead to possible error. When necessary, switch to manual focusing and focus visually.

Macro Capability—A lens with a macro setting allows you to focus on a subject very close to the lens, to produce a relatively large image. It is useful if you want to film small objects such as insects, flowers, postage stamps or 35mm photo slides.

IMAGE PICKUP

Let's take a look at the location where the lens focuses the image. This is the *image pickup,* which corresponds to the image plane or film plane in a regular photographic camera. The image pickup converts the brightnesses and colors of the focused image into electronic signals that can later be reconverted to visual images on your TV set. A video camera can use one of two image-pickup devices—a picture tube or a solid-state sensor.

Picture Tube—This is a device that scans the focused, moving image. In doing this, it separates each image into the red, blue and green components that make up the subject's colors. It also senses the relative brightness or darkness of each image point. This information is translated by the picture tube into electronic impulses that are passed on to the VCR. There, the impulses are recorded on magnetic videotape.

When the tape is played back, the impulses are reconverted to colors and brightnesses, giving you a complete visual image once again on your TV screen.

Solid-State Sensor—Unlike the image tube, the sensor is a solid-state device resembling a computer microchip. It is extremely small and lightweight. Because it has no moving parts or separate components, it is very durable. It may be somewhat less light-sensitive than a picture tube and, therefore, not as effective in dim light levels. It is also less susceptible to damage from direct sunlight or other extremely bright light. Moreover, bright lights or reflections moving across the sensor do not streak or smear in the viewed image as they do with tubes.

Like the picture tube, the solid-state sensor accepts focused light from the camera lens and breaks it into red, blue and green color components. These components are translated into electronic impulses and recorded as such on the magnetic videotape in the VCR.

Tube or Sensor?—As I've indicated, each of the two image-receiving devices has its advantages and disadvantages. I'll briefly list them again:

● A solid-state sensor is lighter in weight and more compact than a picture tube. Thus, a camera using a solid-state sensor can be more com-

The built-in electronic viewfinder in this camera is actually a miniature b&w TV set.

An optical viewfinder, shown here, is rarely found on today's home-video cameras.

pact and lightweight than a camera with a picture tube.

• A picture tube is generally more light-sensitive than a solid-state sensor. This means you can shoot in a darker room, on a cloudier day or later in the evening with a tube camera and still get a good picture. However, I should point out that both picture-tube and solid-state-sensor cameras are remarkably light sensitive and capable of producing good images in surprisingly dim light.

• The picture tube is more prone to damage from direct sunlight or other extremely bright light.

• A solid-state sensor has no separate or moving parts and is, therefore, more sturdy and durable than a picture tube.

• With a picture-tube camera, panning the camera through a scene containing a bright light, reflection or object can result in *comet-tailing,* especially in dim overall illumination. The bright light records across the image as a smear. Comet-tailing does not occur with solid-state sensor cameras.

VIEWFINDER

Like all cameras, a video camera has a viewfinder. You view the image on it to compose your scene. There are several viewfinder types.

Optical—This is a simple optical device that allows you to view the subject, not through the camera's taking lens but along an axis parallel and close to that of the camera lens. It is the least expensive of all viewfinder types. Because it gives you a *similar* view of what the camera lens sees, and not precisely the *same* view, it is the least accurate finder for framing and image composition. Most modern video cameras do not use such viewfinders. They were used more commonly in the past as a cost-saving feature.

The optical finder shows the scene in full color—but not electronically, as the camera will record it and the VCR and TV set will later show it. This means that you must rely on your camera's built-in light-level and color-balance sensors to deliver an acceptable image.

You can't use this kind of viewfinder for focusing. You have to measure or estimate the camera-to-subject distance and set the lens distance scale accordingly.

TTL—Many modern video cameras have a through-the-lens (TTL) reflex viewfinder. This type of finder is built into the camera system and shows you the precise image the camera lens sees. You can focus the image through it.

Although you get a more accurate representation of what the camera lens sees than with a simple optical finder, you still don't see what the electronic interpretation of the scene will look like. This means that you still have to rely on the camera's light-level and color-balance controls to give you satisfactory electronic reproduction on your television screen.

Electronic (B&W)—Most home video cameras have a b&w electronic viewfinder. Unlike the previously mentioned viewfinders, it doesn't show you simply an optical image, but an electronic one.

The image you see represents what you would see if the image were shown on a b&w television set. The viewfinder is, in effect, a tiny b&w TV. The electronic viewfinder also enables you to see an instant replay of the last few seconds you recorded.

Electronic (Color)—This is the most sophisticated—and expensive—of all viewfinders. It is actually a tiny color TV set, built right into your video camera. It shows you exactly what you'll eventually see on your TV screen, as reproduced from the VCR. It enables you to preview your framing and composition, focus, lighting and color balance without having a TV set hooked up to your shooting system. After shooting, you'll be able to see in the viewfinder an instant replay of the last few seconds you shot.

PICTURE-QUALITY CONTROL

In addition to the aperture control in the lens, a video camera has several electronic devices designed to ensure optimum image quality.

BRIGHTNESS AND CONTRAST

Most video cameras have sensors that measure brightness and contrast

levels and make automatic adjustments to provide the best possible image. They work together with the lens iris, automatically fine-tuning the picture from the light passing through the lens.

In dim light, an *Electronic Sensitivity* control can raise video brightness, and a *Gain Boost* control can increase contrast to improve overall picture quality. In bright light, these controls work in the opposite direction to maintain an acceptable picture.

Unlike a lens-aperture setting, a boost or reduction in video gain or contrast does not affect depth of field.

If the illumination on the scene fails to meet or exceeds levels that can be controlled by optical or electronic means at the camera, you must increase or decrease lighting on your subject. A dark, muddy-looking picture results if light falls below compensating capability. A warning light or signal in the viewfinder tells you when this is happening.

If a scene is too bright, it has a hazy, bleached-out appearance with white halations around highly reflective objects or light-colored areas. You're apt to encounter this condition shooting a beach or snow scene. Generally, you have to judge by eye when brightness limits are exceeded—there are no electronic indicators. Normally, the best remedy is the use of a neutral density filter on the camera lens.

Manual Control—The contrast and brightness settings can be controlled manually, just like the lens-iris setting. Of course, you need not limit your use of these settings to getting what is conventionally regarded as the "best" image. You can use them creatively, to achieve special effects or dramatic impact. I discuss special effects in Chapter 7.

COLOR CONTROL

Video cameras are equipped with control systems to provide correctly balanced colors. This means that the balance between the primary colors of red, green and blue is accurate and white is recorded without a color bias.

Different light sources have varying amounts of red, green and blue in the illumination they provide. A reddish light source is called *warm*; bluish illumination is called *cool*. Tungsten lights give a relatively warm light. Daylight is more bluish—except when the sun is low, about the time of sunrise or sunset. At these times the light is distinctly reddish. Fluorescent lights often have a blue-green hue that is particularly unflattering to skin tones.

Because of these variables, each scene you shoot is likely to have a slightly different overall coloring. Light balance can be further influenced by colored reflective surfaces such as walls, foliage or blue sky in shaded areas.

White-Balance Control—A video camera uses white as a reference in controlling color balance. To achieve a proper color balance, you simply aim the camera at a white surface in the lighting used for the scene being recorded and push the white-balance button. The surface can be a wall or a card held in front of the lens. However, it's important that it be truly white.

When you depress the *White Balance* button, the camera automatically makes the white surface register as pure white. When white registers as white, all other colors will record accurately also. Of course, you must white balance your camera this way each time you change light sources.

Automatic Color Tracking—This feature, included in some camera

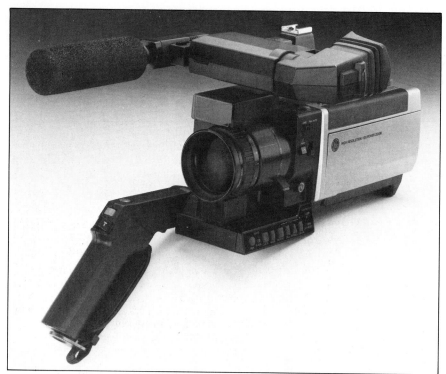

This GE camera features a microphone that extends well forward, toward the subject.

models, provides continuous and automatic white-balance control. As you change from one kind of light source to another, the camera makes the necessary adjustment. There is a manual override, enabling you to set the white balance to meet specific creative needs.

Indoor-Outdoor Setting—Many video cameras have a control that enables you to set the camera for shooting under various, specific light conditions––outdoors in bright sunlight, outdoors under cloudy sky, indoors in tungsten light or indoors in fluorescent light. This helps to maintain a properly color-balanced image under those light conditions.

In conventional photography, you select color-slide films balanced for the light in which you're going to shoot. With video, the indoor-outdoor setting achieves the same thing.

Color-Adjust Control—In a photographic camera, if you wanted to further control color balance, you would add a filter to the lens. The equivalent of this in a video camera is the color-adjust control. It gives you scope for additional creative expression with color.

Before you use this control, make sure your TV set is adjusted for best color rendition. Only this way can you have total control of the adjustments you are going to make. The best way to adjust a TV set for best color is by balancing skin tones. Everyone is so familiar with skin tones that even the slightest imbalance toward, say, purple or green is noticeable.

MICROPHONE

Remember that a basic part of making video movies is the recording of sound that accompanies the visual

event. Thus, a key part of your video camera is a built-in microphone. It lets you record sound as you shoot.

There are two basic kinds of microphones. One picks up sound coming from all directions and is called *omnidirectional*. The other is *unidirectional,* picking up sound mainly from the direction in which the camera is aimed.

For taping a subject at some distance from the camera, it's best to have a unidirectional mike. If the camera doesn't have one, you can use an accessory mike plugged into the external mike jack on the camera.

For more about microphones, and sound recording in general, see Chapter 9.

USEFUL CAMERA EXTRAS

In addition to the features just discussed, home video cameras have other special features that can be helpful in a variety of ways. Following are the more important and common ones.

POWER-SAVER SWITCH

A video camera gets its power from the VCR it's hooked up to. When you're using a portable recorder, the camera draws on its battery. It does this even when you're not shooting. The power-saver switch cuts down the amount of electricity the camera uses between shots. It turns the electronic viewfinder off, yet keeps the camera warmed up and ready to go.

POSITIVE/NEGATIVE SWITCH

This feature enables you to convert the positive image into a negative. This means that all colors and tones are reversed. For example, green will record as its complementary color— magenta. In the same way, blue will record as yellow. Black will repro-

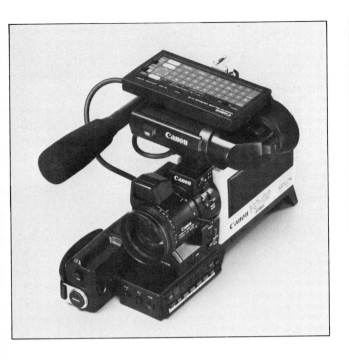

LEFT: Accessory character-generator and time-lapse controllers are available with certain camera models. ABOVE: An RCA character generator, used to title video movies.

duce as white, and dark gray as light gray.

The result can be fun for bizarre creative effects—but the feature can also be useful. For example, it enables you to produce positive color images on videotape from color-film negatives.

AUTO CAPPING

Achieved by a device sometimes called a *Shutter Switch,* this is a useful safety feature. It completely closes the lens opening into the camera, thus protecting the sensitive picture tube from exposure to strong light when the camera is not in use. It can prevent irreparable damage to a camera.

REMOTE CONTROLS

In addition to a *Start/Stop* button or trigger, some cameras have controls to let you operate your VCR from the camera. The more you can control operations from camera position, the more you can concentrate on shooting. A camcorder, of course, pro-

vides a built-in solution to this problem.

PAUSE CONTROL

If you use the VCR *Stop* button when you've finished a shot, the tape will not be at precisely the same location when you begin the next shot. You can prevent this by using the *Pause Control,* which stops the tape and holds it in position until you shoot again. The precise positioning of the tape that results enables you to edit your tape in-camera without undesirable visual and audio interruptions.

Most of the newest camera models have a *Start/Stop* trigger that automatically puts the VCR into the *Pause* mode. This occurs when you re-press the trigger to stop recording at the end of a shot.

FF/REV/PLAY

The designations on this remote control stand for *Fast Forward, Reverse* and *Play.* They match corresponding controls on the VCR and

enable you to advance the tape rapidly to a desired position, rewind the tape or play back your shots, either on your TV screen or in the electronic viewfinder of your camera.

CHARACTER GENERATOR

This useful feature, not available with all video cameras, creates letters electronically so you can add titles or dates to your movies. You can superimpose lettering over a picture you've already taped or set the lettering against a colored background. Generally, you can produce the letters in a variety of colors, too. Some models enable you to position type in different quadrants of the picture.

Some character generators offer ready-made titles such as "Happy Birthday" or "Happy Anniversary." You can add them at the touch of a button.

STOPWATCH DISPLAY

This is a standard timer like a digital electronic stopwatch. You see its readout superimposed on the image

in an electronic viewfinder as you shoot. However, this feature is available only in cameras that also have a character generator.

ON-SCREEN TIMER

This, too, works off a character generator in a camera. The timer's number display can be brought into or out of the picture according to your needs. It can add excitement to sporting events such as races.

CAMERA SUPPORT

Strictly speaking, a camera support is not part of the video system. However, I regard it as a sufficiently vital part of your total equipment to warrant a special mention here.

TRIPOD

Make a habit of using your camera on a good, sturdy tripod at all times, except when the need for mobility prevents its use. The investment in a tripod will repay you manifold with steady, professional-looking pictures. Especially when you want to pan or tilt the camera while shooting, you'll get a steadier result when the camera is on a tripod. However, you'll also need a smoothly operating pan-and-tilt head.

SHOULDER BRACE

If you want to be mobile with your camera and yet produce steady pictures, consider a shoulder brace. It helps you move, pan and tilt the camera—or to hold it still, for that matter—with maximum steadiness. The shoulder brace is particularly useful if your camera isn't of the type designed to rest on your shoulder.

CAMERA DOLLY

This is another device, commonly used by professional moviemakers, that ensures steady pictures even though the camera is moved during shooting. Basically, the dolly is a small vehicle for the camera. A small platform on wheels, a child's wagon or a wheelchair can make an excellent dolly. When you use a dolly with care and imagination, you can achieve a variety of interesting moviemaking effects. I'll discuss its use further, later in this book.

THE VIDEOCASSETTE RECORDER

The second basic component of your video moviemaking system is the VCR. It records the pictures transmitted from your camera and plays them back on your TV set. There are three basic videotape formats and four types of VCR models.

FORMATS

The three basic VCR formats are Beta, VHS and 8mm. They are not compatible. For example, you cannot

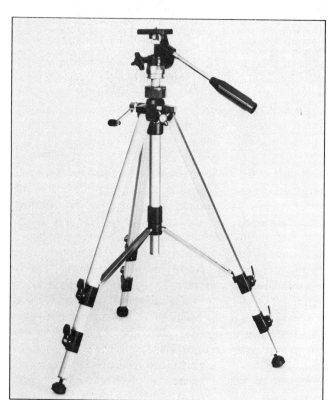

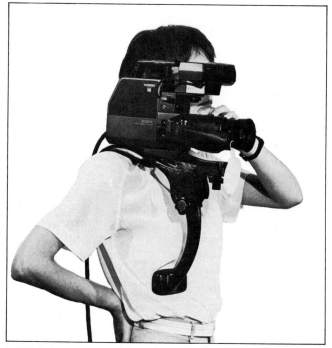

LEFT: RCA's sturdy tripod permits raising and lowering camera height with a hand crank. ABOVE: A "chest pod" or "shoulder pod" can help steady your camera while shooting handheld.

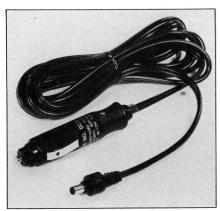

For portability "on location," you can power your camera and VCR from your car battery by plugging an attachment such as this into the cigarette lighter.

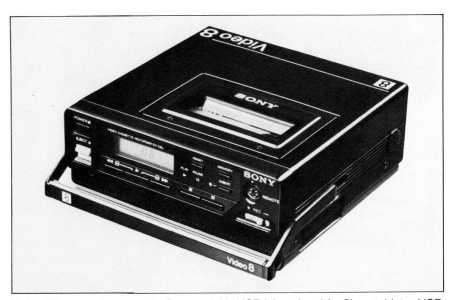

Major differences between the Sony portable VCR (above) and the Sharp tabletop VCR (below) are size and weight. The tabletop unit is made for use in the home and is powered by AC; the portable, without the tuner—which is built into the tabletop model—is designed to be carried and operates on battery power. It is intended for shooting home video movies.

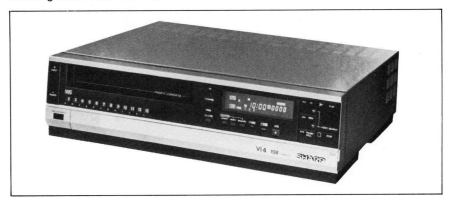

play a Beta cassette in a VHS recorder or vice versa.

The 8mm format is used in camcorders and 8mm VCRs. Any 8mm cassette will play in any other 8mm recorder or playback unit, regardless of manufacturer. Videotape in the 8mm format can also be easily transferred to VHS or Beta tapes, so it can be played on VCRs for those formats.

MODELS

VCRs are available in the following models:

Tabletop—The tabletop model includes a built-in tuner that enables you to select and receive broadcast TV programs. It also has a timer you can set to tape specific programs automatically. The tabletop VCR is relatively bulky and heavy.

Generally, to use a video camera with a tabletop VCR you need an auxiliary power-supply unit for the camera. That's because the tabletop uses 110-volt AC household current while the camera is designed to operate on DC battery power.

Portable—The portable VCR is relatively lightweight and is designed to be carried around easily. It's battery powered but can generally also be plugged into an AC outlet. Most portable VCRs can be powered by a car battery. To do it, you need a special connecting cable that inserts into the car's cigarette-lighter socket.

Combination—There are VCR models that are, in effect, a combination of tabletop and portable. The recorder part can be separated from the tuner/timer section. This kind of VCR can be battery powered or plugged into an AC household outlet. It, too, can operate from a car battery through the lighter socket, with the appropriate connector.

Camcorder—The fourth type of VCR system is a combination video camera and recorder. The portable and relatively lightweight unit, called a *camcorder*, enables you to shoot and record. The system gives you easy mobility as there are no trailing wires or connecting cables.

The camcorder is the closest thing in video movie-making to a Super-8 film camera. The big difference, of course, is that you can play your pictures back immediately.

Camcorders are available for Beta, VHS, VHS-C and 8mm formats.

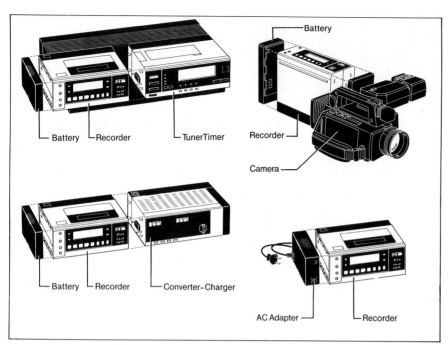

Kodak has a unique, modular 8mm camcorder system that enables you to use the separate units in different ways. You can shoot with the VCR attached to the camera unit or separated from it and slung over your shoulder.

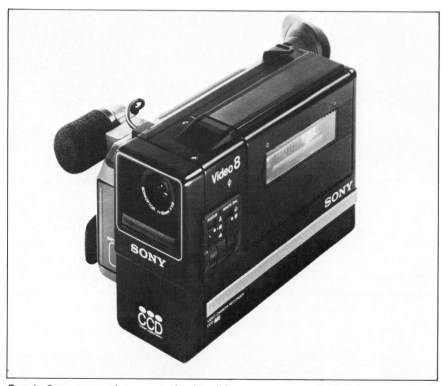

Sony's 8mm purse-size, super-simple, all-in-one camera and VCR is appropriately called the Handycam.

HOW A VCR WORKS

The video image picked up by the camera is recorded electronically on magnetic tape. The tape is neatly packaged in a videocassette, protecting it from dust and physical damage. The videocassette slides into the VCR. The tape records and plays back the image and sound much like a common cassette tape recorder records and plays back sound only. For more details on the operation of a VCR, please see *Buyer's Guide to Home Video Equipment*, also published by HPBooks.

USEFUL VCR FEATURES

In addition to the basic job of recording and playing back video images, many VCRs offer other useful features that can make your home video moviemaking more exciting.

Audio Dub—This feature enables you to add new sound to an existing videotape by erasing the original sound. You do this while playing back the original videotape with the VCR in the *Audio-Dub* mode. For example, you can use this feature to add a commentary to a video movie that had no original sound or to replace with music the sound originally recorded with the image.

Sound on Sound—This enables you to add new sound to a tape *without erasing* the sounds you had originally recorded. You can use this feature to *add* commentary or narration to your *original* audio track, mix music with it or add sound effects for realistic, dramatic or comedic impact.

Audio Level Control Defeat—Most VCRs adjust the sound recording level automatically with an *Automatic Gain Control* or *Automatic Volume Control*. If the sound you're recording gets too loud, this control automatically lowers it. Conversely, if your sound level is too low, it is automatically boosted. This ensures

a consistent sound volume throughout the audio track.

A few VCRs allow you to override—or defeat—this control. This is useful when you're recording music and want to adjust levels to your own taste. You'll also need an *Audio Gain Meter*, however, so you can monitor volume as you record.

Pause—I described this feature under the remote controls for your camera. If your camera doesn't have it, use the one on the VCR. However, you should use it only for short intervals between shots. That's because the recording head continues to rotate while the tape is stopped. This can eventually abrade and weaken the tape.

Tape Remaining Indicator—Some VCRs have an indicator that keeps you informed of how much tape is left for recording. This can be a very useful reminder when you're thinking of numerous other tasks while recording.

Picture Scan—This is helpful when you're searching through a tape for a specific shot or scene. In the simple *Fast-Forward* or *Reverse* modes, you don't see a recognizable image. *Fast Scan* or *Visual Search* lets you speed up your tape, in forward or reverse motion, and still see the pictures.

The *Slow-Scan* mode lets you reduce tape speed while keeping picture visibility in slow motion. In this manner, you can examine sequences closely or locate points to make an edit from one shot to another.

Freeze Frame—To produce one full picture, the TV screen is scanned by an electron beam 30 times every second. Therefore, a VCR plays back 30 frames per second. The *freeze-frame* feature, not available on all VCRs, enables you to stop the tape on any one frame so you can study it. Sports enthusiasts can use freeze

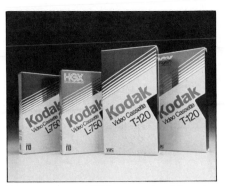

Because many VCRs can extend the play of a "two-hour" tape to four hours or more using different tape speeds, these half-inch VHS and Beta cassettes are common. The L-750 (Beta) and T-120 (VHS) lengths are the most common. To achieve best picture quality, shoot your movies at the fastest VCR speed only.

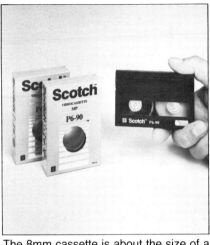

The 8mm cassette is about the size of a deck of cards. This one records up to 90 minutes; others can record 30, 60 or 120 minutes.

frame in all kinds of exciting ways. For example, baseball fans can determine whether the umpire was right and the runner really was out!

Frame Advance—This takes freeze frame one step further, allowing you to advance the tape one frame at a time. This can give an even better indication of whether the runner was safe or not. I'll tell you how you can use this feature for editing in Chapter 10.

VIDEOTAPE CASSETTE

The third basic component of a video system is the videotape cassette. It is a self-contained unit holding the tape that stores your movies and enables you to play them back.

HOW VIDEOTAPE WORKS

Videotape is coated with a magnetically sensitive material. When the tape passes over video and audio heads in a VCR, the material responds to magnetic impulses generated by the picture and sound information provided by camera and microphone. Unlike photographic

film, videotape can be erased and reused.

The VCR can "read back" the magnetic information stored on the tape to produce images and sound on a TV set.

Color—Color never becomes an integral characterisitc of videotape as it does of photographic color film. The tape is simply a messenger: It picks up the color information provided by a camera and passes it on to the VCR. The VCR relays the information to the TV screen.

Control Track—Videotape records not only picture and sound, but also a *control track*. The control track serves a function similar to that of sprocket holes in film: It ensures precise tape speed at all times across the recording and playback heads in the VCR. This is especially important when you edit tape by re-recording from one VCR to another.

FORMAT

Videotape cassettes come in three basic formats: VHS, Beta and 8mm. Each VCR or camcorder is designed for one specific format.

17

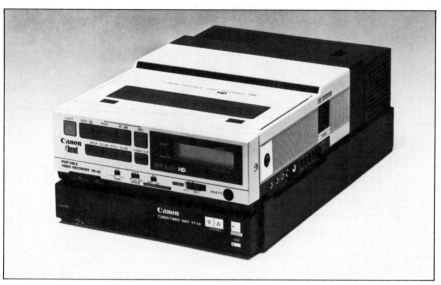

This portable VCR is attached to its tuner/timer. This way, you can use it to record TV programs. The top part of the Canon unit detaches, to be mated with a compatible camera for making video movies.

At present, 8mm videotape can be used only in camcorders or VCR units made to accept that format. Some VHS-format camcorders use a VHS-C cassette, which is smaller than the standard VHS cassette. It needs an adapter to plays in a VCR for standard VHS cassettes.

Non-Compatibility—The various videotape formats are not compatible or interchangeable. A Beta cassette cannot be used in VHS equipment, nor can a VHS cassette be played in a Beta VCR. An 8mm cassette cannot be used in equipment for either of the other formats although most 8mm camcorder systems provide easy transfer to either VHS or Beta. Be sure to obtain the right tape format for your equipment.

RECORDING TIME

Cassettes come in various tape lengths. Total recording time depends on the length of the tape and on the speed at which the tape passes over the recording heads in the VCR. You have a choice of recording speeds. You can select a speed that gives you the recording time you need. See the accompanying chart.

Image Quality—An important consideration in selecting recording speed is image quality: The faster the tape speed, the better the image quality you'll obtain. That's because at faster speeds the electronic information is able to use more tape. At slower speeds, the same information is compressed into less tape.

An approximate equivalent in photography would be the relationship of film size and image quality. For example, an image on 8x10 film is likely to be of better technical quality than a 35mm image of the same subject.

VIDEOCASSETTE RECORDING TIMES (Minutes)

Format	Type	Recording-Speed Setting		
VHS		SP	LP	EP
	T-30	30	60	90
	T-60	60	120	180
	T-90	90	180	270
	T-120	120	240	360
	T-160	160	320	480
VHS-C		20		60
Beta		X1*	X2	X3
	L-125	15	30	45
	L-250	30	60	90
	L-500	60	120	180
	L-750	90	180	270
	L-830	**	200	300
8mm		15		30
		30		60
		60		120
		90		180
		120		240

*X1 was original Beta consumer recording speed but is no longer available on home-video-recording equipment. It is available on some home VCRs as a playback speed only.
**Do not record at X1 speed with L-830 cassettes.

CARE OF VIDEOTAPE CASSETTES

Here are a few valuable tips to help you protect your videotape cassettes from harm:

- Store cassettes in a location that is cool, dry and dust-free. Don't leave cassettes in direct sunlight, near heating units or in a car in hot weather.
- Store cassettes in an upright position in suitable storage cases.
- Do not store cassettes near magnetic fields such as are generated by electric motors, transformers, magnets or electronic equipment such as a TV set, VCR or computer.
- Ideally, it is best to store cassettes with the tape fully wound onto one or the other reel.
- Never touch the tape itself.
- Avoid physical shock to the cassette.
- If a tape has been allowed to become cold, wait for it to reach room temperature before using it.
- Don't leave your equipment in the *Pause* mode longer than five minutes maximum. Doing so would wear both the tape and the recording heads and may cause permanent damage.

ABOVE: Videocassettes are available in a variety of formats and tape lengths, as discussed in the text. Shown here is the selection of 8mm, VHS, VHS-C and Beta tapes offered by only one of many companies. BELOW: Canon offers three tape lengths in their 8mm videocassette line.

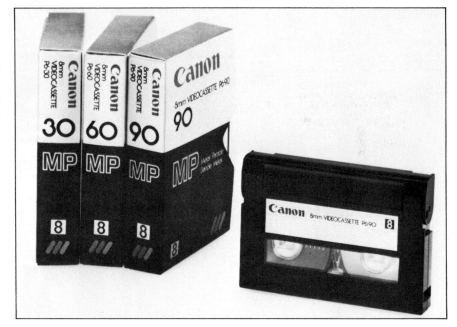

Preparing for Action

The old Boy-Scout slogan "Be Prepared!" is perhaps the best advice for the novice video movie maker. When you've got your subjects—or performers—in front of your camera, you must be prepared to give them all your attention. You should know what equipment you plan to use and be confident that all components of that equipment will work. You should have all the accessories you will or may need.

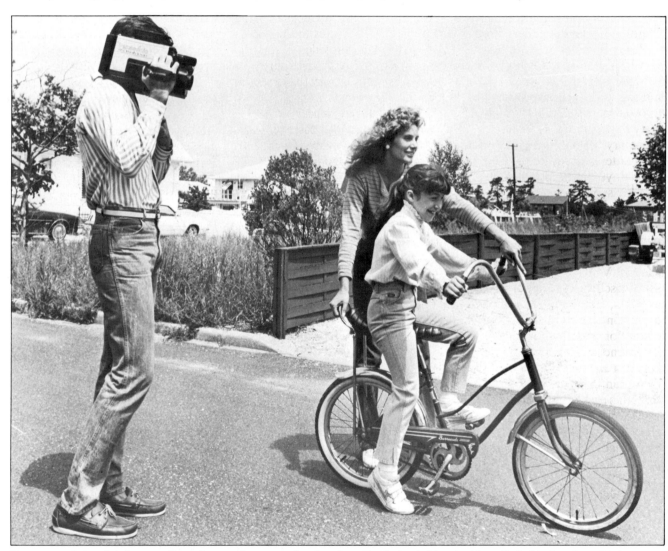

No one wants to miss documenting a "momentous occasion," such as the first solo bicycle ride or first at-bat on the Little League team. With a camcorder such as Panasonic's OmniMovie, this is easy to achieve. Always have your equipment ready for operation. Be sure the battery is charged, and keep extra blank cassettes handy.

light. You can buy three-light kits of quartz lights at most photographic dealers. A kit features several useful attachments, including diffusion screens, "barn doors" to control the light beam and adjustable stands.

Quartz lights require a lot of electrical power. Be careful not to overload circuits so you don't blow fuses or trip circuit breakers. To spread the load, use outlets in separate rooms. To do this, you'll need special heavy-duty extension cables.

Photo Lamps—A less elaborate lighting kit would include two or three 250-watt or 500-watt photographic lamps. They are relatively inexpensive and available at most photo dealers or department stores. You'll need light stands and heavy-duty extension cables.

Camera-Mounted Light—When you're more interested in camera mobility than creative lighting, you'll find a camera-mounted light most useful. It travels with the camera wherever you move it and always lights your subject frontally. You can use the light for main illumination when the available light is too dim. Alternatively, you can use it as fill light when the subject is backlit by a brighter source, such as the sun.

Camera-mounted lights can be operated by battery or AC power.

Reflectors—Two or three large, white cards—at least 18x24 inches—can make an important contribution to your lighting needs. Aim them to reflect a light source at subject areas that need additional illumination. You can attach the cards to light stands or chairs, using tape or clamps. When used thoughtfully, reflector cards can take the place of additional light sources. This cuts down your equipment needs and also helps to keep the shooting area cooler.

A useful type of reflector, commercially available, has one smooth, silvered side and one matte, white side.

Outdoors, reflectors are particularly useful in bright sunlight. When the sun is directly overhead, they can direct the illumination onto the subjects more frontally. In addition, any deep shadows are easily filled with reflected sunlight if you use a couple of cards.

I'll discuss lighting more fully in Chapter 6.

Light Stands—Your equipment should include two or three extendible light stands. In addition to holding lights or reflectors, they can be used as hidden supports for foreground props, such as branches.

Power Supply—If you're shooting away from home but with AC power supply available—such as in a school, theater, church or sports

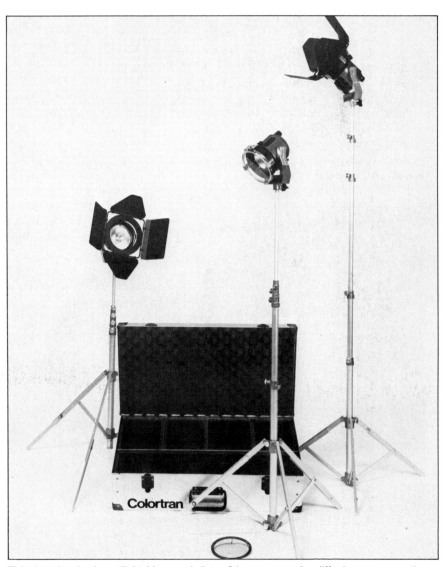

This is a basic three-light kit, consisting of lamps, stands, diffusion screens, "barn doors" and carrying case. For many staged productions—discussed later—this is all the lighting you should need.

This Lowel Omni-Light kit has three lights. It also includes light-control accessories that color, diffuse and bounce light or convert it to a large, soft source.

A small, camera-mounted light is a useful accessory for home or location shooting. It's lightweight and easy to use.

arena—be sure to find suitably located outlets before it's time to shoot. Be sure you have sufficient lengths of extension cord to reach the outlets from camera position. A multiple plug box with four or five outlets is useful, too.

An external battery pack is a useful item when you're shooting on location. Whether in the form of a portable battery pack or battery belt, it'll give you three to five hours of running time for your VCR and camera. I recommend that you use AC power whenever possible so you needn't worry about your power supply running out.

SOUND

Your camera's built-in microphone will pick up clear voice sounds from no more than about 6 feet from the camera. If you plan to shoot subjects at greater distances—during lectures, concerts or other performances—you'll need an external mike and cables. You can plug the cable from the external mike into the mike jack on your camera. This enables you to place the mike near the source of the sound and aim it as desired.

I advise you to consult your video dealer regarding the best mike for your specific purpose. Don't forget to also get a mike stand. You can get floor or table models.

If you want to monitor accurately the sound you're recording, you'll need a set of good headphones. Those used with portable cassette players are fine, although you may need an adapter jack.

As mentioned earlier, even if you're using your TV set as video monitor, you must keep the sound turned down while recording, to avoid unwanted feedback from the microphone.

For more detailed information on sound recording, see Chapter 9.

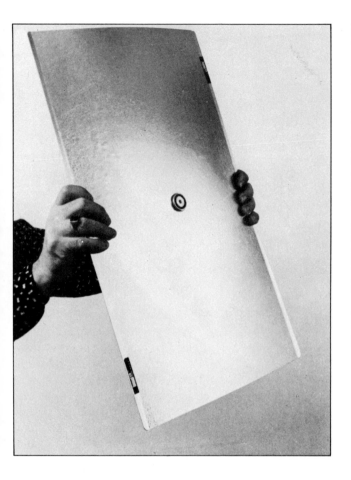

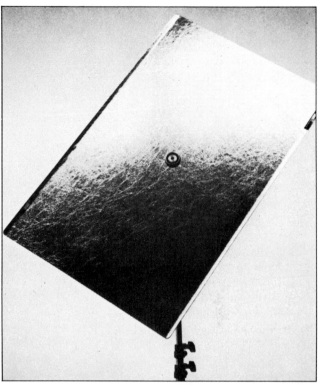

You can handhold this Lowel light reflector or mount it on a stand, to provide "fill" light by reflecting other light sources. This helps to brighten shadow areas and results in more even lighting.

GAFFER'S TAPE

Moviemaking—professional or amateur—is unthinkable without the all-useful *gaffer's tape*. A gaffer is a technician who is responsible for positioning and adjusting lighting. One of his ever-present tools is a roll of silver-colored adhesive tape. It will tape almost any two objects together. It's used to hold things up, down, open, closed and at this or that angle.

Gaffer's tape will help you aim a light, support a reflector or hold a foreground prop in position. You can use it to achieve a better fit of clothing that's too loose for one of your performers. If a door won't stay open—or closed—use gaffer's tape.

You can prevent people tripping over cables by securing the cables to the floor with the tape.

Canon's auxiliary microphone can be handheld or set up on a desk or table to record performers beyond the reach of your camera's built-in mike. It is one of several types of microphones that can be substituted for your camera's built-in mike.

Gaffer's tape is available from motion-picture supply houses. Alternatively, go to your hardware store and ask for the less-expensive *duct tape*. It's nearly the same thing.

PROPS AND SCENERY

The *objects* you need in front of your camera, to supplement and interact with the *subjects,* are called *props.* They can include houseware and tableware, tools, books and virtually anything else that "sets" the scene. Larger props, such as furniture, drapes, bookshelves, artificial trees and backdrops are called *scenery.* Make a comprehensive list of needed props and scenery well in advance. Be sure you have them all when shooting is due to begin.

Wardrobe—This includes anything you want your performers to wear. It may be your subject's own clothing or period costumes. Theatrical costumers who have a rental service can fill almost any imaginable need. List your requirements and check them off as you get them. Don't forget to get sizes appropriate to your intended performers.

Artwork and Graphics—Remember titles for opening and closing your movie, and for transitions, identifications and credits. When possible, shoot titles in the correct sequence to avoid needless editing later. However, if you plan to do extensive editing anyway when shooting is complete, it may be more convenient to shoot all titles at the same time. Whichever way you do it, have all artwork and graphics ready before you start shooting.

You can use gaffer's tape to attach almost anything almost anywhere. There was no other way for me to hang my lights at this location.

3 Basic Camera Work

The two previous chapters have familiarized you with your equipment and told you what it can do for you. I also showed you how to get prepared for shooting. Now it's time to show you how to use your camera creatively to get the visual effects you want.

Your video camera is a sophisticated and remarkably versatile moviemaking tool. You can use it in many ways to tell a story, provide information, amuse or touch the emotions. Modern cameras offer many *technical* features and controls. However, *creative* results depend on

you. To make a good movie, you must make important decisions regarding two things—movie *content* and shooting *technique*.

Content is the subject of later chapters. Here, I want to tell you about some basic shooting techniques. You'll learn some well-

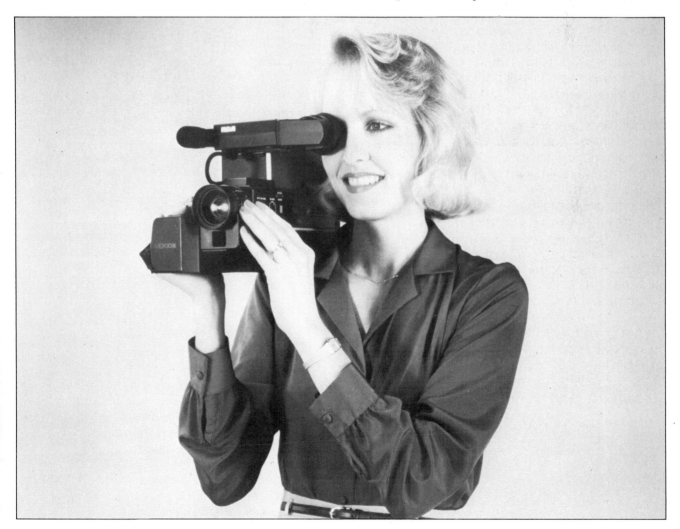

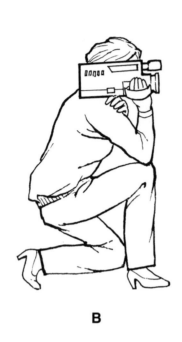

A

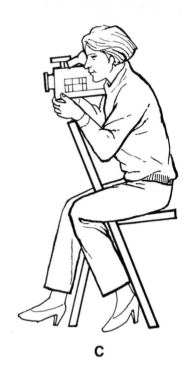

B

C

The basic shooting positions are standing, kneeling and sitting. For steady camera operation, follow these guidelines:

(A) *Standing:* Keep feet firmly planted with legs slightly apart. Steady the camera with your elbows braced against your body. If possible, lean against something such as a wall or tree.

(B) *Kneeling:* Support right or left elbow on one knee, get comfortable, and steady the camera with your other hand.

(C) *Sitting:* The back of a chair gives good support, with a higher camera position than sitting on the ground or kneeling.

(D) *Sitting:* Brace your back against a firm support such as a wall, keeping your elbows as in (A).

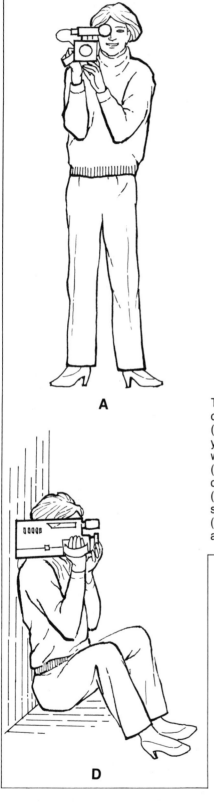

D

established methods that have served filmmakers for a long time. They include where to aim the camera, at what angle and for how long a time. For example, you can choose to frame more or less of the scene in front of you. You can also select to hold the camera still or move it while you're shooting. Learning these tech- niques gives you a good foundation. From there, you can explore other methods to suit different ideas and achieve specific effects.

CAMERA STEADINESS

Most movies look best when the image appears steady on the screen. A jiggling image is fine if you're aim-

ing for a special effect, but it is disturbing to the viewer at all other times. Therefore, camera steadiness is very important.

The best way to keep a camera steady is to mount it on a sturdy tripod. A perfectly steady camera is especially important when you're using a telephoto lens setting. At higher magnification, image unsteadiness is more evident.

However, you'll often want to use your camera handheld. To ensure the steadiest pictures, brace the camera against your chest or shoulder. If you're going to do a lot of handheld shooting, I advise you to invest in a special shoulder support or brace for the camera.

Some of the techniques that follow involve deliberate swinging, tilting or moving of the camera. It's important that those moves be steady and not jerky. If you walk with your camera, do it steadily and slowly, without a bounce. If you swing the camera through a scene, swing the upper part of your body with a smooth, level sweep. Later, I'll tell you about other devices and methods that will ensure smooth camera movement.

THE SHOT

Each continuous shooting period, from the moment the camera starts shooting until it stops, is called a *shot*. The camera need not be aimed in the same direction, or located in one position, during an entire shot. For example, you can pan to follow a moving subject or to show a wide panorama. You can also change camera-to-subject distance or camera viewpoint by moving the camera during a shot.

Shots are the building blocks of a motion picture. Basically, each new shot should lead you on logically and smoothly to the next shot in the story

you're telling. When you start on a new shot within a scene, it's advisable to change camera viewpoint, angle or distance.

Shot Duration—The average shot should have a duration of between 5 and 15 seconds, depending on the action. Every shot should tell its story in an interesting, attention-holding manner. If it's too short, the viewer will be confused; if too long, the viewer is likely to become bored.

Exceptions, requiring shots of longer duration, are activities that last longer and must be shot in one sequence. Typical examples are theatrical productions, concerts and sporting events. In such cases, the length of a shot is determined by the time each scene, piece of music or play in a sport takes to complete. To maintain viewer interest in a shot of long duration, you can zoom or pan the camera during taping. I will explain these techniques a little later.

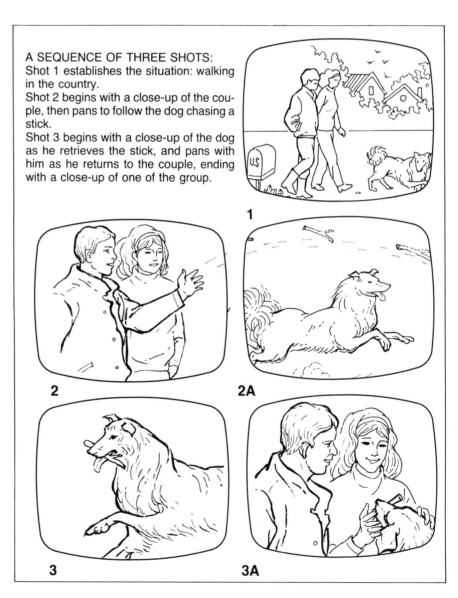

A SEQUENCE OF THREE SHOTS:
Shot 1 establishes the situation: walking in the country.
Shot 2 begins with a close-up of the couple, then pans to follow the dog chasing a stick.
Shot 3 begins with a close-up of the dog as he retrieves the stick, and pans with him as he returns to the couple, ending with a close-up of one of the group.

1

2 2A

3 3A

SHOT DISTANCE

Movie shots fall into three basic categories: *Long Shot (LS), Medium Shot (MS)* and *Close-Up Shot (CU).* These terms define how much of the scene in front of you will be recorded by the camera and seen on the TV screen. Indirectly, therefore, they define camera-to-subject distance. You can change that distance by moving the camera. You can achieve the same effect artificially—without moving the camera—by changing the focal-length setting of the camera's zoom lens. I discuss this more fully later in this chapter.

Long Shot—It establishes the scene, showing your subjects in their surroundings. To make the long shot, you are relatively far from the subjects or, alternatively, using the wide-angle setting of the zoom lens. It tells the viewer where the action is taking place.

Medium Shot—It shows your main subjects fully but eliminates much of the surrounding background. It tells something about who the subjects are, what they are doing and what the movie is about.

Close-Up Shot—It zeros in on a key activity in the movie. When the medium shot shows a sculptor at work, the close-up shot may show just his hands and details of what he's working on.

Variations—There are also variations of the basic three shots. Their names indicate clearly what they are. For example, the *Extreme Long Shot (ELS)* includes even more than the long shot, and the *Extreme Close-Up (ECU)* shows small detail even larger than the close-up shot. Other in-between designations include the *Medium Long Shot (MLS)* and *Medium Close-Up (MCU).*

Use the above shot designations when you're planning or scripting your movie. For added convenience, use just their recognized abbreviations.

SHOOTING ANGLE

The shooting angle is the camera's viewpoint of the subject. The angle can contribute greatly to the impact of a scene—or it can totally confuse the viewer. Always choose your shooting angle carefully, bearing in mind what you want to achieve. In addition, for a smooth and comprehensible transition from shot to shot, you must bear in mind what preceded that particular shot and what is to follow it.

Here are four basic camera angles, with advice on how to use them:

Eye Level—This is the most commonly used angle and the one you should shoot from most of the time. Remember, eye level means *eye*

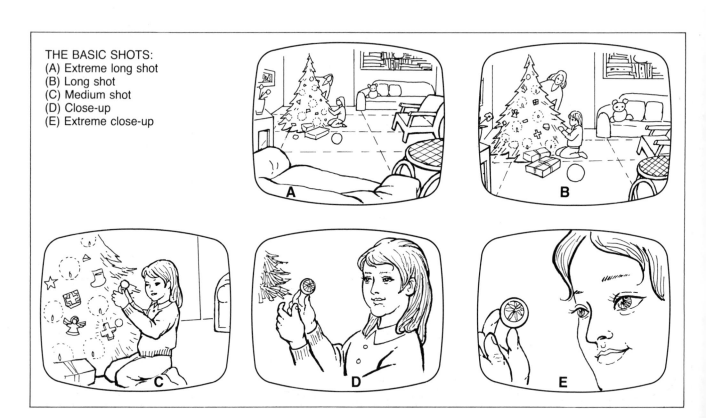

THE BASIC SHOTS:
(A) Extreme long shot
(B) Long shot
(C) Medium shot
(D) Close-up
(E) Extreme close-up

level, whether the subject is standing or seated and regardless of how small or tall your subject may be.

Low Angle—The camera is well below the main part of interest of the subject and is aimed up. This angle exaggerates height and can make a subject appear powerful, authoritative or ominous. The exact effect depends on the context of the movie and on the lighting you use. I discuss lighting in Chapter 6.

When you use a low angle, the subject background will generally be above rather than behind the subject. Typically, your background might be a ceiling, the sky or the foliage of a tree.

When you take a long or medium shot from a low angle, it can help establish a location. For example, if a shot is to introduce a scene high up in a tall building, shoot the building from the outside, aiming the camera upward toward a high, upstairs window.

High Angle—The camera is well above the part of main interest and is aimed down. This angle has the effect of reducing the apparent height of a subject. It can make a subject appear small, weak or insignificant.

The high angle is useful for creating dramatic impact, especially for a medium shot. When you get close for a detailed close-up, however, it's generally best to return to an eye-level viewpoint—unless you're aiming for a specific effect.

Over-the-Shoulder—This is a standard technique used when shooting a conversation between two people. Normally, the speaker's full face is shown while the camera is aimed over the shoulder of the listener. You may show only the back of the listener's head or give a partial side view from the back.

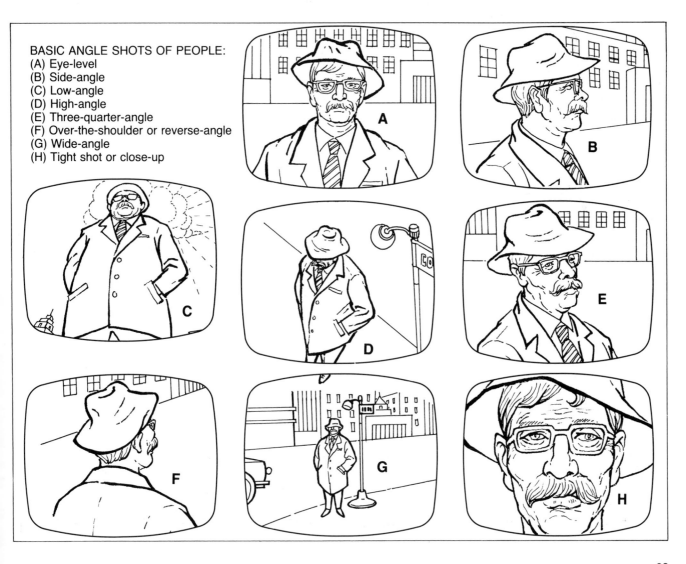

BASIC ANGLE SHOTS OF PEOPLE:
(A) Eye-level
(B) Side-angle
(C) Low-angle
(D) High-angle
(E) Three-quarter-angle
(F) Over-the-shoulder or reverse-angle
(G) Wide-angle
(H) Tight shot or close-up

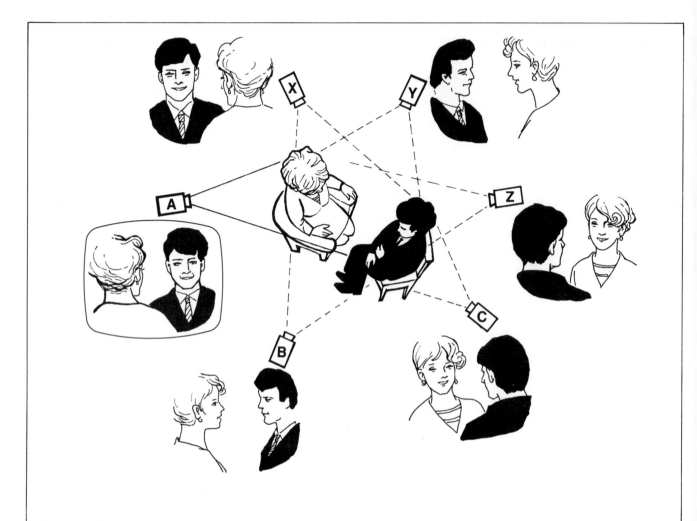

Avoid over-the-shoulder angles that reverse subject position. When you begin with shot A, you can change to B or C, keeping your subjects in their proper relationship in the frame. But if you shoot from X, Y or Z following shot A, your subjects will jump to opposite positions on the TV screen, confusing your viewers.

Sometimes you may want to show the listener's reaction to what the speaker is saying. In such a case you change the shot by reversing the above, showing the listener's full face.

You can move back and forth, shooting over the shoulder of one and then the other. To avoid confusion, return to the same position you occupied previously. For example, if you were shooting over the left shoulder of a subject to begin with, keep shooting over that shoulder. If you were to change and shoot over the right shoulder, your subjects would suddenly change sides on the TV screen.

If you want to change camera or subject positions, inform viewers visually that you are doing so. A good way to do this is to move, or *truck,* the camera sideways past the subjects while you shoot. Or, you can direct the subjects to change positions during a shot while the camera stays stationary.

You can shoot over-the-shoulder shots as medium or close-up shots.

CAMERA MOVES

Because you're making movies—or motion pictures—it's OK, and often even desirable, for your camera to be in motion while you're shooting. After all, action and motion are what movies are all about. There are three basic ways of getting motion into your movies by moving the

camera and changing viewpoint without necessarily altering the camera-to-subject distance.

PANNING

This involves swinging the camera horizontally, left to right or right to left, while you're shooting. The sweeping movement of the camera should be smooth. Whenever possible, have the camera mounted on a sturdy tripod with a smoothly operating pan head. With a handheld camera, assume a solid stance and brace your elbows against your body to steady the camera.

You can use panning to follow moving subjects, to shift viewer attention from one subject to another, or simply to display a panoramic view.

Usually, you should pan the camera slowly. Sometimes a pan is made more meaningful if the camera follows a moving object or gesture. For example, pan with a child's hand as it is outstretched to pet a dog. Or, pan with the dog as he moves from one child to another.

When you pan to shift viewpoint, the pan should last about two or three seconds, depending on the panning distance. When panning to show a panoramic view, take about six to eight seconds to sweep the camera through an angle of 45°. Hold the camera still for two or three additional seconds at the beginning and end of a pan shot.

To pan with a rapidly moving subject, such as a car or runner, you must move the camera fast enough to keep the subject in the frame. With experience, you'll be able to hold a moving subject steadily in the image area without jiggling.

A word of warning about panning—don't overdo it! Don't pan unless you have a reason for it. When you do pan, do it smoothly and slowly. If you don't heed this advice, what might seem fun to the camera operator can become an experience verging on seasickness to the viewers. And, after all, it's the viewers you're shooting the movie for.

Swish Pan—As I've indicated, panning is usually done smoothly and

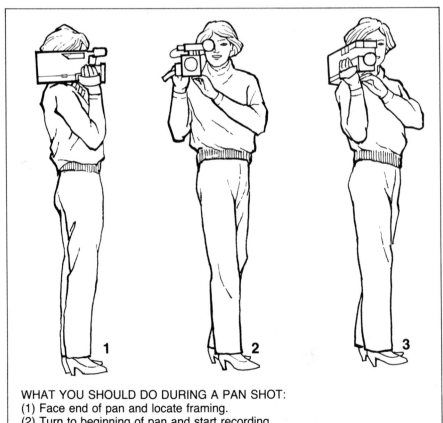

WHAT YOU SHOULD DO DURING A PAN SHOT:
(1) Face end of pan and locate framing.
(2) Turn to beginning of pan and start recording.
(3) Pivot smoothly to end of pan, hold a few seconds and stop.

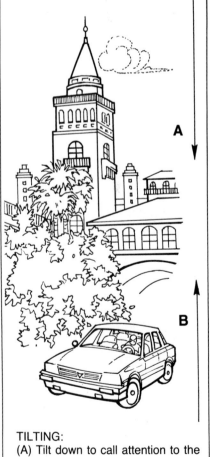

TILTING:
(A) Tilt down to call attention to the lower part of the scene.
(B) Tilt up to dramatize the height of a subject.

slowly. However, a fast pan, or *swish pan,* can create an effective transition from one scene to another. It can give the viewer the impression that a period of time, or a long distance, passed between two shots. End one shot with a rapid pan from left to right. The pan should be fast enough to make the scene unrecognizable. Try a 60° sweep in about 1/2 second. Begin the next shot with an equally fast pan in the same direction.

There are a couple of things you have to be careful of when you make a swish pan. You must stop shooting while you are still in your first pan—otherwise you'll end up with a sharp image. When you start your second pan, you must already have the camera in motion when you start shooting, or you'll begin the second shot with a sharp image. You must end the second swish—and remember it's fast—at exactly the spot where you want the second shot to begin. Finally, as with all panning, don't overdo it!

TILTING

This is basically similar to panning but involves sweeping the camera in a vertical direction. The precautions that apply to panning apply here, too.

You can tilt the camera to follow action that rises or falls. Or, you can use it to establish location. For example, to indicate the location of an office interior, you can begin by scanning a tall building from ground level to an upper floor.

Tilt the camera steadily and slowly. Avoid any jerkiness or wobble. Hold the camera still for a few seconds at the start of the shot and again at the end of the tilt.

Pan and Tilt—You can pan and tilt your camera at the same time. For example, you may want to follow a subject going up a slope or shift viewpoint from a high point to a lower one in a different direction. Perform this camera movement slowly and steadily. It may take a little practice for you to confidently arrive at the correct framing at the end of the camera sweep.

TRUCKING

This technique involves changing the camera viewpoint continuously while the camera is running, just like panning. However, there's an important difference: By trucking you

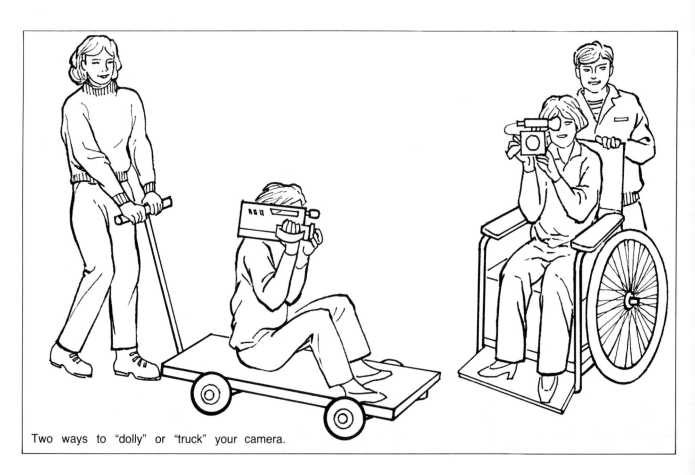

Two ways to "dolly" or "truck" your camera.

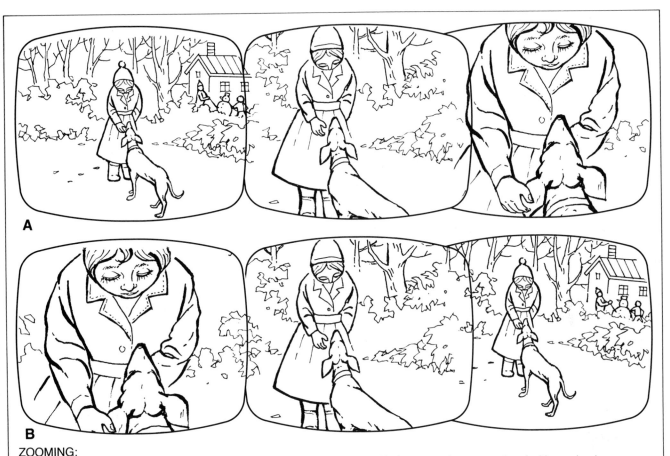

ZOOMING:
(A) Zoom in—from wide angle to close shot—when you want to start with the general scene and end with emphasis on your subject. (B) Zoom out—from close shot to wide angle—when you want to start with your subject and expand by showing more of the surrounding scene.

change camera viewpoint by actually changing camera location. You do this by moving the camera sideways or in an arc across the scene without changing the camera-to-subject distance significantly. Usually, the main subject will remain centered in the frame throughout the trucking movement.

You need a steady vehicle and floor, just as you do for dollying, described a little later. A child's wagon and a wheelchair are both suitable vehicles. A simple board platform on soft wheels will also do the job. However, the suspension of most baby carriages is too springy to make them suitable camera carriers. You

can rent excellent *dollies,* specially made for cameras, from professional movie-equipment supply houses.

Trucking gives the basic effect you see when looking out the side windows of a moving car. Nearby objects, like telephone poles by the roadside, move relatively fast. Farther objects, such as houses in the middle distance, move relatively slower. Distant scenes, such as mountains, will appear not to be moving at all. This relative movement of objects is created by trucking. It gives the viewer a very real sensation of "being there."

To enhance the trucking effect, I suggest you deliberately place some

object such as a lamp or plant in the near foreground of the scene you're shooting. Outdoors, you can use a fence post or tree for the same purpose. The back view of a person can also often serve the same purpose.

CONTINUOUS DISTANCE CHANGE

Earlier in this chapter, I discussed changing the camera-to-subject distance for different shots to achieve long, medium and close-up shots. You can also change the distance of the subject from the camera continuously, while the camera is running. There are two ways of doing

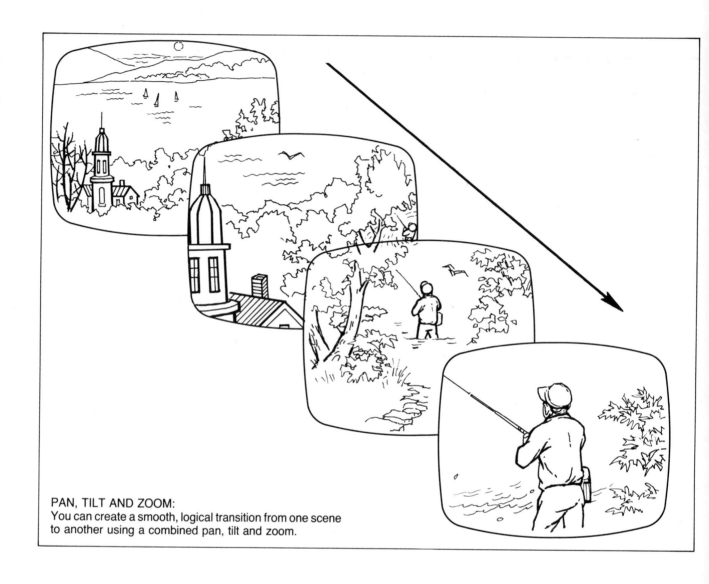

PAN, TILT AND ZOOM:
You can create a smooth, logical transition from one scene
to another using a combined pan, tilt and zoom.

this—*zooming* and *dollying*. Because comparisons between the two methods are important, I'm going to put them both in this section.

Zooming is by far the more common method used. However, because dollying describes more clearly what is being achieved, I'll describe it first.

DOLLYING

To achieve a distance change, you do the obvious thing—move the camera toward or away from the subject. To achieve a smooth motion, the moviemaker uses a *dolly,* which is simply a suitable carriage for the camera and its operator. As described for trucking, there are several wheeled devices that you can adapt for use as a dolly. The important features you need are smooth motion, the ability to mount the camera securely and, if possible, room for you to ride along.

If you use a wheelchair, simply sit in it, use the camera handheld and have someone push you—slowly and steadily. Of course, you must have carefully discussed and re-

hearsed the shot beforehand with your "driver."

You can use a dolly on which there isn't room for you. However, you must be able to follow behind and look through the viewfinder as you shoot.

To ensure smooth operation of a dolly, the floor must be flat and smooth. Otherwise, you will get a jerky picture.

As with most camera movements, you should begin a shot with the camera stationary for a few seconds, then dolly slowly and steadily toward

or away from the subject. When you end the dollying, keep the camera operating for a few more seconds to establish the new viewpoint.

ZOOMING

This method doesn't really change the camera-to-subject distance but only makes it appear so. Instead of moving the camera, you change the focal length of the zoom lens on the camera. As I indicated earlier, because it is far more convenient, zooming is the more common way to get a distance change—or, more accurately, an *apparent* distance change.

To be sure of a smooth zooming action, use the power-zoom feature on your camera. An electric motor ensures a zoom of uniform speed. Again, begin each shot with a few seconds of non-zoom and end it the same way.

I recommend that you use manual zooming only for special effects, such as when you deliberately want a fast or irregular zoom action.

I warned you earlier about overusing panning. The same applies to zooming. Use it selectively, for a specific reason. Excessive zooming, done indiscriminately, is very disturbing to the viewer.

You can achieve some exciting visual effects by combining zooming with panning and tilting. For example, you might begin with a wide, panoramic view of a mountain valley. Then, while slowly zooming in, you pan and tilt in a diagonal direction, ending the shot on a man fishing. When executed smoothly and slowly, this technique can give a movie a really professional look.

Previewing—Before you record a zoom shot, preview it in the viewfinder. Check the composition of the initial and final frames.

Whether you're zooming in or out

KEEP THE HORIZONTAL PLANE LEVEL

INCORRECT: Nothing is more disturbing to your viewers than to see the horizon tilted.

CORRECT: If the horizon line appears level in real life, keep it that way in your video movies.

in a shot, always focus with the lens at its telephoto setting, where depth of field is most limited. If you focus at the wide-angle setting, the image made at the tele setting may not be totally sharp.

ZOOM OR DOLLY?

If your only object is to make the main subject larger or smaller as you shoot, it doesn't matter whether you zoom or dolly. However, there are two important esthetic differences between the two techniques. When you know them, you can always select the method that better suits a specific need.

First, because the camera moves through the scene when you dolly toward a subject, you see objects in the scene approach the camera and eventually move past its sides. This gives a very real feeling of "being there." When you zoom in on a subject, you don't get this effect. You simply see the frame closing in on a subject that is getting progressively larger.

The second difference between zooming and dollying concerns perspective. When you dolly toward a subject, that subject becomes larger in relationship to its distant background. Also, all objects in the scene change their relative positions as the camera approaches. That's what you would expect to happen. These are the same effects you experience when you walk toward someone.

When you zoom in on a subject, with the camera in a fixed position, you simply tighten the frame around a subject that's constantly increasing in size. All objects in the scene retain their relative positions. As a result, you see the subject getting larger without having the feeling that you're actually approaching the subject.

When you zoom, the subject and its distant background enlarge

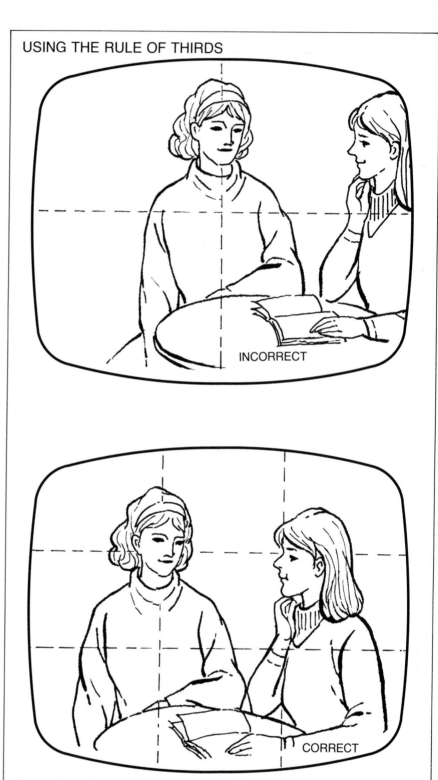

USING THE RULE OF THIRDS

INCORRECT

CORRECT

To avoid incorrect framing, top example, divide the frame into imaginary thirds, horizontally and vertically. Put the main subjects on those lines and particular points of interest where the lines cross, lower example.

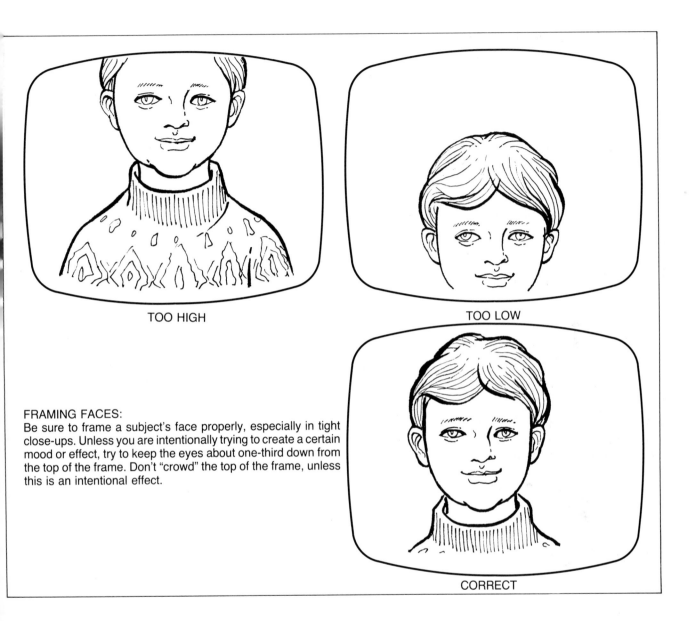

TOO HIGH

TOO LOW

CORRECT

FRAMING FACES:
Be sure to frame a subject's face properly, especially in tight close-ups. Unless you are intentionally trying to create a certain mood or effect, try to keep the eyes about one-third down from the top of the frame. Don't "crowd" the top of the frame, unless this is an intentional effect.

together in the same proportion. Because, in real life, you expect a background to become relatively smaller as you approach a nearer subject, the zooming action fools you. For example, as you zoom in on a person, the distant mountains don't get relatively *smaller,* as you would expect. Because of this, you're fooled into believing that the mountains are getting *closer* as you zoom in. We're all familiar with this foreshortening of perspective.

You can use the foreshortening effect creatively by zooming—or avoid it by dollying.

DISTANCE AND ANGLE CHANGES

Changes of camera distance—or apparent distance, through zooming—and camera angle should always be decisive. Don't be halfhearted about it. A slight change will only confuse the viewer. If you change

from a long shot to a medium shot, be sure the difference is significant and the reason for it obvious. If you change camera angle, don't limit yourself to 5° or 10°. Make a distinct change, and be sure the viewer understands why you're making the change.

It's generally most effective to change camera angle when you change shooting distance or zoom between shots. When you go from a medium shot to a close-up, for ex-

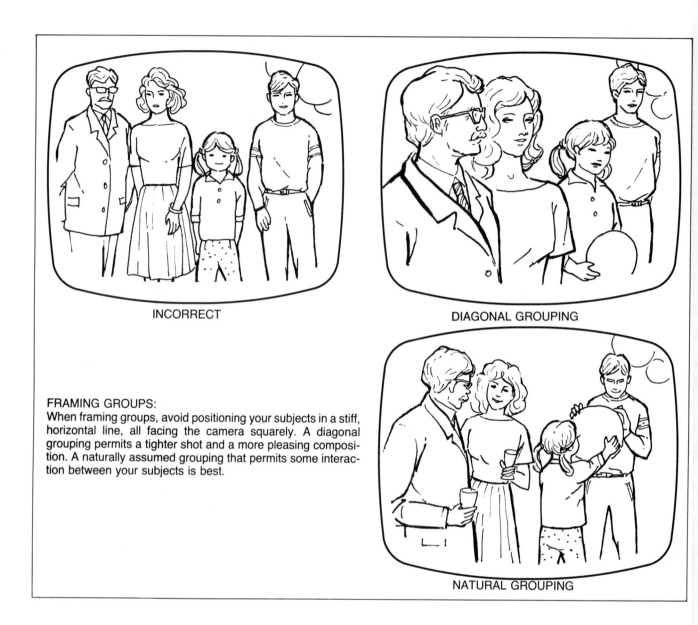

INCORRECT

DIAGONAL GROUPING

NATURAL GROUPING

FRAMING GROUPS:
When framing groups, avoid positioning your subjects in a stiff, horizontal line, all facing the camera squarely. A diagonal grouping permits a tighter shot and a more pleasing composition. A naturally assumed grouping that permits some interaction between your subjects is best.

ample, accompany this with a change in camera angle.

When you change distance and angle together in making a new shot, differences in your subject's position and attitude are less obvious and the appearance of a continuous flow of uninterrupted action from one shot to the next is more pleasing.

It's a good idea to change shooting angle and distance when you change subjects, too. For example, don't follow a shot of one art student at work at his easel with a shot of another student at the same angle. To emphasize the change in scene, consider using a different camera angle.

IMAGE COMPOSITION

So far, I've described a wide variety of ways to put action in your movies. They involve varying shot distance and angle, swinging the camera, moving with the camera and zooming. While the image is steady in the viewfinder, there's another important consideration to keep in mind. It involves image composition—the attractive and effective placement of image components in the picture frame.

INCORRECT CORRECT

FRAMING FACES:
When framing faces, leave a little extra space on the side of the frame toward which your subject is looking.

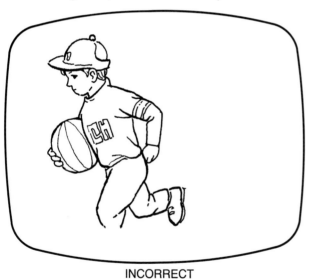 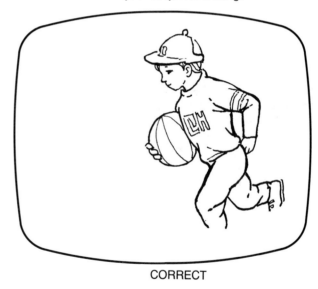

INCORRECT CORRECT

FRAMING TO FOLLOW ACTION:
When panning to follow a moving subject, leave space in front of the moving subject.

HORIZON

Keep the horizon level in your pictures. A sloping horizon—or a floor that doesn't appear horizontal—is distracting to viewers. Of course, there are exceptions to this rule. For example, if you want to dramatize a rough sea, you may get the best effect by securing your camera to the deck of a boat so that the viewer will get a true sailor's view. The boat will remain upright, but the impression of the storm will be dramatically imparted by the seesawing horizon.

Alternatively, if you were to shoot a ship on rough water from a shore position, it would be best to keep the horizon stable and allow the ship's movement to tell the story.

RULE OF THIRDS

This basic rule of composition states that the most effective location of the key part of a scene is about one

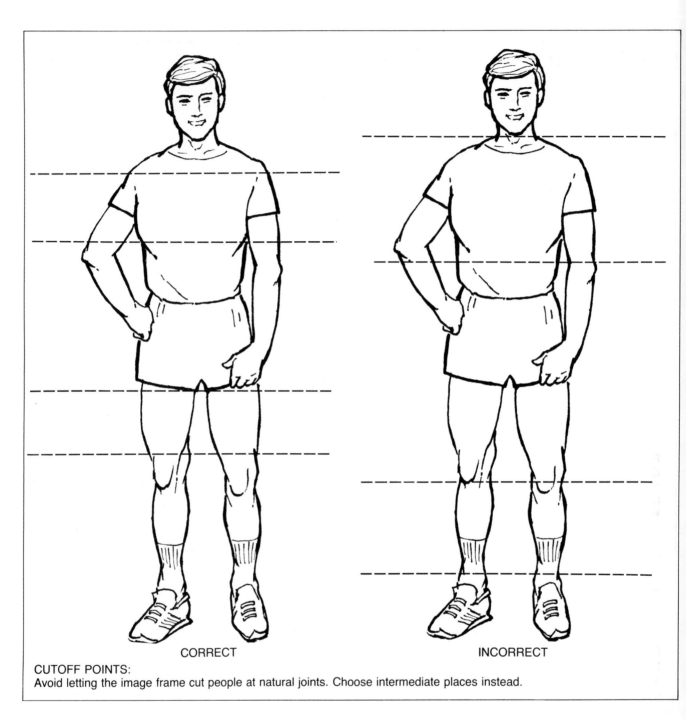

CORRECT

INCORRECT

CUTOFF POINTS:
Avoid letting the image frame cut people at natural joints. Choose intermediate places instead.

third of the way into the frame, from top or bottom and one side or the other. When you're making a shot in which the camera is stationary, remember this guideline. For example, if two people are sitting at a table in a garden, against a distant scene, it's much better to have the key figure at the table slightly off center in the picture.

Of course, there are exceptions to most rules, and that applies here, too. If your creative instincts tell you that the center is the best place for the key subject, then put it there.

FRAMING FACES

When you're shooting faces close-up, you should generally place eyes about one-third of the way down from the top of the frame. Allow

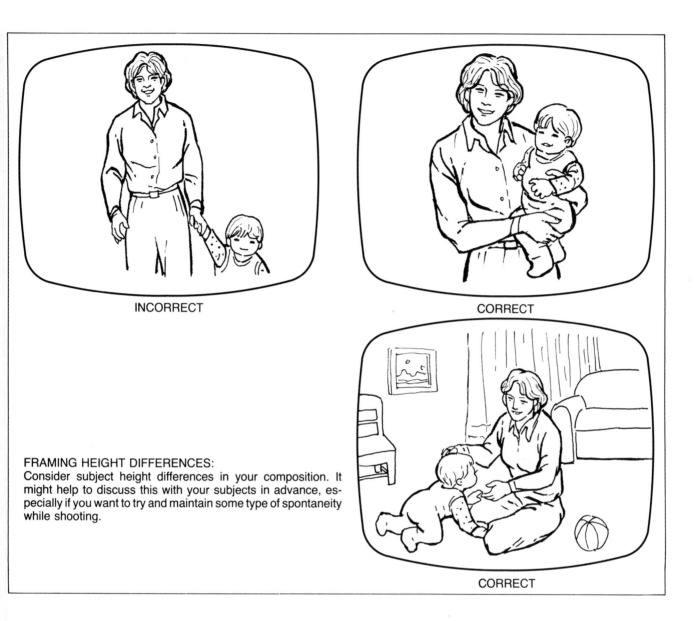

INCORRECT

CORRECT

FRAMING HEIGHT DIFFERENCES:
Consider subject height differences in your composition. It might help to discuss this with your subjects in advance, especially if you want to try and maintain some type of spontaneity while shooting.

CORRECT

enough headroom to prevent an appearance of crowding at the top of the frame.

When shooting a profile, locate the subject in the frame so there is more space in front of the face than behind it.

POSING GROUPS

Pose groups in a casual manner so their positions look natural. When appropriate to the purpose of the shot, have heads at different heights and faces looking in different directions. Avoid groups of people posed in a straight line, all facing the camera.

PANNING

When you're panning the camera to keep up with a moving subject, such as a racing car, a horse or a baseball player, be sure to leave some room in front of the subject. This will avoid giving the impression that the subject is about to move right out of the picture frame.

HORIZONTAL FRAME

A basic consideration in video moviemaking is the format of the final image. The TV screen has a certain height-to-width relationship (3:4). However, the most important consideration regarding composition is that the TV image—unlike a normal photographic image—must *always* be horizontal. All of your scenes must be designed to fit this

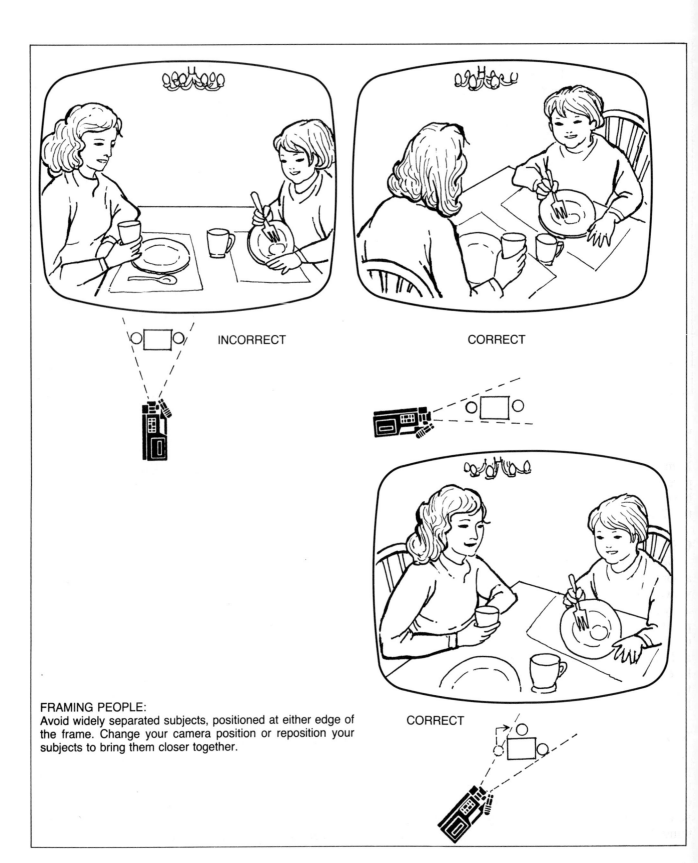

INCORRECT

CORRECT

CORRECT

FRAMING PEOPLE:
Avoid widely separated subjects, positioned at either edge of the frame. Change your camera position or reposition your subjects to bring them closer together.

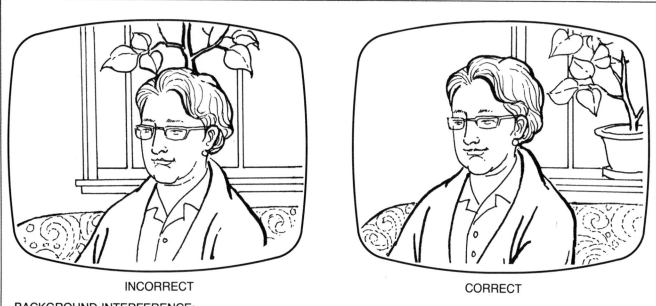

INCORRECT CORRECT

BACKGROUND INTERFERENCE:
Background "interference" is something you generally see but rarely think about—until it's in your movie. In this example, the plant seems to be growing out of the subject's head. It's easy to avoid, once you are aware of it.

horizontal format. Arrange and compose the elements to fit this format. Remember this also when you prepare artwork or titles. They must have the 3:4 height-to-width ratio of the TV screen.

CENTER THE INTEREST

Not all TV tubes give you the same amount of an image. To be sure your viewers are going to see your movie as you intended it, avoid having points of major interest at the edge of the frame. This applies also to titles and artwork. Avoid running your lettering to the extreme edge of the frame. If you do, you may find some letters cut off on some TV screens.

KEEP IT SIMPLE

When speaking about image composition, one can truly say that "less is more." Include in the frame all those aspects that are vital to the story you're telling. Then, exclude everything that's nonessential. Doing this

will emphasize the essential—and strengthen the impact of your movie.

HEIGHT DIFFERENCES

Avoid large height differences between two people in a scene. Having a head at the top of the frame and another at the bottom, with a long body in between, makes for an extremely ugly picture.

If you have a small child with an adult, have the child on the adult's knee, or have the adult get down to the child's level. Or, have both seated at appropriately different heights. If the adult goes down to the child's level, lower your camera position accordingly. Get in close to fill the frame with the important part of the scene.

SUBJECT CLOSENESS

When you have two subjects in the frame engaged in a conversation, eating or playing a game, keep them as

close together as possible. One person at each end of the frame, with a large table between them, makes for an unattractive image.

BACKGROUND INTERFERENCE

Avoid background objects that interfere with the main subject. The classic example is the plant or lamp "growing" out of Aunt Alice's head. A slight movement of subject, camera or object can easily avoid these faults.

CENTER THE INTEREST

Not all TV tubes give you the same amount of an image. To be sure your viewers are going to see your movie as you intended it, avoid having points of major interest at the edge of the frame. This applies also to titles and artwork. Avoid running your lettering to the extreme edge of the frame. If you do, you may find some letters cut off on some TV screens.

How to Plan Your Video Movies

Making creative video movies demands considerably more than a simple command for "Lights, Camera, Action." Although there are occasions for spontaneity and candid shooting, most movies benefit from a firm foundation. Just as a sturdy building is built brick by brick, so a good movie must be carefully put together shot by shot.

One of the great rewards for moviemaking is seeing your viewers enjoy and applaud your work. But movies aren't entertaining simply because they are movies. *Good* movies don't just happen—they must be carefully *planned*.

There's no conflict between creative freedom and decisive planning. Planning involves dealing with the basic questions of why you're making a movie, what it's to be about and who your intended audience will be. When you've established these key factors, you can shoot the movie accordingly. However, this discipline does not preclude spontaneous and candid material when the occasion presents itself. If it did, most movies would be lifeless indeed.

A *staged* production, resembling a stage play, requires detailed planning throughout. A *documentary*, however, records an aspect of life as it is happening. It is unpredictable by nature. You can plan the basic outline and purpose of a documentary but must always be prepared for unexpected, spontaneous shooting. In a documentary, much of the creative production takes place after shooting, at the editing stage, when shots are repositioned to make clear sequences from spontaneously recorded shots. I discuss the difference between staged and documentary productions more fully in the next chapter.

THEME

What's your movie to be about? When planning a movie, it's important to have a clear idea of your *theme*. Be sure it is a *theme* and not just an *idea*. There's a difference. A simple idea may be sufficient for making one photograph. However, a movie requires continuity. This calls

for a story, or theme. Write down your theme in the form of a series of phrases or illustrate with simple thumbnail sketches.

Stick to your story as you shoot. Add candid, unexpected material if it fits in and contributes to the impact of the movie. But don't be sidetracked. Don't start making a video movie about your dog and end up concentrating on the cat simply because it wandered into a shot and began fraternizing with the dog. If you do, you'll lose control—and your audience will sense it.

If you should discover that you don't like the original theme or that it is unworkable, stop shooting and develop a new story line.

PURPOSE

Your intent in making a movie may be to entertain, inform, instruct or simply record a memorable event. Establish your purpose, and shoot the movie accordingly.

If you want to entertain, inject humor and surprise into the production and keep it moving along at a lively pace. The pictures should be colorful and the sound exciting.

An informational or educational film should be jampacked with information—all of it accurate, of course. When you make an instructional film, you should concentrate on a logical order of events, and shoot plenty of detailed close-ups. When appropriate, use graphics for clarity or emphasis.

Recording a memorable event comes under the category of documentary shooting and requires a more candid approach. Plan ahead as much as the situation permits.

INTENDED AUDIENCE

Is your movie intended for small children, teenagers, adults or senior citizens? Is it for family and friends, or the members of a specific club or organization? Audiences vary in their backgrounds, interests and attention spans. Therefore, to achieve the greatest viewer impact, you must target your audience carefully and treat your subject accordingly. That's the only way to get and hold viewer attention.

A movie for small children should be fast-moving, with lots of close-ups, bright colors, lively sound— and more than a few laughs.

Although adults have a longer attention span than children, it's still worth knowing some tricks that will help to hold their interest. The sound track should not duplicate the picture. This means you should avoid describing in words what is clearly visible in the image. Use your commentary to tell things that the picture can't show.

Change of pace is always an effective interest holder. Intermingle short shots with longer ones, fast action with more placid scenes, colorful images with more subdued ones. For audio variety, consider changes using commentary, music and background sounds and effects.

All audiences like a good story. But the kind of story each audience likes, and the manner of presentation they'll appreciate most, will differ somewhat. So, consider your audience when you plan a movie and be clear about what you want viewers to get from it.

BEGINNING, MIDDLE AND ENDING

A good movie should have a smooth flow throughout. For planning purposes it's useful to divide a production into three key parts— beginning, middle and ending.

Beginning—This is the opening that sets the scene. It tells what the movie's theme and purpose are. It should, quite literally, put the viewer "in the picture" regarding what the movie is about. The opening should be designed to immediately capture the viewer's attention and interest.

A movie doesn't necessarily have to begin with titles and credits. Commercial and TV feature movies frequently go right into some appetite-whetting scenes before the titles are run. You can do the same thing.

You may want to start a movie with a "teaser," showing a little of what's to come. To include at the beginning of a movie some shots that belong at a later stage, you'll need to do some editing. Alternatively, you'll have to shoot the same material twice.

Sound is an important attention getter. Use some dramatic music, sound effects or a dynamic commentary or dialogue to launch your movie.

Middle—The so-called *middle* of a movie actually represents its bulk. This is where most of the story unfolds. However, although this middle section is the longest part of the movie and contains most of the story, it is totally dependent on a beginning and an ending to give the production meaning.

Ending—A movie shouldn't simply fizzle out. The ending should justify or explain what preceded. Justification can come in the solution of a problem the movie confronted, or in the culmination of a human drama, or simply with a "surprise" ending. The surprise ending can be funny, dramatic or tragic. It all depends on the nature of the story and the effect you want to achieve.

An Example—The classic tale of Humpty-Dumpty tells very effectively the function of beginning, middle and end. If you were to make a movie of this story, the middle—and bulk—of the story would concern itself with "Humpty-Dumpty had a great fall." It would show the drama of top-heavy Humpty trying to remain on the wall and ultimately losing his balance, falling off and breaking into a thousand pieces.

ESTABLISH CONTINUITY:
A good movie has (1), a beginning; (2) and (3), a middle; and (4), an end.

The beginning would introduce Humpty-Dumpty, show his size and clumsiness and show that "Humpty-Dumpty sat on a wall"—which got him into his dilemma in the first place.

The ending, "All the king's horses and all the king's men couldn't put Humpty together again," would tell the outcome of the story—and perhaps even provide a moral. The same ending could be treated in a comical, sad or whimsical manner, depending on the effect you want to achieve.

SCRIPTING

Scripting is just another word for *planning*. For some kinds of movies you'll want to write a script containing a full story. In addition to the story, however, the script should provide *shooting* directions.

For example, indicate when a shot is to be long, medium or close-up. Describe the scene or set and its background. Where special costumes are called for, write down the details. Indicate the positions of your performers and their movements during shooting. The script should also tell how much action and dialogue are to be contained in each separate shot.

Some movies won't need a full story and dialogue script. However, the shooting script—containing the information indicated in the previous paragraph—is nearly always helpful.

A script can be in the form of brief written notes or it can be in the form of a *story board*. A story board consists of a sequence of simple sketches, each representing one shot. Together with a few key words, these sketches provide the camera operator with all the shooting information that's needed. In effect, the story board is the moviemaker's equivalent of the musician's score.

Long, Medium and Close-Up Shots

—When preparing your shooting script, remember the basic formula for shooting a scene. Start with a long shot, establishing the scene with a wide view. Move to a medium shot to show the performers and their activities in a more revealing way. Then go to a close-up, giving a detailed picture of the key activity.

For example, if you're making a simple movie about your baby, open with an overview of the environment. Include a large area of the room, with the baby in a location where you would most likely find him—such as a playpen or crib. Next, go to a medium shot, showing the baby playing with a toy. Finally, take a close-up shot, showing the baby's expression as he plays or giving a detailed view of what his tiny fingers are doing.

While this is the classic approach to moviemaking, there are times when you'll want to change the order in which you present long, medium and close-up shots. It depends on the story you're telling and on what you want to achieve with the movie. As with most rules, use them as guidelines and *break* them, when you think this will give a more effective movie.

Be consistent. If your long shot

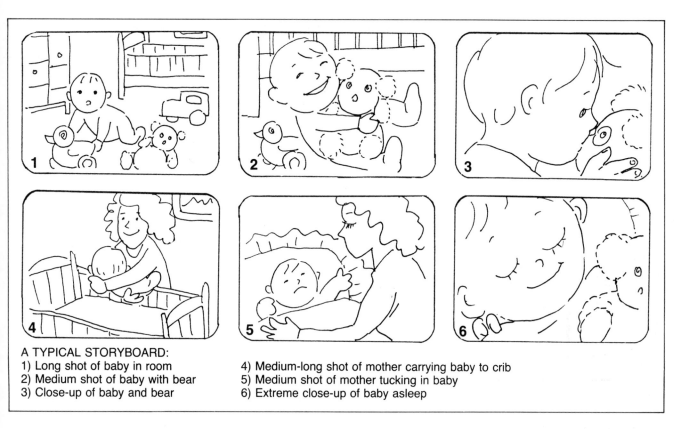

A TYPICAL STORYBOARD:
1) Long shot of baby in room
2) Medium shot of baby with bear
3) Close-up of baby and bear
4) Medium-long shot of mother carrying baby to crib
5) Medium shot of mother tucking in baby
6) Extreme close-up of baby asleep

showed the baby in a playpen, don't then take a medium shot of the baby in a crib. If the baby is playing with a teddy bear in the medium shot, don't zero in on a different toy in his arms in the close-up.

If the baby moves, you can use this motion to liven up your movie. For example, if the baby begins to crawl on the floor from one side of the room to the other in a long shot, you can change to a tighter shot or zoom and pan with him in a medium shot.

All the shooting stages just discussed can be planned and scripted. However, when you're shooting unpredictable action, such as that of a child, be prepared for the unexpected. If you get a good shot that you hadn't expected, don't discard it just for that reason. Find a place for it. I'll discuss this more fully in Chapter 10.

THE IMPORTANCE OF GETTING CLOSE

When you plan your video movies, always remember the importance of the close-up shot. In any movie, a close-up provides that special human impact and appeal. Video, with its relatively small viewing screen, especially relies on the close-up for effective moviemaking.

Not only does the TV screen give a relatively small image, but image resolution on a TV screen is also limited by the picture-scanning lines. With these limitations, you'll get a much sharper-looking image of the large features of a close-up face, for example, than of objects and scenes that are distant and therefore appear small.

Use the long shot just long enough to establish the scene. Don't dwell on it too long. Frame your medium shots

as tightly as possible without excluding important parts of the scene. For real drama, go to close-ups and don't be afraid to make the shot duration longer than for other shots.

SHOT DURATION

Long shots, establishing the location, should generally be between 5 and 12 seconds long. Medium shots should be long enough to show their theme and activity clearly without becoming boring. A satisfactory duration is usually 10 to 15 seconds. I recommend that you keep your close-ups to between 5 and 12 seconds.

The above are no more than guidelines. You can make any shot as long as it will hold viewer attention. Don't stop a shot in mid-action simply because it has run for the time I've recommended. At the other extreme, don't be afraid of shooting 2- to 3-

You can plan your movies around a theme. Here, dad is working with his son to get him ready for the football tryouts. Follow up by shooting the tryouts and, if he makes the team, get some of the scrimmages on tape.

second shots, if they seem appropriate.

STICK TO YOUR PLAN

When you've completed your plan—or shooting script—stay with it when you shoot. Don't be tempted to ad lib. As I've indicated earlier, this doesn't mean you should resist shooting and using charming spontaneous occurrences or unrepeatable candid shots. You can always work these into your basic plan. The important thing is to have a solid plan to build on.

Shoot It Several Ways—You've heard the movie terms "Take 1" and "Take 2." They refer to the method used to identify a series of repeats of the same basic shot. Sometimes there's a need to go as high as "Take 20" or even higher. Perhaps you've seen examples on one of the TV *Blooper* shows that have become so popular. The same shot is repeated until the director is happy with what was shot. The chosen "take" is later edited into the movie.

If you plan to edit your video movies after shooting, you can use the same technique. It doesn't involve changing your basic shooting plan. It simply provides you with several variations of a shot that is easy to repeat at the time but would be difficult to restage later. Edit the version you like best into your movie when you've finished shooting.

If you can't decide how to stage a shot, shoot it a couple of different ways. There's an old filmmaker's adage that says, "There's only *one* way to shoot it—*two* ways!" I would add, in some circumstances, " . . . or three or four ways!"

HOW I PLANNED A MOVIE

I want to tell you about a movie I made on a family vacation in Bermuda. In its planning and preparation I used most of the techniques I've discussed.

Our hotel had three free-form swimming pools that terraced a hillside set with palm trees and colorful shrubs. Small waterfalls connected the three pools. Beyond the highest pool, a garden with winding, pebbled paths and bright flowers led down the far side of the hill. Beyond that, a golf course with steep, grassy slopes dropped toward a sandy beach, set with surf-carved rocks at the ocean's edge. The location was truly beautiful. Recording it was, for me, a must.

Theme and Purpose—I needed a theme for my movie. My four-year-old daughter, Lucy, provided the perfect subject. The theme would be simple but would still tell a definite story: a child's joyful journey past waterfalls, through pools, along garden paths and over a hill, down to the beach by the ocean.

My target audience would be family and close friends. The objective of the movie was to record the idyllic setting and Lucy's happy experience

Opening sequence of my movie, "Lucy's Day." A single zoom-and-pan shot presented an eye-catching beginning, established the setting and the basic activity.

there. I was planning a movie that would entertain and, in later years, help us to remember.

Planning the Shots—To plan the shot sequences, I scouted each location to find the best areas for action and the most attractive backgrounds and to determine the best camera angles. I carefully checked the angle of the sunlight at various times of the day to determine the best shooting times at each location.

I determined whether supplemental lighting might be needed. For this project, it wasn't. I didn't want to shoot during hours when the sun was directly overhead, so did not need fill light to soften harsh shadows under facial features. I'll tell you more about lighting in Chapter 6.

Early-morning and late-afternoon sunlight would be ideal. The sun's low angle would ensure good modeling on my subject and give soft illumination to the scenes. Bright surfaces around the pools, the white pebbles on the garden paths, the sandy beach and the water all provided adequate fill light to brighten shadow areas.

Wardrobe—Bermuda in summer called for the simplest clothing requirements—no more than a bathing suit.

Sound—I needed no dialogue and, therefore, no script. I would record the natural background sounds of bird calls, distant voices, splashing water and roaring surf. This would most realistically preserve the atmosphere of the experience.

Crew—This was a relatively simple project. The entire shooting crew consisted of Lucy's older sister, Suzy, and myself. Suzy assisted with the VCR, controlled props and recorded background sound effects.

Production—There were no special pre-shooting problems because my shooting would in no way interfere with hotel guests or management. Therefore, I needed no special permission or cooperation.

Whenever you plan to shoot in a location where you may require cooperation or assistance from strangers, or permission from a public authority or management, be sure to discuss the matter fully in advance. If you don't, at worst you may find that you can't shoot the movie at all. At best, you probably won't get the wholehearted cooperation you would have received if you had openly discussed your needs beforehand.

Shooting Schedule—I estimated that my movie would run five to seven minutes. Total production and shooting time was about five hours. I decided to shoot the pool sequences in the morning. The garden, golf-course and beach scenes would be shot in the afternoon.

Shooting Script—As I indicated earlier, I had no need for a script because there was no commentary and no dialogue in the movie. However, I did prepare a *shot sequence* plan. It indicated when I would take a long shot and when a close-up; when I would zoom or pan; the actions I would direct my subject to perform.

HOW I SHOT MY MOVIE

In the description that follows, I have highlighted the various techniques I used by italicizing the relevant words.

I opened with a big *close-up* of a purple-and-white flower, floating on the water in the lowest pool. I *directed* Lucy to bring her hand into the shot and pick up the flower. As Lucy slowly raised the flower to her face, I *panned* and *tilted* my camera to fol-

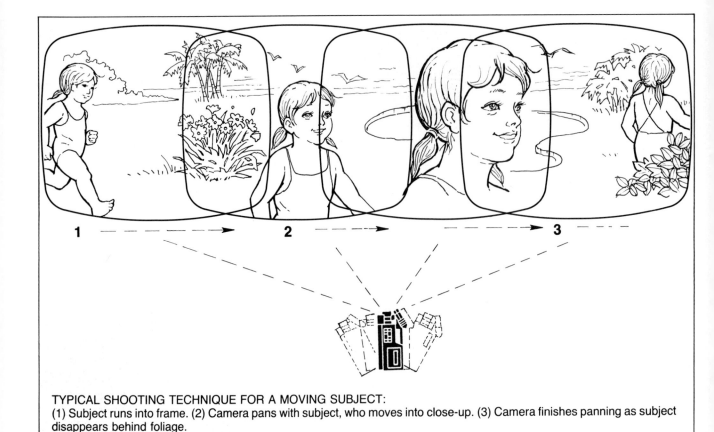

TYPICAL SHOOTING TECHNIQUE FOR A MOVING SUBJECT:
(1) Subject runs into frame. (2) Camera pans with subject, who moves into close-up. (3) Camera finishes panning as subject disappears behind foliage.

low the movement. At the same time, I gradually *zoomed* the camera lens to a wider view, showing first the blossom and Lucy's face and then the scene beyond. With subject and environment established, I *directed* Lucy to turn and dive into the pool.

I *changed the camera position* and shot a *close-up* of Lucy swimming across the pool. Going to a *medium close-up*, I made a shot of Lucy splashing through the first waterfall and out across the second pool, above, panning and zooming smoothly to follow her action. A series of *quick shots from different angles and distances* carried her to the farthest end of the top pool. There, she emerged dripping and trotted cheerfully into the garden.

A series of shots followed that showed her skipping along the path, appearing from behind flowering shrubs and vanishing behind waving palmetto fronds. This led her to the hilly vistas of the golf course.

I made an *extreme long shot,* using the wide-angle setting of my lens, to show Lucy's tiny figure running down a steep, green slope. I *moved the camera position* to the seaside rocks to record Lucy peeping around a boulder and moving closer to the camera. On her way to the ocean, I *shot her from several angles* as she splashed through tide pools.

My final shot began with a *close-up* of a blissful Lucy sitting on the beach. As I zoomed out to a *medium shot*, the picture showed her building a sand castle. To end the movie, I slowly *zoomed out all the way* to frame her diminishing figure against sea and sky in the late-afternoon sunlight.

When we got back home, I spent a few hours on *two-VCR insert editing* to produce an attractive movie of brisk sequences. I'll tell you something about editing in Chapter 10. If you don't have your own editing capability, you may be able to get some help at a local school. Many schools have excellent editing equipment. Or, perhaps your community cable TV facility can help. In addition to having the appropriate equipment, cable-TV stations often have student interns who are familiar with editing techniques and can help you.

RESULT

I had made a movie that satisfied all the requirements described in this chapter. It had a *theme*, a *purpose* and a *target audience*. It had an eye-

catching *beginning,* an entertaining and fast-moving continuity in the *middle,* and a decisive and appropriate *ending.* It was made up of a series of interconnected *close-up, medium* and *long* shots.

Each shot related closely to the one that preceded it and the one that followed. No shot was an isolated entity. When I changed the direction of Lucy's action or altered my camera viewpoint, I always made sure that these would not confuse or disorient the viewer.

Remember that a movie is not made from a series of independent snapshots but from a carefully combined sequence of interrelated shots. Each shot is a building block in a larger construction.

A PROFESSIONAL TECHNIQUE

This example illustrates a shooting technique professionals use. You can plan to use it too. Here's how:

To get a continuing flow of action when shooting a subject moving across a sequence of shots, plan a shot that starts framed on an interesting composition in your setting. Direct your subject to move into your picture on one side and perform the required action. Follow your subject with the camera as he moves across the scene. Then, as the action for the shot concludes, stop your pan and let the subject continue out of frame on the opposite side of your picture.

Continue in a similar manner with several succeeding shots as your subject moves from one place to another. This is much more eye-catching than a long, dull pan shot.

This technique is particularly effective when you're using *cuts* (abrupt transitions from shot to shot) rather than *dissolves* (one shot *blending* gently into another). It avoids the jumpy look of cutting directly from

It's important to maintain continuity of direction—keeping your subject moving in the same direction from shot to shot in sequence. It would be especially important if this were a real soccer game. To avoid confusing viewers, each team should consistently play toward one side, at least until half time. This means keeping your camera on the same side of the field.

figure to figure in successive shots. Incidentally, dissolves are created by editing, which I discuss in Chapter 10.

It's important to keep the subject moving in the *same direction* in each succeeding shot. Mixing the way your performer faces in the frame can confuse the audience. If they don't actually see the change in direction, they won't know where the performer is going.

Of course, if you're shooting an abstract movie sequence of someone running—just running, to no special place—then you can mix directions. Then the subject can move left to

right, right to left, toward camera or away from it with no confusion to your viewers—as long as you make your intention clear.

When planning your shots, remember the basic guideline: Keep the direction a subject faces or moves consistent—unless you're aiming for a special effect. If you want to make a change in direction, *show* it happening.

You can recognize these moviemaking techniques in feature films and TV commercials. It's fun to look for them. Try them for yourself. They'll give your tapes a professional appearance you'll be proud of.

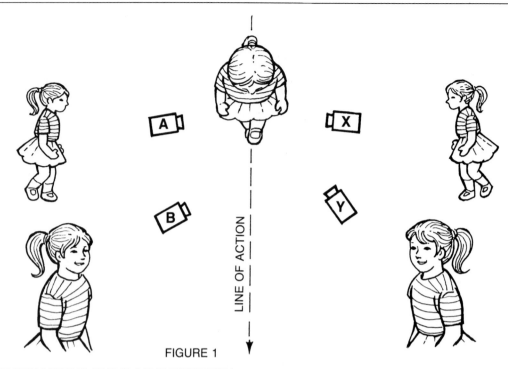

FIGURE 1

KEEP A SUBJECT MOVING IN THE SAME DIRECTION:
The child's line of movement provides a "line of action" (Figure 1). If you cut from one shot to another on the same side of the line, such as A to B, the shot will work, since in both shots the subject will be moving left to right. However, if the line is crossed to make the next shot X or Y, a reversal of direction will appear to have occurred, and the subject will suddenly appear to be walking right to left. The line can be crossed, however, by cutting to an intermediate shot, C (Figure 2). This may be a cut-away, a very wide shot or a neutral shot for which the camera is placed exactly on the line itself. The change of direction that follows will then be acceptable.

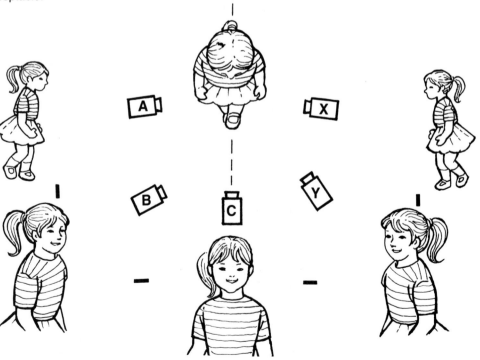

FIGURE 2

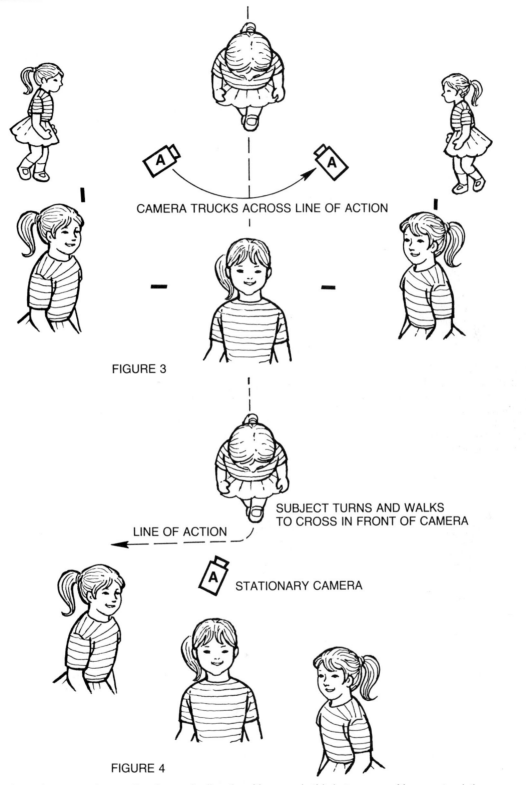

CAMERA TRUCKS ACROSS LINE OF ACTION

FIGURE 3

SUBJECT TURNS AND WALKS
TO CROSS IN FRONT OF CAMERA

LINE OF ACTION

STATIONARY CAMERA

FIGURE 4

An alternative is to *show* your viewers the change in direction. You can do this in two ways. You can *truck* the camera across the line of action from one side to the other (Figure 3) so your viewers can see the change of direction taking place. Or, you can direct the subject to cross in front of the camera (Figure 4) so viewers will again see the change of direction happen on the screen.

5 *Documentary and Staged Production*

If you're planning a series of sequences on location, such as different sporting events, scout the area before the event and find out whether you're permitted to shoot there. Places such as indoor sports complexes or courts may have restrictions about shooting on the premises. Determine whether the location and the lighting lend themselves to satisfactory shooting.

In this chapter, I'm going to tell you about two distinctly different types of video movies you can shoot—the *documentary* and the *staged production*. Each is suitable for specific themes and objectives, but they require different approaches, both in preparation and execution.

Occasionally, you can treat the same subject matter in either way. You must decide which method to follow, depending on the effect you want.

Generally, a *documentary* is a movie of an event as it occurs. As moviemaker, you should interfere with the event as little as possible, recording it as it happens. Don't attempt to "stage" such an event or "recreate" it at a later date. Excessive scripting, staging and direction may result in an artificial movie experience. Your goal should be to capture the detail, atmosphere and meaning of the occurrence in an honest, truthful way.

Of course, there are special exceptions to this rule. For example, if you're deliberately planning to make a historical documentary that recreates as faithfully as possible a past event, you must plan, script, direct and rehearse. In effect, you must often use the approach described later, under *Staged Production*.

I think that most of your documentary movies are likely to be of such

personal events as birthday parties, weddings, anniversaries, children at play and sporting events. Strive to preserve on videotape the fun, excitement and atmosphere of the happening. Record the natural, spontaneous actions and spoken words, the reactions and emotions of your subjects.

Remain as unobtrusive as possible when you shoot, so you don't interfere with, or detract from, the natural behavior of the subjects.

Of course, there are times when even a *spontaneous* event needs some control on your part. For example, when you shoot an artist at work, a musician rehearsing for a performance or a mechanic repairing a car, the subject's cooperation helps you achieve the shots and angles you want. Nevertheless, you must permit each subject to pursue his activity spontaneously and naturally. Only in this way can you capture the unique individuality of the subject and the natural flow of the activity.

You should also permit each subject to speak naturally, using words and phrases he or she typically uses. In other words, don't *script* more than is absolutely necessary.

A *staged production* is one in which you create, plan and direct the entire movie. *You*, or a team, write the words, plan the action, organize the shots and control the continuity of the production.

You begin by preparing a script and drawing a story board. You select the actors and eventually direct them in their performances. You guide the camera, shooting the images according to your well-prepared plan.

A staged production typically requires rehearsals. They allow your performers to learn their actions with confidence and deliver their lines convincingly.

About Editing—Editing a video movie after the shooting can help *both* a documentary and a staged production. In a documentary, you must shoot events as they happen. Often, you'll find later that a different sequence of events would be more effective or appropriate.

In a staged production, it's often more economical to shoot similar scenes, with the same performers and in the same location, at the same time—even if they won't appear in the finished movie in that order. This makes editing a helpful tool for *all* moviemakers. It often gives you additional creative scope.

DOCUMENTARY

Shooting methods for a documentary are likely to be suitable for most of your purposes, so I'll discuss them first. I'm sure you'll often shoot real-life events or occasions where the "plot" unfolds quite naturally, without any interference or direction on your part. The time and effort needed for pre-shooting planning is usually minimal. There's no need for rehearsals and often no opportunity for retakes.

BASIC STEPS

Here are some key steps you should follow in preparing a documentary video movie:

1. Analyze the Action you expect to shoot. With many events, you can anticipate specific things happening. For example, at a birthday party much of the action will be spontaneous and unpredictable but certain other happenings can be predicted. You know that guests will arrive, games are likely to be played, gifts will be opened, a cake will be presented and candles will be blown out. The cake will be cut, served and enjoyed. Guests will leave and the party will end. The birthday child will remain—probably exhausted but happy—surrounded by gifts and "wreckage."

The formal parts of occasions such as weddings can be predicted and planned fairly accurately. An artist at his craft is relatively predictable also. He can be directed by you to some extent—but don't destroy the basic naturalness of his actions.

2. List the Basic Steps that will comprise the action of the movie, in the order in which they will occur. In the case of a wedding, it helps to attend a rehearsal. When recording an artist at work, watch him working prior to the shooting session. Notice the actions he performs and the procedures he follows.

3. Plan a Structure for your movie. Devise a compelling opening and a memorable ending, as described in Chapter 3. Introduce a story-line, in context with the backgrounds and personalities of your subjects and the event.

For example, a birthday-party movie might begin with a series of photos from previous birthdays. For a wedding movie, the story-line can include reminiscences of the couple's early relationship and their mutual interests. When shooting an artist, show your viewers how he developed his specialty, the meaning it has in his life and where he gets his inspiration.

4. Consider the Shots that will make up the movie. Think about framing, shooting angles and shot distances. Plan to use long, medium and close-up shots, as described earlier in this book.

Be sure to include an *establishing shot* for each event, even though you may sometimes elect to begin with an eye-catching close-up shot.

5. List the Shots you've planned, even though you know the action you'll be shooting will be spontaneous and random. Although

you'll need to improvise as you shoot, it's important to have a basic plan to guide you. At the very least, plan to shoot standard sequences—wide-angle shots to set the scene, medium shots to identify participants in context with location and event, and close-ups for detail.

Have a definite introductory and closing shot in mind, in case the natural activity doesn't work.

6. Check the Shooting Location, whether it be living room, playroom, back yard, church or school. Make sure you have ample shooting space. Look for suitable camera positions.

If you plan to dolly or truck your camera, check that the floor is smooth. Rugs may cause problems, so see whether they can be removed.

7. Check the Illumination and determine whether you'll need extra lights. The best way to find out whether the available lighting is sufficient is by taking your camera and VCR to the location, hooking them up and checking the camera viewfinder's light-level indicator. Also examine the resultant image on a TV screen. Some cameras have an insufficient-light warning signal.

If you're using a camcorder, simply turn on the power switch and observe the light-level indicator in the viewfinder. Record for a few seconds, then push the playback button and check the taped image in the viewfinder. Although the image will most probably be b&w, the brightness level will be clearly apparent.

If you have a photographic light meter, you can check the available light by taking readings. Your video camera's manual tells you the minimum illumination needed for an acceptable picture. For good images, try to use more light than the bare minimum.

8. Be Sure the Electrical Supply is Adequate and that you have all the extension cables you may need for your equipment and lights.

9. Check for Back Lighting from windows or other strong light sources. You may need lights or reflectors to add frontal illumination so your subjects won't be silhouetted. Be prepared to use the camera's auto-iris override or back-light button to avoid unwanted silhouettes.

Perhaps you can cover windows or unwanted lights to eliminate back lighting. However, this would probably still call for additional illumination from the front.

10. Check for Distracting Backgrounds and cluttered areas. Clean them up, if you can, or avoid them. Sometimes you can cover a really distracting background with drapes or sheets to make it simpler. However, don't do this too often or you'll lose much of the atmosphere and natural ambiance of the scene.

11. Be Aware of Excessive Outside Noise from passing traffic, playing children, planes overhead and numerous other sources. They can interfere with your sound recording. Perhaps you can move to a quieter location. If not, minimize the problem by using a directional mike that picks up sound from a relatively narrow angle.

12. List the Props you may need, in addition to the natural setting of the scene. They may include furniture, pictures, plants and other common household items.

SHOOTING TECHNIQUE

There are two basic kinds of documentary movies, and you should use a slightly different technique with each. In one, you're faced with random, relatively unpredictable activity, as found at a party, play at the beach or a championship ball game. The other kind is generally predictable and controllable, at least in the overall sequence of events. It includes such occasions as weddings, school performances, craft or hobby demonstrations and formal family celebrations.

UNPREDICTABLE ACTIVITY

While you're shooting, distract your subjects as little as possible. Let them be themselves—natural and unselfconscious. Don't induce them to *ham it up* unless the nature of the movie you're making specifically demands it. But don't cause them to *clam up,* either, because of the presence of your camera and VCR.

An obvious way to avoid intrusion is to shoot from a distance. I recommend 15 to 20 feet in most circumstances. Use an auxiliary, unidirectional microphone near the subject for adequate sound pickup. If space is very limited, get as far away as the location permits and use the telephoto setting on your zoom lens. Sometimes you can gain a little distance by shooting from a doorway or balcony, from behind a lamp, around furniture or through plants and shrubbery.

The long-focal-length setting provides limited depth of field. This puts backgrounds into soft focus, keeping attention on the main subjects.

By including foreground objects such as lamps or plants in the picture, you may achieve some interesting compositional effects as well as create a sense of depth.

Focus at Tele Setting—Always focus your zoom lens at the extreme telephoto setting. This ensures sharpness at all other settings when the subject is at the same distance. If you were to focus at a wide-angle setting, zooming to a telephoto setting could cause the image to lose sharpness due to the more limited depth of field at the tele setting.

When a subject moves closer to

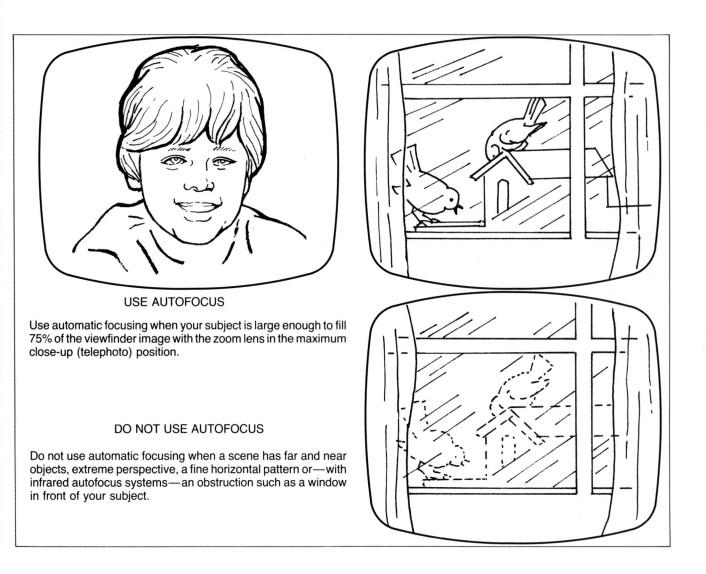

USE AUTOFOCUS

Use automatic focusing when your subject is large enough to fill 75% of the viewfinder image with the zoom lens in the maximum close-up (telephoto) position.

DO NOT USE AUTOFOCUS

Do not use automatic focusing when a scene has far and near objects, extreme perspective, a fine horizontal pattern or—with infrared autofocus systems—an obstruction such as a window in front of your subject.

you or farther away, you can refocus while shooting. Or, you can zoom and refocus between shots.

Auto Focus—If your camera features automatic focusing, it'll do the focusing for you. This is particularly helpful with moving subjects or, for example, when you're making a pan shot of a group of people who are all at different distances from the camera. Focusing manually on subjects whose distances from the camera vary constantly takes skill and practice. An auto-focus camera does it in a split second.

Watch the Foreground—If you're framing with an object such as a plant or lamp in the foreground, the autofocus camera may focus on that foreground. You may find a sharply defined plant in the foreground while your *star* performer is a blurred blob in the background. If you see that such a danger exists, it's best to change to the manual focusing mode.

Camera Jiggle—As you set your lens toward the telephoto position, the danger of camera movement becoming evident in the picture increases. To avoid camera jiggle at

those settings, mount your camera on a sturdy tripod or at least use a shoulder brace. This will enable you to get clear, steady images.

Handheld or Tripod-Mounted Camera?—A tripod may be desirable to avoid camera jiggle. However, a documentary often demands camera mobility, which makes a tripod impractical. Try to plan ahead, determining when you *must* use the camera handheld, when you can afford to use a tripod, and at what points you'll have the necessary time to switch from one to the other.

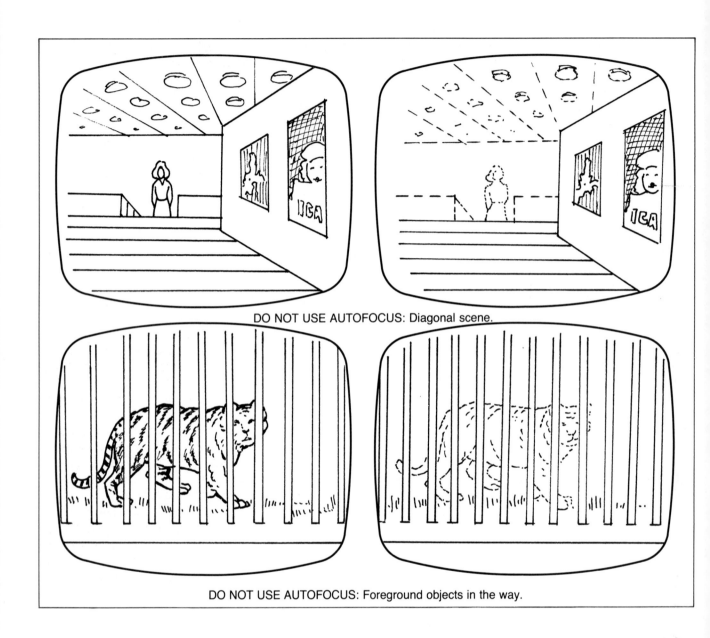

DO NOT USE AUTOFOCUS: Diagonal scene.

DO NOT USE AUTOFOCUS: Foreground objects in the way.

If you elect to shoot handheld at a telephoto setting, do everything you can to ensure steady pictures. Use a shoulder brace for the camera and steady yourself against a suitable support such as a wall, archway or table. If you can't find a way to steady the camera, use a shorter focal-length setting on your lens and come closer to the subjects.

Perspective—A wide-angle lens— or the wide setting on a zoom lens— not only gives a relatively wide view but also changes the apparent perspective of a picture. The depth of the scene, from camera to most distant object, appears greater than it would with a telephoto lens from the same viewpoint. You can use this to your advantage, or avoid it, if that seems appropriate.

Be especially careful when shooting close-ups of people. When you get close enough with a wide-angle lens to fill the frame with a face, you are likely to get very unflattering pictures. Noses will appear big, eyes excessively wide apart and ears will seem to disappear from view behind the head.

PREDICTABLE ACTIVITY

Some documentary situations are relatively predictable and controllable. They include formal occasions, such as weddings and recitals, and

relatively placid events such as artists and craftsmen at work. In such situations, you can plan ahead with confidence. You can often use a tripod-mounted camera at predetermined locations. However, the goal is the same in most documentaries—to capture the event on tape without interference, so it appears natural and spontaneous.

By all means plan your documentary. However, always remember that, first and foremost, you're *recording* your subjects' activities rather than *creating* a movie.

When your subjects are required to speak, encourage them to do so in their own words. Don't present them with a scripted dialogue unless it is appropriate or they seem to need it.

An artist or craftsman knows his subject. Even though he may not be as eloquent as you, your movie will be more realistic and appealing if you let him "tell it like it is." You'll find that performance and delivery are much more relaxed that way. Reciting a written narration can appear awkward and phony.

Encourage your subjects to go at their own pace. Of course, you can give some direction. If you want a subject to look at the camera rather than at his work while talking, suggest that he do so. Sometimes people who are not used to speaking in public, or into microphones, tend to speak in a flat, monotonous tone. Encourage them to put more life and emotion into their speech—and demonstrate to them what you mean. It can greatly improve a presentation.

STAGED PRODUCTION

In the staged production, you take total control. You create the story, write the script, select the scenes and locations, choose the performers and direct the shooting. You have complete control of action, shots and dialogue from concept to conclusion. Planning and preparation are major keys to your success.

BASIC STEPS

When you have an idea for a movie you want to make, follow these important steps:

Concept—Write a brief narrative description of the movie from start to finish. It needn't be elaborate. Just tell the story on a page or two, as if you were relating it to a friend. Putting the concept on paper in this way gets you off to a coherent start. It makes sure your idea is sufficiently substantial to be turned into a movie.

Script—Working from the concept, write your script. The accompanying illustration shows what I consider the best format to work with. Put all shot and action descriptions under the *Video* heading. Place this column on the left side of the page.

On the right side, under the *Audio* heading, write your narration or dialogue. This gives you a clear, workable script that easily lets you identify shots and link action with associated sound.

Remember that you're dealing with a compellingly visual medium. As you write your script, think in *visual* terms. Imagine what your viewers are going to *see,* rather than what they're going to *hear.* Develop what you're going to *show* before you decide what you're going to *tell* your audience.

There's a natural tendency to write excessive narration and dialogue. Resist it. Say no more than you need to supplement your pictures. Your movie will be stronger when you do. Rehearsal and shooting problems will also be minimized. The cast will be grateful, too, because they won't need to work so hard to remember lines!

Storyboard—This contains a series of simple illustrations depicting the shots that will make up the movie. You place each drawing in a rectangular frame representing the video picture. You can obtain special storyboard paper in some art-supply stores. Or, you can easily draw them up yourself. Under each frame, write the narration or dialogue that goes with it, according to your script.

Your storyboard doesn't need to be elaborate. Stick figures, drawn with a ball-point or felt-tip pen, will do.

The storyboard is a helpful guide for both preparation and shooting. It helps you visualize your shots and angles. It's an important reference when you're shooting. It helps you stage your scenes, direct your cast and position and aim your camera. It helps you plan and prepare backgrounds, lighting and props. It shows, in advance, how you want your movie to look.

A script concentrates on dialogue and narration. It also describes each visual image briefly in words. A storyboard shows each shot and its composition graphically.

Sets and Scenes—When you have the movie planned on paper, it's time to prepare for shooting. Locate the necessary *sets*—interior rooms or outdoor areas. Select areas that have the necessary space to stage your action and set up and move your camera.

Check for lighting requirements, electrical outlets, cable runs, floor conditions and possible sound problems—just as I described earlier for documentaries. Evaluate the need for extra background elements such as drapes, decor or furniture. Make a list of any special props your script and storyboard indicate you'll need.

Extra Equipment—Make a list of any extra equipment you may need, including additional lights, cables, reflectors and microphones.

Crew—You'll probably need some help, both in preparing for the movie and in shooting it. Enlist friends and family members. Inquire at schools, colleges or your local cable TV station. They may be able to put you in touch with interested students and others who would be happy to join your team. If you offer them interesting participation and an opportunity for hands-on experience, they may return for your next project, too!

Performers—Assembling a cast is an important part of the production of a directed movie. Think of people who might be specially suited for specific parts. Discuss your project with them and, if they're interested, try them out. An informal audition should help you make your selection.

When you're looking for two performers who must interact closely in the movie, it's a good idea to audition them together to be sure there's adequate compatibility.

Give your candidates time to study the script. Observe their interpretation of the script. Only then, if necessary, give them specific direction. A performer can often provide an interesting and effective interpretation that you hadn't thought of yourself.

Be patient. Make your performers feel relaxed. Do everything you can to encourage their potential talents and abilities to come to the surface.

DIRECTING

Directing is a major part of the production of a staged movie. You direct the same as the conductor of an orchestra. Your cast knows the script, just as the orchestra members have the musical score. However, more than that is needed. You must *guide* the performers to an effective and convincing performance.

For a stage performance, actors must project their voices and gestures to make them clear to a fairly distant audience. Movie actors, by contrast, can come very close to the audience through a close camera viewpoint or by means of long lenses. For this reason, the art of directing a movie is to have your performers seem to behave naturally rather than obviously act. In the intimate medium of the movie, acting easily becomes overacting. Guard against it!

Directing means *guiding*—not *dictating*. Be tactful and understanding. Watch for individual talents and characteristics that may add a dimension to a part that you had not anticipated. Part of your directing job will certainly be to tell performers where to stand, which way to face and how to move. This is necessary to retain coordination between performers in the production.

However, when it comes to bringing the characters in the movie to life, you should rely largely on what the characters within the actors can provide. Don't try to *change* the basic characteristics of your actors, but rather *exploit* them to the best possible effect.

Rehearsal—You can give only limited direction to your performers during the actual shooting. The major direction must be done in advance. That's the purpose of the rehearsal.

Because videotape is inexpensive and reusable, rehearsals should be taped, too. Everyone can benefit from watching the results and then do better during the "real thing."

Go through each shot and scene until you have it the way you want it and the performers feel comfortable and confident about their parts. Only then should there be a call for "Lights, Camera, Action!"

Cue Cards—On the professional stage, there is often a *prompter* to help the performers with their lines. The prompter is a person who, hidden from the audience but visible to the actors, guides actors who temporarily forget their words.

In the movie world, the equivalent of the prompter is a series of *cue cards*. The script is written, little by little, on large cards in large letters. An assistant holds these cards, always out of camera view, of course, and facing the actor for whom they are intended. This way, an actor can go through all the motions necessary and still always have the cue cards within easy view. If a performer should forget his lines, the cards act as his prompter.

You should use cue cards only to help an actor when he needs it. Don't plan for your performers to read the entire script during the performance. This would tend to make performances stiff and contrived. An audience easily becomes aware if a cast is reading its parts. Keep your scripts as simple as possible and rely on your performers to memorize their parts.

TRANSITIONS

When you go from one shot to another within a specific scene, the transition should be a *cut*. This is an abrupt transition produced by simply stopping the camera after one shot and starting it again for the next. You should use this method, for example, when changing from a long shot to a medium shot in the same basic scene.

If your camera's Start/Stop button does not automatically set the VCR to Pause when you push it to stop recording, shoot with your VCR in the Pause mode. This prevents your cuts from producing picture breakups or *glitches* on the TV screen.

Do not leave the Pause button engaged for more than two or three minutes at a time. The drum continues to rotate, and this can cause the tape to become weakened. Most VCRs will automatically turn off after a few minutes on Pause to prevent ex-

cessive tape wear.

When you change scenes, rather than shots within a scene, use the camera's *Fade* button. It enables you to fade out one scene and fade in the next. It provides a gradual transition from scene to scene. You would use it, for example, when switching from one location to an entirely different one, or from one period in time to a later one. Another way to produce a fade is by using the manual iris control of your camera.

I discuss transitional effects further in Chapter 8. In the meantime, remember that an abrupt *cut* signifies a change from shot to shot within a scene. It is the *comma* in the movie "statement." A *fade* signifies the conclusion of a scene or episode. It is the *period* in the movie statement.

SCHEDULING

If you're planning an elaborate movie, involving lots of people and equipment and several locations, it's important for you to keep a *schedule*. Set up meetings with people involved in pre-production preparations. Plan rehearsals. List when you're going to shoot at each location. Add the estimated shooting time at each location. List special equipment or props needed at each location.

Give a copy of the schedule to each person involved in the production of the movie. Try to stick with the schedule. If you need to change it, let everyone know. The schedule is your insurance that everyone, and everything, will be in the right place at the right time.

MUSICAL PRESENTATIONS

Concerts, recitals and other musical presentations may be treated as either documentary or staged events, depending on the nature of the occa-

Position cue cards close to the camera lens. This enables the performer to appear to be looking into the lens—at the viewer.

sion. Following are some techniques that relate specifically to the taping of musical events.

No matter how interesting it may be visually, a musical presentation is first and foremost a *sound* event. Whether you're taping an orchestra, band, instrumentalist or singer, get as much variety as possible into the video. But don't compromise on sound quality!

SOUND

An auxiliary microphone placed close to soloists or small groups is a must. Your built-in camera mike will provide an unsatisfactory record of a performance.

Pop Singers—Pop singers require very close positioning of the microphone. They generally prefer to handhold the mike, which gives them greater freedom of movement. Instruct them to sing across rather than directly into the mike. This prevents pops and breath noises and also gives a clearer view of the performer's face.

Solo Instrumentalists—In most cases, the mike should be close to the instrument. Make some test recordings to determine the best mike position for each instrument.

Classical Singers—They must work farther from the microphone. The volume they deliver would otherwise cause distortion in the recorded audio track. Place the microphone on a floor stand and position the singer three or four feet behind it. You will have to experiment a bit to locate the best distance.

Accompanists—Most soloists perform with single or group accompaniment. You must achieve a good balance between them. When using a single microphone, locate it between soloist and accompanist in a position that will give the best possible balance between the two sound sources. The accompaniment should be heard clearly behind the soloist but should not overwhelm the soloist's performance.

You'll have to record some test footage, shifting the microphone between performer and accompaniment until you achieve a satisfactory balance. A set of headphones, plugged in to your camera or recorder, lets you listen to the balance as you adjust the mike.

Two microphones provide the best solution. If your camera is equipped for stereo sound, use the two mike jacks for auxiliary microphones. Position the mikes so they give you a satisfactory balance. Otherwise,

you'll have to use an audio mixer, as described in Chapter 9. It provides proper balance by increasing or decreasing sound volume from one microphone or the other rather than by precise positioning of the microphones.

Sound Continuity—If you want to tape an entire musical number without interruption in the sound, do not stop or pause your VCR or camcorder to change shots. Doing so would interrupt the soundtrack. For a continuous musical recording, keep the camera running; rely on panning, zooming and trucking for visual variety.

If you want to stop the camera for shot changes, record the music on a separate audio recorder or a second VCR. You can transfer the complete music track to the master videotape later. Be sure to record enough video to accommodate the entire musical number.

CAMERA

Camera placement depends on one major consideration: You must be as unobtrusive as possible to performers and audience alike. The kind of instrument or group you're recording largely determines the best camera position, as described a little later. A position directly in front of or slightly to the side of performers is generally best.

To give your tape visual variety, change camera positions between numbers, if it does not disturb anyone in the hall.

Operate your zoom lens slowly and smoothly. Your camera work should not distract the viewer from the musical performance. Pan and zoom sparingly and slowly when the tempo of the music is slow. Increase their frequency and rapidity during lively selections, to match the pace of the video with that of the music.

Soloists and Small Groups—For vocal soloists and small groups of two or three singers, concentrate on medium close-ups and waist shots. Avoid extreme close-ups of singers. With singers' mouths wide open, they are in danger of resembling dental shots!

Because pop singers move about a lot, you should frame shots sufficiently wide to contain the action. Avoid the visual distraction of having performers exit and re-enter the picture as they perform.

Accompanists—During opening passages or interludes that feature accompanying instruments rather than soloist, pan and zoom smoothly to show viewers this aspect of the performance. Avoid concentrating on a performer waiting for his musical cue to sing or play.

Familiarize yourself with the music before the event. This will prepare you to shift your camera viewpoint at the right times during a performance.

HOW TO TAPE COMMON INSTRUMENTS

Instrumentalists present a variety of shot opportunities. Here are some of the instruments you're most likely to encounter:

Piano—The best angle is a three-quarter view over the soloist's right shoulder toward the keyboard or a profile view looking along the keys. Generally, you should tape the pianist from the keyboard side of the piano. This is because it is important to show the performer's hands. However, with an opened grand piano, you can get a good occasional shot of the performer head-on, aiming the camera "through" the piano.

When you show the performer's hands, shoot from his right side. It makes a more interesting picture because the right hand plays the main melody.

Don't forget to take some close-ups of the performer's face. It frequently expresses deep emotional involvement with the music.

Interchange smoothly between close-ups of hands or face, medium shots of pianist and piano, and long shots of audience and performer.

Violin—To get the best view of the instrument, you should aim the camera at a violinist or violist at a three-quarter angle from the performer's right side. The camera should be at a slightly higher level than the instrument and should point down.

As with other instrumentalists, vary your shots from close-ups to medium shots. Get detailed views of the action of both hands and of the facial expression of the player. When the soloist is accompanied by another instrument, such as a piano, get some shots of both together. You can use these at the opening and closing of the performance and during passages in which the accompanist performs alone.

Cello—Because the cello faces forward, a cellist is best recorded from the front or very slightly from either side. A low camera angle can be very effective. Vary your shots, as suggested for violinists.

Guitar—Like a violinist, a guitarist is most effectively shot slightly from the right side. If the guitarist is singing as well as playing, place the microphone halfway between his right hand—which plucks the strings—and his face. This will give an even balance between instrument and voice. Check the balance with some test shots or through headphones before you record a performance.

A pop guitarist singing on stage often moves about a considerable amount. Frame the picture to leave ample space for this movement and prevent the performer from leaving the image area.

Wind Instruments—Clarinet, oboe, flute, trumpet, trombone, french horn, tuba and other wind instruments can be taped effectively from a low angle. Shoot head-on or slightly from the side that shows the instrument to best advantage. Avoid obstructing the performer's face with the instrument.

With close-ups, you can direct attention to one or both hands or to the face. With instruments that extend away from the face, you can direct attention by focusing selectively on specific parts, such as one hand, the other hand or the face. You can shift focus while shooting.

For added variety, shift your camera position between shots. However, be sure to never compromise on sound quality for the sake of a more spectacular picture.

Flautists tend to bob and weave about considerably, so be prepared to follow sudden movements or widen your shot enough to accommodate the action.

Percussion Instruments—These include drums, xylophone, cymbals, triangle, marimba and a wide variety of other instruments. Because the instruments and the manner in which they are played differ considerably, each has its best camera viewpoint. Shoot from where you see the instrument and its use best.

Drummers are often taped best from a high, three-quarter view. This shows in detail the various parts of the instrument and the moving hands and sticks.

ORCHESTRA, BAND OR CHORUS

Concentrate on medium shots of instrumental or choral sections and small groups, together with close-ups of individual performers. Take a wide, frontal view of the whole ensemble as an opening and closing shot, but avoid it elsewhere.

Vary your camera position between selections as much as possible. Find at least one location where you can obtain medium to close-up shots of the conductor. If the performance is on an auditorium stage, a position in the wings is a possibility. However, you'll probably have to get permission to shoot there.

Microphone Placement—There are several ways to record the sound from a large instrumental or vocal group. A single cardioid mike suspended above the performers provides a good sound track. At a central position in the audience, about 20 feet from the stage, such a mike will pick up a large group adequately.

If your camera offers stereo capability, you can place two cardioid microphones on floor stands midway on either side of the performing ensemble. Or, use this microphone setup connected to an audio mixing unit, as described earlier.

When a performance is being recorded by the people presenting it, you may be able to suspend your mike along with theirs or even connect to their sound system. You'll have to pre-arrange this with the auditorium sound or electrical staff.

I don't recommend using a built-in, omnidirectional mike. It would provide only very rudimentary sound from the performers, with much interference noise from the audience.

Light Placement—When taping large groups such as orchestras and bands, you'll generally have to use the available stage lighting. Small groups that take up relatively little space can be lit by supplemental lighting. Avoid directing glaring lights at performers. Bounce your lights, either from walls and ceiling, or from umbrellas.

6 Basic Lighting Techniques

Your video camera is capable of providing optimum picture quality under varying light conditions. The lens iris, gain boost and contrast controls work to enhance the video image—automatically or by manual adjustment. These are *light-level* controls rather than *esthetic* lighting controls. They ensure bright images as well as color-accurate ones. To get any picture at all, you need a certain light brightness. When the light is too dim to produce a satisfactory image, there is a warning signal to tell you so.

The controls just mentioned do little or nothing to add modeling and form to your subjects or atmosphere to your scenes. In this chapter, I'll first say a little more about how to control the *amount* of light. Then I'll discuss lighting techniques that relate to the *quality* of the illumination.

BRIGHTNESS

Your first objective must be to provide the camera with the proper amount of light that will produce a clear, crisp picture.

Insufficient Light—When there is too little light on a scene, the video image is dark and lacking in contrast. On the TV screen, it is usually superimposed by white or colored spots called *noise*. This occurs when the illumination is too dim for the camera's electronic light-adjustment features—the iris, gain boost and contrast control—to compensate adequately to restore an acceptable picture.

Because an image produced with inadequate light lacks contrast, there is little modeling or differentiation between light and shade. Modeling is important because it provides roundness and form to people and objects, and depth and dimension to scenes.

Insufficient Depth of Field—In dim illumination, the camera's iris must be opened to a large aperture to admit as much light as possible into the camera. This results in limited depth of field. It makes it difficult to keep a subject in focus when you're following action. It also often prevents an entire scene from being in sharp focus at the same time.

Excessive Light—General illumination that's too bright for your camera to handle produces a light, washed-out image. It's easier to correct for too much light than for too little. If the camera controls don't give you sufficient scope for adjustment—which is unlikely—you can reduce the brightness of the lights or move them farther from the subjects. As a last resort, you can use neutral density (ND) filters on the camera lens.

Too much light from small areas can cause several problems. For example, bright background lighting from a window or lamp can cause the auto iris of the camera to close down by way of compensation. The result will be a correctly exposed background—and a main image that's much too dark.

Comet Tails—Bright catchlights caused by reflections from shiny objects such as mirrors, polished furniture or metal surfaces and cars can cause *comet tails*. These are light trails drawn on the image as the camera is moved and the catchlight also moves about the image area.

Bright light points can seriously damage a camera's picture tube. Never allow your camera to remain stationary on a scene containing bright light sources or catchlights.

Comet tails occur only with picture-tube cameras. Solid-state image sensors are immune to the effect.

If there's no way of removing an object that is causing this kind of flare, try dulling the reflective surface with dulling spray, available at most photo, hardware and paint stores.

CONTRAST WITHIN A SUBJECT:
Subject wearing a white shirt and light tie against a dark suit produces high contrast. It may result in a washed-out shirt, lacking detail, an excessively dark image of the jacket, or both.

CONTRAST BETWEEN SUBJECT AND BACKGROUND:
Subject in a white dress positioned against a dark background produces excessive contrast for the video system. The result may be a washed-out dress, with no detail, or an excessively dark background.

Depth-of-Field Control—If the illumination is very bright, the lens will be stopped down to a small aperture. This will give you great depth of field, especially when you're using the wide-angle setting of your zoom lens. If you want limited depth of field, to render a distracting background less obtrusive, reduce the light brightness—or use a neutral-density filter—until you have the lens aperture you want.

If your camera features manual brightness and contrast adjustments, you can also reduce depth of field by stopping down the iris manually. You must then adjust the brightness and contrast controls accordingly.

CONTRAST

When some parts of a scene are bright and others are dim, the scene has high contrast. This can be caused by different areas receiving different amounts of illumination, by component parts of the scene being in-herently light and dark, or a combination of both. I'll tell you about three basic types of contrast. You can deal with them by modifying objects within the scene, moving objects or changing backgrounds. You can also achieve a lot by controlling your lighting.

Contrast Within a Subject—A typical example is a combination of light shirt and dark suit. The shirt will *burn out,* losing all detail. It will also cause *blooming,* or a bright halation, in the image. At the other end of the scale, the suit will appear muddy, dark and without detail.

Contrast Between Subjects—An extreme example is a man in a dark suit standing in the shade of a tree while a woman in a bright dress is out in bright sunlight. Each will lack detail—one because of excessive darkness and the other excessive brightness. The remaining parts of the scene may well be recorded with satisfactory detail.

It's possible to control this kind of contrast by asking the participants to dress appropriately and by keeping the illumination on them reasonably uniform.

Contrast Between Subject and Background—A good example is a woman in light clothing standing in front of a mahogany-paneled wall or a deep-blue drape. The figure would lack detail and the dress would bloom against the dark setting. Here the obvious solution is to change the background.

Contrast Control with Lights—By using additional lights, weaker than the main illumination, you can fill shadow areas without affecting the modeling. You can do the same with reflectors—silvered or white reflective panels—which can redirect some of the main illumination to shadow areas. You can also screen off unwanted light from objects that are inherently bright. Barn doors on lights are ideal for this. You can use

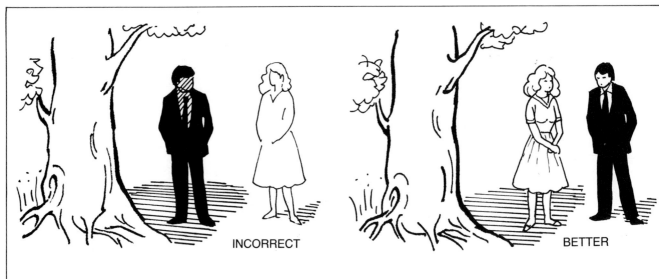

INCORRECT

BETTER

CONTRAST BETWEEN SUBJECTS:
Man in a dark suit, in shade, beside a woman in a white dress, in full sunlight, results in excessive contrast that will obscure the detail in one or both subjects.

When the white dress is in the shade and the dark suit is illuminated by sunlight, contrast is reduced and you'll get more detail throughout the image.

cardboard panels for the same purpose.

You can also soften the light source in various ways, as I'll explain later in this chapter.

THE RIGHT LOOK

So far, I've discusssed ways of bringing the subject's appearance within a range that the camera can handle to produce a technically fine image. Now I want to discuss the esthetics of lighting—making the image look good and effective.

Modern video cameras are so light-sensitive that your normal concern will not be so much "Do I have *enough* light?" as "Do I have *good* lighting?" Besides giving you clear, bright and colorful pictures, lighting can improve your pictures in several ways. It can add depth and dimension to a scene. It can give modeling and form to your subjects. It can create a specific mood or atmosphere and can change the mood from scene to scene. It can add sparkle and bril-

liance to a scene, or make a scene sad and somber.

Modeling and Detail—Modeling gives pictures a three-dimensional look. It's achieved by careful light placement so that shadows and highlights fall in the most effective places. To retain detail in shadows and dark areas, you must put additional light in those areas.

Mixed Lighting—Try to avoid shooting under mixed lighting conditions. For instance, you may be faced with a combination of tungsten and fluorescent lights in one location. If at all possible, shoot with one or the other but not both. A combination can confuse the camera's compensating systems and as a result colors will not be accurate.

If tungsten illumination at the scene doesn't provide sufficient light, add tungsten light of your own. It is also possible to supplement existing fluorescent lighting with more similar lights. Place them on the floor to the left and right sides of your

subject rather than attempting to add them to ceiling lights.

Mixed lighting can be particularly undesirable when your subject moves between tungsten and fluorescent lights during a shot. A camera corrected predominantly for tungsten light will lose color balance as your subject moves under the fluorescent source. A continuous white balance capability can help, but only if there are white objects or areas in your scene that the camera can use for white reference.

If you must supplement daylight—such as from a window—use daylight-balanced, blue photoflood bulbs as supplementary light source. To fill shadows outdoors, white or silvered reflectors are effective. They reflect the sunlight into the shadows, so all areas have the same color balance.

AVAILABLE LIGHT

Now I'm going to tell you how to use *available light*—the natural or

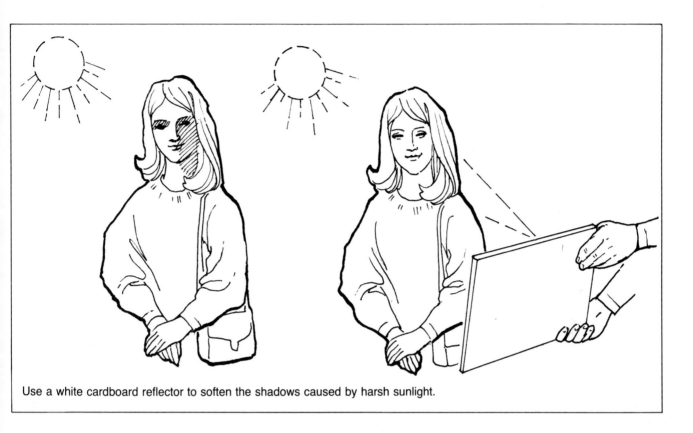

Use a white cardboard reflector to soften the shadows caused by harsh sunlight.

usual illumination you find at a scene—when you shoot your video movies. I'll show you how to work with it both outdoors and indoors in ways that enhance your pictures.

Available light can be sunlight, both outdoors or shining through a window into a room. It also includes normal lamps, ceiling fixtures, spotlights and other fixed electrical sources in a home, school, concert hall, theater or ballpark.

Available light can be used by itself or supplemented by additional lighting if increased levels of illumination are required or if shadow areas need to be lightened.

OUTDOORS

The source of light outdoors is usually the sun. The quality of this light can vary greatly from contrasty, direct sunlight to totally diffused illumination from an overcast sky.

Direct Sunlight—On a clear, sunny day, the light is contrasty. A subject has bright highlights and deep shadows. Or, part of a scene is in direct sunlight while the rest is in deep shade. A video camera can expose properly for either the highlights or the shadows, but not for both if the contrast is excessive.

Direct sunlight is softest in the early morning or late afternoon, when it comes from near the horizon. When the sun is low, its light has to pass through relatively more atmospheric haze. This makes the illumination softer. You get the softest direct sunlight of all when you shoot with the low sun behind you. Then, visible shadows are at a minimum.

Fill Light—The easiest and most effective way to lighten shadows that are too deep is to use one or two white or silvered reflector cards. You simply direct some of the sunlight into

the shadows by placing reflectors in appropriate locations.

Another alternative for filling shadows is to use a portable light source such as a blue photoflood. However, if you are shooting on location, you'll also need a portable power supply.

Overcast Sky—A hazy sky or a bright overcast, when the sun is visible and causes distinct shadows but its light is diffused, gives ideal illumination for most purposes. Not only is the sunlight soft, but shadow areas are filled by light from the uniformly overcast sky.

A heavy overcast, when the sun is not visible at all, gives uniform soft lighting that is virtually shadowless. It is often more desirable than harsh, direct sunlight. However, it lacks the subtle modeling provided when the overcast is thin enough to allow some direct sunlight through.

Scrim—A scrim is a loosely woven gauze screen that diffuses the light passing through it. By placing a large scrim, mounted in a suitable frame, between the sun and your subject, you can greatly soften the direct illumination from the sun. The effect is similar to that given on a hazy or lightly overcast day.

Of course, a scrim will be effective on a close-up subject only and not on a distant scene. However, it's generally the close-up subject that's most important in your movies.

Back Light—Avoid back lighting as the only light source unless you want to record your subject in silhouette. Back lighting can be attractive, however, when you use auxiliary lighting or reflector cards. The sun behind your subject can provide attractive rim and hair light. The sun can also play the part of main light—reflected onto the subject by an efficient foil reflector. Or, you can use blue tungsten photofloods, provided a power source is available at your shooting location.

INDOORS

Daylight through windows and artificial lights tend to give uneven lighting. They create pools of light that may give sufficient illumination in their immediate vicinity for an adequate video image while other areas are lit insufficiently.

If the action can be confined within one or two of the illuminated areas, you may not need supplemental lighting. If you need a wider area to work in, there are three convenient ways to supplement the available light:

Additional Light Source—Two to four photoflood bulbs in reflectors will add needed light effectively. Use regular bulbs if you're supplementing tungston light and blue bulbs if you're adding to available daylight.

As an alternative, you can use a portable camera light, attached to your camera. It will raise the illumination level on your subject to give you an acceptable image. Lighting from it will be flat so it will act as a fill light rather than a main light that provides subject modeling.

Brighter Room Light—You can raise the general light level in a room by replacing bulbs in existing light fixtures with higher wattage bulbs or photofloods. Be careful not to overload the electrical wiring.

In addition, you may still need some fill light to lighten the darker areas.

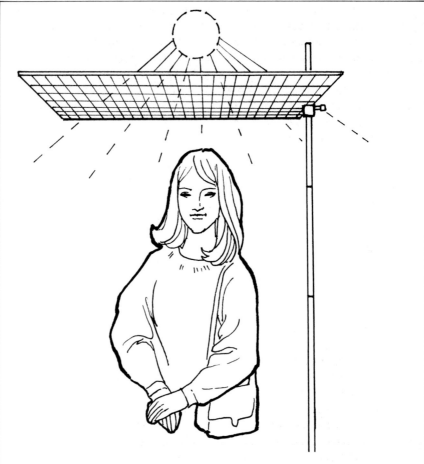

Soften harsh overhead sun with a diffuser, or *scrim,* positioned between the subject and the sun.

Back Light—Avoid back lighting as the only light source unless you want to record your subject in silhouette. Back lighting can be attractive, however, when you use auxiliary lighting or reflector cards. The sun behind your subject can provide attractive rim and hair light. The sun can also play the part of main light—reflected onto the subject by an efficient foil reflector. Or, you can use blue tungsten photofloods, provided a power source is available at your shooting location.

STUDIO LIGHTING

For the best creative control of illumination, you should use lighting equipment specifically intended for photography or moviemaking. I'm going to explain basic illuminationg with such *studio lights*. You can vary the classic lighting system I describe to suit your individual needs and tastes.

Studio lighting consists of the following four basic lights:

Key Light—This provides the main illumination and gives the subject modeling. This means that, by the proper placement of highlights and shadows, it gives the subject apparent three-dimensional shape in a two-dimensional picture.

Set this light up first, carefully positioning it to get the light-and-shade effect you want. With people, this light should generally be somewhat to the side of the camera and point down at the subject at an angle of 30° to 45°.

Fill Light—Its purpose is to lighten shadows to lower the contrast, or brightness range, of the scene. The fill light should not create shadows of its own. This means it should be soft and weaker than the main light.

Back Light—This light illuminates the subject from above and behind. It adds highlights to hair and a rim light to shoulders and arms. It can provide similar highlights and rim lighting to subject matter other than people. When used well, back lighting can give an image an attractive, three-dimensional appearance.

Beware of having the back light too bright. If it is much brighter than the main light, the highlight or rim light you create will burn out, causing unattractive light patches without any detail.

Be careful not to have the back light—or any other bright light—shine into the camera lens. Doing so

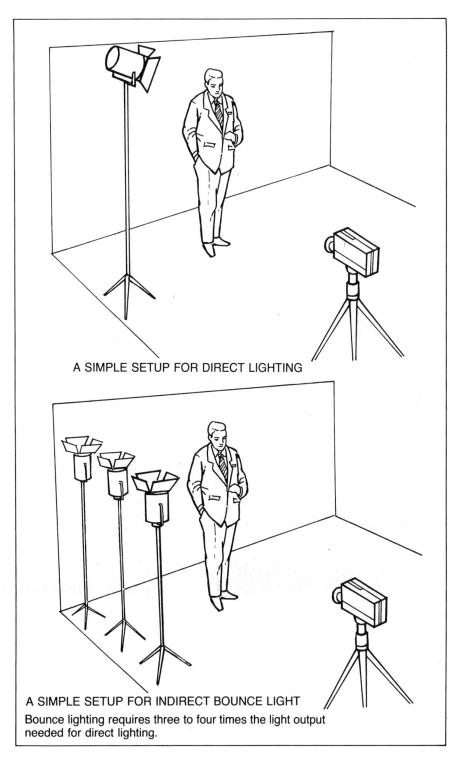

A SIMPLE SETUP FOR DIRECT LIGHTING

A SIMPLE SETUP FOR INDIRECT BOUNCE LIGHT
Bounce lighting requires three to four times the light output needed for direct lighting.

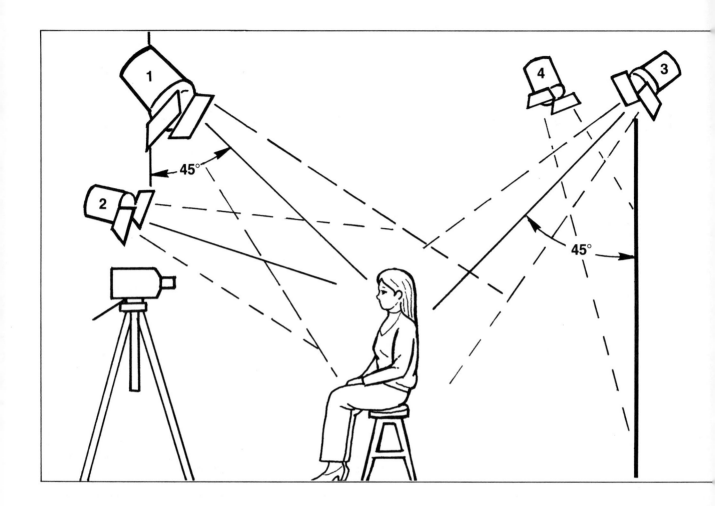

could damage your camera.

Background Light—The background light, also known as the *set light* in movie circles, simply lights the background behind the performers. You can create uniformly lit backgrounds of different brightnesses or backgrounds that are brighter in some areas than others. You can also project interesting shapes onto a plain background.

An Alternative—If you want creative control of the scene and are interested in creating atmosphere with light, use the lighting setup I've just described. However, a much simpler way to light a scene is to use overall soft illumination. All you need is two banks of soft light. You can easily construct these. A bank basically consists of a large box, painted white inside. In the box are one, two or three photoflood lamps. On the front of the box is a white, translucent diffusing screen.

The size of the boxes and the power of the lamps inside depend on the area you want to light.

Place the lights so the entire scene is lit as evenly as possible. Be careful to avoid harsh shadow areas that could occur on the background.

AUTO IRIS

Anyone who has used modern cameras with built-in exposure meters knows that a meter can sometimes be fooled by the subject or lighting conditions. The same is true with the auto iris in a video camera.

For example, a large area of bright sky in a scene will fool the auto iris into stopping down more than it should to provide adequate exposure for the foreground scene. The result will be an underexposed scene.

The same thing happens when a bright light source or catch light is "seen" by the camera's light sensor. The auto iris will stop down to allow for the bright light and consequently the subject will be underexposed.

If you can't avoid bright sky or strong back light in the scene, use the camera's manual override and set the iris as you see fit.

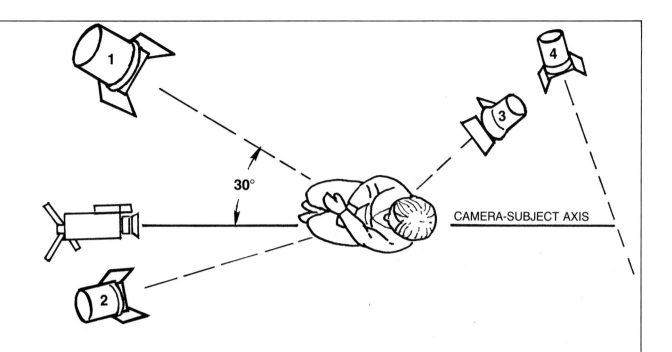

30°

CAMERA-SUBJECT AXIS

FACING PAGE: A typical four-point lighting set-up: Key light (1); fill light (2); back light (3); background light (4).

ABOVE: A top view of a basic four-point lighting set-up, showing positioning of (1) key, (2) fill, (3) back and (4) background lights, relative to the subject.

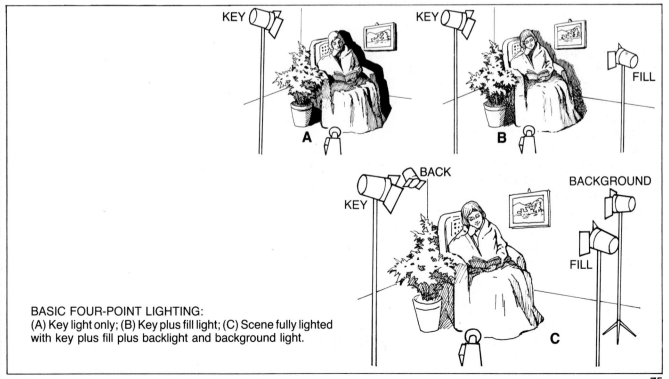

KEY

A

KEY

FILL

B

BACK

KEY

BACKGROUND

FILL

C

BASIC FOUR-POINT LIGHTING:
(A) Key light only; (B) Key plus fill light; (C) Scene fully lighted with key plus fill plus backlight and background light.

Special Effects

The mere mention of *special effects* conjures up images of outer space, awesome explosions, spectacular crashes, storms, fires and floods. It makes us think of Hollywood's make-believe at its most extravagant. For all that, however, there are many simple but spectacular effects you can create for your own home video movies. All you need are a few easily obtainable ingredients and a little know-how and practice.

I'll show you how to produce dramatic effects of rain, snow, fog, reflections in water and the glow of firelight. You'll learn how to use mirrors to create intriguing shots, and how to use filters.

All this will help to add atmosphere, mood, drama and polish to your movies. Naturally, many of the effects will be particularly useful when you're staging a production, as opposed to shooting a documentary.

BACKGROUNDS

I'll begin by showing you how to create interesting background effects with simple materials and creative lighting.

BLACK BACKGROUND

The so-called "limbo" effect provides the simplest background of all—it contains, or reveals, nothing. In this sense, the somewhat ominous word *limbo* simply means "a dark void" behind and around the subject.

This type of neutral background is excellent for a narrator. He can talk about the scenes and events shown in the movie without having his own background detract viewer attention or interfere with the continuity of the movie.

You'll need a black drape about room height and wide enough to cover the area behind your subject that's within the camera's view. An adequate size for most purposes is 9x12 feet. The material should be soft and absorb as much light as possible. Avoid shiny materials that will reflect light back to the camera. Black velvet or velour is best.

A large room with dark furnishings and no reflective objects can serve as a possible alternative. However, you must carefully mask all lights to prevent recording any detail in the background. As an added precaution, darken your video picture slightly

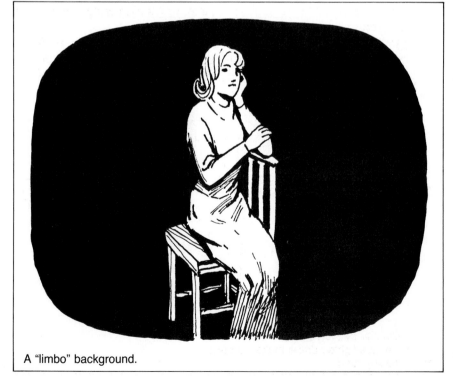

A "limbo" background.

with the brightness and contrast controls on your camera.

When you're using a black drape, position your subject well in front of the drape—at least six feet and preferably more. Illuminate *only* the subject. Shield your lights with barn doors or large squares of black cardboard so no illumination strikes the drape or background.

If you want to create a sinister effect, light your subject from below, placing a light on the floor or near floor level. To increase the eeriness of the effect, or to simulate hallucinations, dreaming or a disoriented mental state, add moving or flickering light patterns to the background, using a small spotlight or a stroboscopic light.

CURTAINS OR DRAPES

If you want a simple background that isn't dark, use curtains or drapes. With careful lighting, they can provide an attractive, yet non-distracting setting. You can use plain or textured material, preferably in a solid, neutral color. Soft, pastel tones generally make better backgrounds than bright, primary colors. The latter can be distracting.

Medium blue makes a good back-

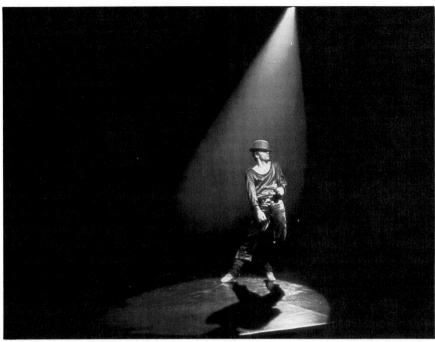

A staged limbo setting for a performer. Photo courtesy of Rosco Laboratories, Inc.

ground for people because it enhances flesh tones in a picture. However, beige and a warm, medium brown are also good choices. Avoid vivid patterns with contrasting colors. You should also beware of small herringbone or checkerboard patterns. They can "in-

terfere" with the scanning lines of the TV screen, giving an annoying wavy pattern or shimmering effect in the picture.

Lighting a Drape—To achieve a striking background effect, you must light the drape or curtain effectively. Here are several methods:

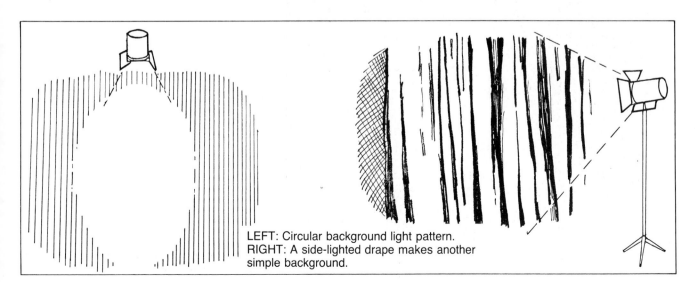

LEFT: Circular background light pattern.
RIGHT: A side-lighted drape makes another simple background.

● Place a photoflood at one end of the drape, a couple of feet in front of it and a little more than halfway up. Aim the light across the drape at a glancing angle. The illumination will be brightest near the source and gradually fall off toward the far side of the drape. This cross lighting will emphasize folds and texture in the drape in the form of light and shadow.

Place your subject four to six feet in front of the drape. If you want to record the background softly, keep the illumination brightness relatively low on both subject and background. This will cause your camera's iris diaphragm to open, giving you limited depth of field. Focus on the subject, and the background will be slightly out of focus.

● For a more dramatic effect, project a circle of light from a spotlight onto the background directly behind the subject. Position the light about three feet from the background. Aim it so that, from camera position, the top of the light circle is just above the subject's head and the center is around the subject's shoulders.

If you want the light in the circle to fall off toward the top, place the light near the floor and aim it upward. If you want the top of the circle to be brightest, raise the light and aim it down toward the drape. View the shot on a TV set and, if necessary, adjust the light position and brightness.

● You can create a dynamic background effect by aiming a narrow beam of light diagonally across the background drape. Use a small spotlight or a quartz light with barn doors. Position the light near one of the upper corners of the drape and aim it down toward the diagonally opposite corner. Close the barn doors or adjust the spotlight focus until you have a narrow shaft of light.

This will give you a dramatic diagonal light beam across the background. The light will be brighter on

A simple light circle on a plain background helps enhance the appearance of your subject. Photo courtesy of Rosco Laboratories, Inc.

the side where the source is situated and dim as it reaches the farther corner. This is also cross lighting and, as such, will bring out folds and texture in the background material.

● You can add color to a neutral drape or a plain, colorless background by using colored lights. By

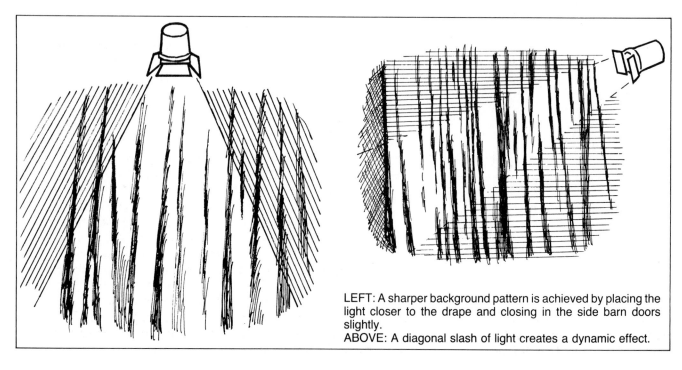

LEFT: A sharper background pattern is achieved by placing the light closer to the drape and closing in the side barn doors slightly.
ABOVE: A diagonal slash of light creates a dynamic effect.

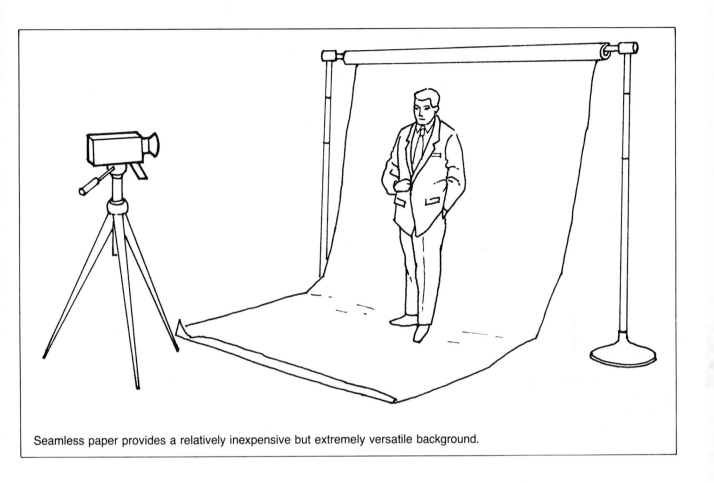

Seamless paper provides a relatively inexpensive but extremely versatile background.

using a red gel over a light, you'll create a red patch on the background. You can use several lights of different colors, to achieve a wide variety of effects. Observe the results on your TV screen and shoot when you like the effect best.

A word of caution: Be sure the gels you place over hot lights are heat and fire resistant. Ask for them at lighting-material or photographic stores.

SEAMLESS PAPER

Photographic background paper, generally known as *seamless* paper, makes a versatile background material for the video moviemaker. It's made in rolls of various widths and lengths. You'll find the 9-foot-wide

and 36-foot-long roll suitable for most purposes. Seamless background paper is available in a variety of colors and is relatively inexpensive.

You can hang a roll of seamless paper from a wooden pole or a pipe made of metal or plastic, supported at each end by a sturdy stand. Roll down as much paper as you need for your setting. Alternatively, you can simply tape the paper to a wall. I recommend you use gaffer's tape or duct tape.

To avoid a line between wall and floor, curve the paper smoothly from wall to floor and lead it along the floor far enough to cover the entire picture area. Your subjects can stand right on the paper. However, avoid

movement on the paper as much as possible before you shoot because footmarks easily show.

Black Paper—For a close-up shot of one or two people down to waist level, black seamless paper makes for an effective black background. Keep the subjects well away from the paper and avoid any light striking the paper. This is important because the paper, unlike black velvet, does reflect an appreciable amount of light.

Getting a totally black background of a wider scene with seamless paper is impractical because the subjects would need to be very close to the background because of the limited width of the paper. This would make light spillage onto the paper unavoidable.

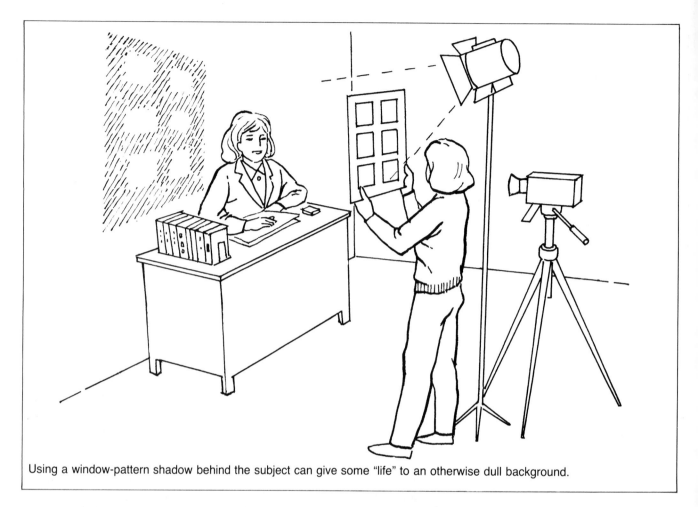

Using a window-pattern shadow behind the subject can give some "life" to an otherwise dull background.

LEFT: These are just a few of the dozens of shadow patterns available from Rosco Laboratories, Inc., of Port Chester, New York. ABOVE: An abstract light pattern readily improves a limbo setting. Photo courtesy of Rosco Laboratories, Inc.

Night-Sky Effect—You can easily create an effective night-sky or outer-space effect with black seamless paper. Punch many irregularly positioned small holes in a sheet of the paper. Position the paper vertically behind your subjects. Aim lights at the holes from behind the paper. The result, at camera position, will be a star-filled sky.

If you want your stars to twinkle, have an assistant move the lights about while you are shooting or have him wave his hands or pieces of cardboard in front of them as you shoot.

Daytime-Sky Effect—This can be easily created with light- or medium-blue seamless paper. Suspend the paper vertically. To create a horizon

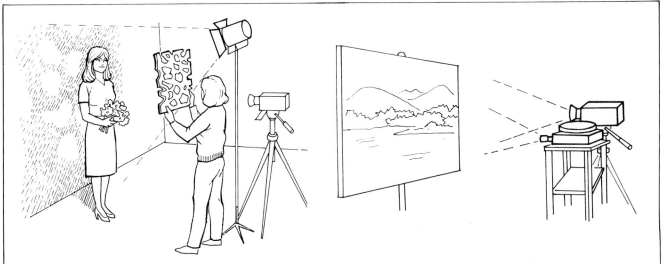

A "cookie" pattern enables you to project an abstract shadow effect on the background. You can also use a 35mm projector to project a background.

effect, place your subjects on a low platform and shoot from a low angle.

Illuminate the background from a low angle so that the lower part of the paper is brighter than the upper part. Your "sky" will be light-blue at the horizon and gradually become darker higher up—just like a natural sky. If you want a blue sky with fluffy, white clouds, simply paint the clouds onto the blue paper with white paint.

By adding a few leafy branches in the foreground and middle distance, you can have a simulated outdoor effect right in your own home.

Colored Backgrounds—You don't need to keep many rolls of differently colored background paper to create backgrounds of varied colors. Use light- to medium-gray seamless paper and place colored gels over your background lights.

I'll repeat it because it's important: Be sure that the gels you use are heat and fire resistant. Support the gels in such a way that there is sufficient air space for a hot lamp to ventilate. Don't let a gel touch a quartz lamp as

this can permanently damage the lamp.

With a light, a colored gel and neutral background paper, you have an instant selection of colored backgrounds. Check the image on your TV monitor and adjust the color, intensity and brightness until you have the desired effect. For example, if red doesn't look right, try orange. If the orange looks too insipid, try two layers of the gel. If the picture image then appears too dark, brighten it by adjusting your camera or add more light.

SHADOW PATTERNS

Shadow patterns, projected on a plain background, can be abstract or realistic. All you need is a directional light such as a focusing spotlight and some interesting shapes to project. The shapes can be real objects, such as a venetian blind, the back of an ornate chair or a ladder. Or, they can be cutouts made of cardboard. You can also purchase a wide variety of ready-made cutout patterns to fit

halogen-quartz lights.

The illustration on the opposite page shows you several examples of effective shadow patterns and how they are created.

Aim the light at the background and position the pattern in front of it. The closer to the light you position the cutout or object to be projected, the softer its pattern will appear. As you move it farther away from the light, the pattern will become smaller and have a sharper edge.

Experiment with the position and angle of the cutout or object, the placement of the light and the relative distances between background, shape and light. Watch the effects on your TV screen.

USE A SLIDE PROJECTOR

A 35mm slide projector and some suitable slides provide an excellent tool for generating effective backgrounds. You can place your subject in a city scene, a country landscape, against a mountain view, beside the sea, before a setting sun—all while

shooting in your own home. To maintain realism in your movies, avoid using slides containing objects that were obviously in motion at the time of shooting. They would appear strangely stationary in your motion picture! I generally find relatively distant views most effective for projected backgrounds.

Consistent Lighting—For added realism, be sure that the lighting in the projected background is similar to that on the subjects. For example, if the shadows in the background scene fall toward the right, be sure your studio lighting makes them fall the same way. If the background was obviously shot on an overcast day, and you're trying to create the illusion that your subject was there, avoid harsh subject illumination.

Screen—For best reproduction, use a large projection screen behind your subject. As an alternative, you can use off-white seamless paper or a light-gray drape stretched tight behind your subject.

Position the axis of the projector lens as close as possible to the axis of the camera lens. To avoid deterioration of the projected image, keep the subject lighting from striking the screen.

The subject lighting will generally be strong enough to eliminate any sign of the projected image on the subject. To minimize the possibility of the projected image registering on the subjects, have them wear moderately dark clothing. The projected image will be seen only on the screen. However, check this out before you shoot. Position your subjects and subject lighting, switch on the projector and examine the image you get on the TV screen.

It's advisable not to move the camera while shooting against a projected background. However, it's fine to zoom in and out.

A city-skyline cutout can be an effective background.

SKYLINE

You can create effective, silhouetted skylines of cities, forests or mountains from simple cutouts made of black cardboard. Place the outline in front of an illuminated sky background. For the silhouette effect to look realistic, the sky should be dark enough to suggest pre-dawn or dusk. Because the outline is in silhouette and without detail, it need not necessarily be cut from one large piece of paper or card. You can piece together several sections.

To maintain the silhouette effect, keep the background lights behind the cutout and be sure the subject lights don't strike the cutout either.

You can also create detailed skylines and light them from the front. They can be placed several feet in front of the sky background and lit separately. Or, they can be placed in contact with the sky and lit with the same lights. These skylines can be realistic, made from enlarged color photographs. Alternatively, they can be painted or even sketched, to produce a poetic or whimsical effect.

FOREGROUND

There's no more effective way of giving a scene a three-dimensional look than by adding foreground elements. For example, a free-standing window frame or a door can create the impression that you're looking into a room from the outside or vice versa.

WINDOW OR DOOR

To simulate a view through a window, place a cardboard or wooden window frame in front of your scenic or indoor background. You can create a silhouette effect by using black, unlit material. To simulate a lighted window, paint the window frame off-white, light-gray or a suitable pastel color and light it.

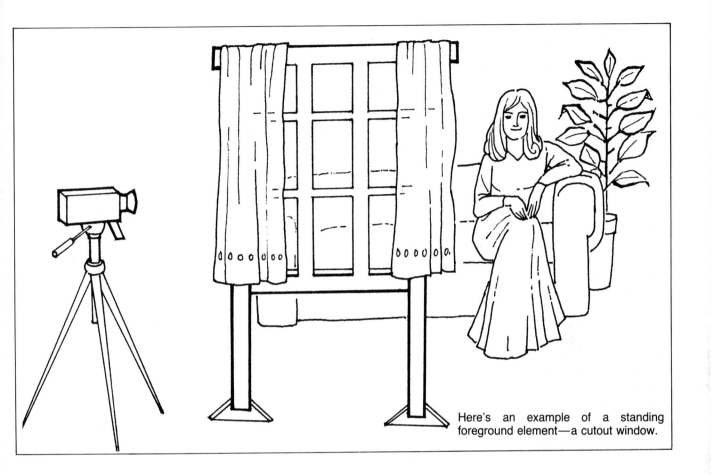

Here's an example of a standing foreground element—a cutout window.

You can construct any kind of window-frame design you like. By inserting the window into a large sheet of seamless paper, and backing the camera away, you can even include the "wall" that surrounds the window. To add more realism, add a shrub or bush close to the outside wall.

By dollying your camera toward the window, you can gradually make the transition from a view from the outside to one from within the room. When you have created the view from inside, you can remove the window from the set and move the camera about the room at will.

When you're creating the illusion of looking out from within the room, it's effective and attractive to put some curtains on the window.

A door can work for you in a similar way. To introduce a scene, use a free-standing door with frame. Be sure it is securely braced and weighted with sandbags or other suitable weights.

This technique enables you to place a door anywhere you want it, if there isn't a suitably located entrance to the room you're shooting in. If you don't want to go to the trouble of getting a real door, make one from cardboard. Paint it a suitable color. Attach a doorknob—real or phony—and hinge the door with gaffer's tape on the side not visible from the camera.

You can then dolly up, have the door slowly opened by someone out of camera view, and dolly or zoom on in to your setting. Once your camer-

a's view has passed through the door, you can remove the door.

Title Sequence—A miniature door provides a useful device for creating opening or closing title sequences. Within one doorway, place several doors, hinged at the same place. Print a title or credit on each door. Open or close the doors in sequence, revealing a new graphic or title with each door. If you're opening the doors, the final door can reveal the actual scene. If you're closing the doors—at the end of a movie—the first door will close the last scene and reveal the first graphic. I'll tell you more about graphics and titles in the next chapter.

There are endless possibilities for creating scenic illusions with simple cardboard cutouts of doors, windows

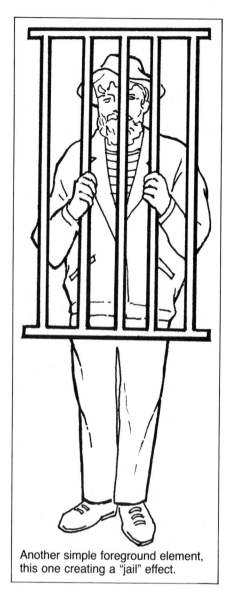

Another simple foreground element, this one creating a "jail" effect.

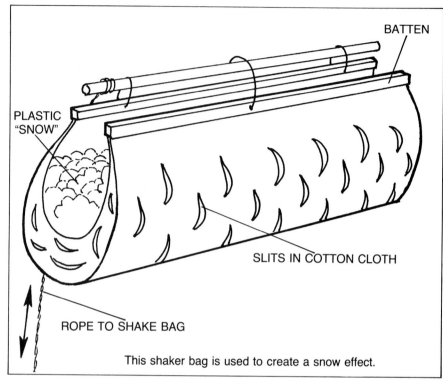

This shaker bag is used to create a snow effect.

[labels on image: BATTEN, PLASTIC "SNOW", SLITS IN COTTON CLOTH, ROPE TO SHAKE BAG]

or other barriers. For example, a jail cell is easily indicated by setting several vertical dark-gray or black bars in front of the camera. Shoot through them to your subject—and you have a prisoner.

You can also shoot through a large cutout keyhole, and then zoom in until you're actually "in the room." Use your imagination and ingenuity to suit your movie's needs.

Glue Gun—An electric glue gun is an indispensable tool for the types of construction I've just described. It uses clear, hot-melt glue-sticks. A drop of hot glue will firmly hold wood, metal, plastics, foam, ceramics, glass, paper, cardboard and cloth. It sets to 90% of full strength in less than a minute. It's also a quick, secure remedy for wardrobe problems—"sewing on" buttons, mending a ripped seam, attaching emblems, feathers and flowers.

You can get an electric glue gun at most hardware and home-supply stores. Keep it with your gaffer's tape. Together, they'll save you in many difficult situations.

ATMOSPHERE AND MOOD

You can easily create several atmospheric effects, ranging from useful to spectacular, for your video movies.

RAIN

Rain is perhaps the most commonly needed and used effect. If you're shooting outdoors, it is also one of the easiest to achieve. Hook up a garden hose equipped with a spray nozzle to the nearest faucet. Aim the nozzle high and let the water fall over your scene. Adjust the nozzle for a fine spray to give a misty, drizzle effect. For a heavy downpour, adjust the nozzle accordingly.

Back lighting makes falling water more visible. Position your shot so the sun is slightly behind your subject. Or, use a large reflector or artificial illumination. This will add sparkle to the rain and make it clearly visible. To avoid the effect of a sunlit scene, manually reduce the iris diaphragm of the camera lens to darken the scene, if necessary.

You can create a rain effect without getting your performers wet. Use a tall stepladder and direct your spray

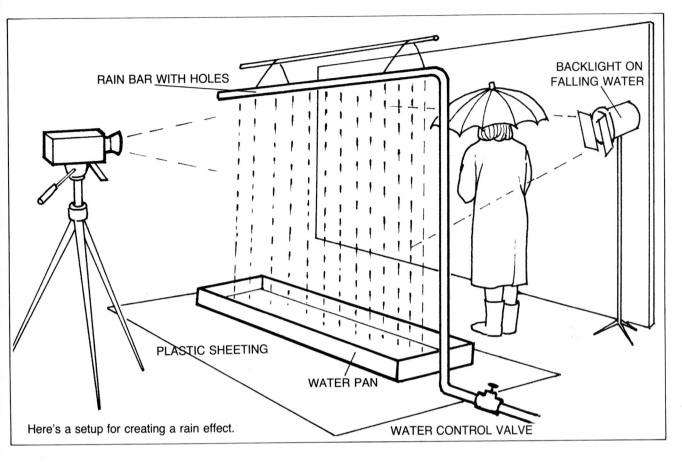

RAIN BAR WITH HOLES

BACKLIGHT ON FALLING WATER

PLASTIC SHEETING

WATER PAN

WATER CONTROL VALVE

Here's a setup for creating a rain effect.

down between camera and subjects. Be sure to keep the camera dry. Don't forget the back lighting to enhance the falling rain.

Indoors—Yes, you can make it rain indoors, too, but it requires more care and preparation. First, you must provide adequate means of catching and containing the water. A large wood or metal trough, lined with plastic sheeting such as a painter's plastic drop cloth, obtainable at hardware stores, is ideal. The trough must be large enough to cover the intended rain area.

To produce the rain, use a *soaker hose*, perforated along its length and closed at one end. You can also use a length of plastic pipe that has had holes drilled along its length.

Suspend the hose or pipe so that the rain falls between the camera and

the subjects. Aim a back light toward the falling water to highlight it. Although your subjects will remain dry, this will create a realistic illusion of rain falling on them.

To obtain the effect of rain outside a window, place your rain device high up and between the window and the exterior background. Again, it's important to back-light the water for added visibility.

A rapidly repeating stroboscopic light, aimed at the ceiling, will add very believable lightning. Switch the strobe on and off in short bursts—but don't overdo it!

GROUND FOG

Fog or mist that stays near the ground can be created with dry ice. Caution: Always wear thick gloves when handling dry ice. It can inflict

serious burns to exposed flesh.

Place pieces of dry ice in one or several pails or in a large tub or trough of hot water, depending on the area you want to cover. It takes quite a lot of dry ice to cover a room-sized shooting area and keep the fog there long enough to record a scene. You have to keep adding hot water because the dry ice cools the water very quickly.

The vapor produced by dry ice is heavier than air and therefore settles near the ground. It doesn't rise like steam or smoke. To create steam or smoke effects you must use other means, described later.

Because dry-ice vapor stays near the ground, you can contain it in a desired area by surrounding it with a low wall of cardboard. You can use a fan, at its slowest speed, to propel the

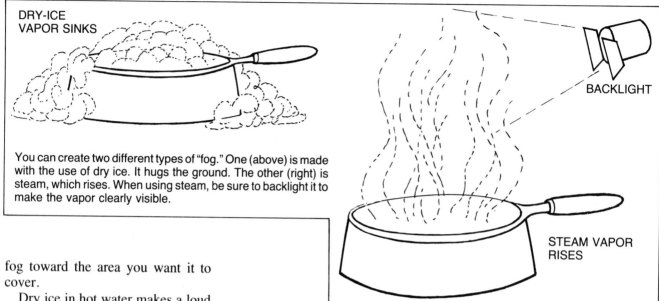

DRY-ICE VAPOR SINKS

BACKLIGHT

STEAM VAPOR RISES

You can create two different types of "fog." One (above) is made with the use of dry ice. It hugs the ground. The other (right) is steam, which rises. When using steam, be sure to backlight it to make the vapor clearly visible.

fog toward the area you want it to cover.

Dry ice in hot water makes a loud bubbling noise that may create a sound problem for you if you're using an omnidirectional microphone. When you use dry-ice effects, it's wise to have a directional microphone available.

Things Dry Ice Won't Do—Dry ice does fascinating things, so there's a danger of overusing it, or using it inappropriately. Remember, the vapor moves downward and tends to rest on the lowest surface it reaches. Therefore, it's not appropriate for simulating steam or smoke. Don't try to create cooking effects with dry ice.

If you want steam, use the real thing. Heat food, or use boiling water from a hidden source to create the illusion of a steaming pot. To highlight the steam, use a dark background and back light the steam. However, be careful not to direct the light straight at the camera lens—especially if you have a tube-type camera that's prone to burnout.

When steam from a pot moves downward around the pot, it evokes thoughts of evil or magic potions. So, if you're making a science-fiction movie and want such eerie effects, use dry ice by all means!

SMOKE

The easiest way to simulate smoke is with a *smoke machine*. These devices, which can be rented from theatrical supply houses, heat oil to generate a fine, white vapor that looks like smoke or mist. Unlike dry-ice vapor, this vapor rises or hangs in the air. Aim the device to direct smoke into the desired area, or conceal the machine behind props or furniture.

Smoke-machine vapor has a slight greasy odor. I recommend you do *not* use it in your house because the oily vapor has a tendency to settle on furnishings.

Do not use a smoke machine in a small, poorly ventilated area. Also, use it with special caution around small children and anyone with allergies or respiratory problems.

FALLING SNOW

For a small scene or close shot, use a spray can of decorative frost, commonly used at Christmas time. Position the can well above the camera lens, between the camera and the ac-

tion. Simply let the "snow" drift down. To give the effect of a snowstorm or blizzard, blow the spray gently across the scene with an electric fan set to a slow speed. You can also use the decorative frost to provide the effect of accumulating snow on objects in your scene.

For the effect of snowfall outside a window, position your spray can between the window and the outside

This smoke machine was developed by Rosco Laboratories, Inc. It is useful for both smoke and atmospheric fog effects.

MIRROR
FRAGMENTS

PAN
OF
WATER

This is a very simple technique for creating water reflections.

scene. The snow will record adequately without extra back lighting because the particles are solid and white.

The spray can may give you some sound problems. The hiss produced by the aerosol propellant will probably be picked up by your microphone, especially if it's omnidirectional. If your performer is close to, or actually holding, a directional mike and the spray can is 10 feet or more away in a fairly large room, the interference will be minimal.

I recommend that you use spray snow mainly in scenes accompanied by music or narration, added at a later stage, rather than with live sound, recorded at the time of shooting.

To produce a "snowfall" to cover a wider area, use white plastic granules. Shredded vinyl serves this purpose best. You can obtain it from theatrical supply houses.

There are various ways to dispense this kind of snow. You can scatter it across your shot by hand, taking care not to let it fall in clumps. To give you the height you need, use a tall stepladder.

Or, you can drop the snow from a *shaker bag*—a long strip of muslin with slits cut in it to release the granules. Use a strip of sufficient length to reach across your scene. Have two assistants on stepladders, one on each side of your scene. Have each hold one end of the muslin trough filled with the granules. When ready to shoot, instruct each to shake the trough gently to create the "snowfall." To make the effect even more realistic, use a large fan, at slow

speed, to swirl the "snowflakes" across the scene.

If you plan to shoot over a period of several hours, a more permanent installation may be required. For this, obtain two long poles, or strips of wood. Attach each of the two long edges of the muslin to a pole, using staples or glue. Suspend the resulting bag above your scene between stepladders or from light stands securely weighted down with sandbags.

Attach a long cord or clothesline to the muslin bag and, when snowfall is needed, rock the bag gently from below, using the line.

WATER REFLECTIONS

Sunlight reflected from water can produce rippling patterns of light on objects near the water. This effect,

too, can be created artificially.

Start with a large, shallow metal pan. Its size depends on the area you want to cover with reflection, but one about two feet long, one foot wide and three inches deep is adequate for an average situation.

Next, take a mirror that's about the same size or a little smaller than the pan. Break the mirror into several pieces about two or three inches in length. I recommend you put the mirror in a sturdy bag for breaking it and wear safety glasses and heavy gloves.

Spread the pieces of mirror over the bottom of the pan. Then fill the pan about half full of water, making sure the pieces of mirror remain submerged.

Position the pan on the floor close to the area in your scene where you want the reflection pattern. Beam a light on the water from a low angle from the side opposite where you want the reflections.

Watching your monitor, adjust the light and pan until you locate the reflections in the desired area. When you're ready to shoot, have an assistant gently rock the pan to produce ripples in the water. You'll achieve a very realistic water reflection in your shot. By using a blue light, you can add a moonlight effect to this technique.

FIRELIGHT GLOW

The flickering glow from a campfire or a fireplace, illuminating performers or a section of a scene, is another effect that's easy to achieve. Attach 10 or 15 strips of cloth, each about one inch wide and separated from each other by one inch, to a long piece of wood or a pole. Illuminate your subject with a small light aimed through a red or orange gel. Shake the cloth strips in front of the light. Watching your TV screen, adjust

SHAKE

LIGHT SHINES THROUGH CLOTH STRIPS ONTO SUBJECT

CLOTH STRIPS

Another simple effect you can create is that of flickering firelight.

the light and movement of the cloth strips until you have a realistic firelight effect.

NIGHT EFFECT

Blue light suggests night. To simulate the appearance of moonlight illuminating your subject—through a window or in an outdoor setting—place a blue gel in front of your main light. Aim the light at the performers from the required direction—through a window or from the sky. Add a blue gel to the back light, to also rim light the subjects in blue. You can retain reasonably normal skin tones by using frontal fill light without a blue gel.

You can combine moonlight with room lighting. Illuminate the scene outside a window with blue light and illuminate the indoor subject with tungsten lighting. Again, the only way to be sure you have the effect you want is to observe the image on your TV screen. Adjust light positions, colors and brightnesses until the scene looks right.

Don't be tempted to color a scene blue by adjusting your camera's electronic color-adjust control. It is not likely to give a believable effect. That's because the electronic control affects the entire image uniformly, eliminating areas of normal coloration such as flesh tones. While you may achieve a certain *non-daylight* effect electronically, a real *moonlight* effect is best created not by disturbing the normal white-balance setting of the video system but by controlling the color of the illumination instead.

A Rosco bottle, smashed over a victim's head can add excitement to a production.

These harmless breakaway items will shatter safely and produce dramatic or comic effects.

UNUSUAL ANGLES WITH MIRRORS

Sometimes you may want to shoot subject from an unusual angle—a high bird's-eye view or a low worm's-eye view. While home video cameras are small, lightweight and highly mobile, some angles are still difficult or impossible to achieve. In situation like this, a mirror can be very helpful. Place the mirror where you would like to have your camera, and then shoot the reflection provided by the mirror.

A mirror, securely suspended over a kitchen table, enables you to record an unobstructed view of food preparation. With a mirror, you can shoot a pianist's hands from an overhead angle, giving an unobstructed view of his performance. Similarly, you can use the mirror from below, aiming up toward the pianist's arms and face.

The mirror you use should be optically flat, so you don't get image distortion. It should be spotlessly clean. It should, of course, be large enough to cover the image area you want to shoot. You may need to experiment a little to find the right positions and angles for mirror and camera. Do this by observing your TV screen.

Because the mirror may introduce a slight color imbalance, adjust the camera's color controls. Use skin tones as your guide.

Mirrors have one distinct drawback: They reverse every image left to right. For example, a pianist suddenly appears to be playing the low notes with his right hand. This can be corrected by using two mirrors. The second one reverts the image back to a right-reading one.

It requires considerable care and patience to get both mirrors and the camera placed correctly. Electronic reversal of the video image is technically possible, but most amateur video moviemakers would not have access to the necessary equipment. For the most part, I would say the eye-catching advantages of a spectacular angle made possible with a mirror outweigh the drawback of a reversed image. However, like so many special techniques, I wouldn't overuse this one.

EFFECTS WITH FILTERS

A *filter* is a transparent material placed in front of a camera lens to alter the appearance of the image. Most often, a filter alters the colors of the scene. A filter can also simply reduce the amount of light permitted to pass through the camera lens.

There are other "filter" types that don't actually filter anything from the light but change the appearance of the image in other ways. Shooting through such *special-effect* filters can

give you a wide variety of eye-catching visual effects.

Color and special-effect filters are made of glass or plastic and can be easily screwed or clamped to your camera's lens. The front mount of your video-camera lens has a specific diameter. You must know that size to buy filters that will fit. If you don't know the diameter, look it up in your camera manual under the specifications section. Or, take the camera with you to a camera or video store when you buy filters.

I'm not going to concentrate here on color filters because you'll normally control color electronically. I'm going to tell you about filters that offer effects that can't be achieved with the video camera alone.

If you use the filters discussed sparingly and selectively, they can add much to the visual impact and fun of your tapes. If you overuse them, or use them with poor judgment, they can spoil a movie. I recommend you use them only when you know what you intend to achieve.

Neutral-Density (ND) Filter—This is not, strictly speaking, an *effect* filter. However, indirectly it enables you to achieve some important effects. Basically, it's a gray filter that reduces the amount of light permitted through the lens without changing image colors. Occasionally, you may find one useful when the light is so bright that you cannot get an acceptable image—such as a snow or beach scene in bright sunshine.

However, in the context of special effects, the ND filter is a useful tool that enables you to control depth of field. In bright light, the lens iris is stopped down to a small aperture, and depth of field is very extensive. Often, you will want to control depth of field so that parts of the scene are slightly out of focus. You can do this

Unusual camera angles are relatively easy to achieve with proper placement of mirrors and camera. You can see the resulting image in the insets, above and on the facing page. Experiment with different mirror/camera positions until you get the desired result.

by adding an ND filter. It will cut down the light reaching the lens and, thus, cause the iris to open up.

Neutral-density filters are available in a series of specific densities, giving you considerable depth-of-field control when the lighting conditions are bright.

Polarizing Filter—This is a useful device for eliminating undesirable reflections from windows or water so you can see detail beyond those surfaces. For maximum effect, the angle between the reflective surface and the axis of the camera lens must be about 35°. To control the reflection, you must rotate the polarizing filter on the camera lens. As with all other effects, study what you see on the TV screen and make adjustments accordingly.

Fog and Diffusion Filters—These attachments enable you to create

effects in your scene ranging from slightly softened picture detail with a misty-hazy appearance to dense fog with haloed highlights.

You can obtain a similar effect by placing a nylon net or hose directly over the lens. Or, you can shoot through a clear glass that has been lightly smeared with petroleum jelly. If you leave the center clear and smear the jelly so it extends outward with increasing density, you'll achieve a clear image in the center, with diffusion spreading toward the edges. Be careful not to get any jelly on the camera lens itself.

Centerspot Filter—This special lens attachment has a similar effect to that just described. It gives a clear image in the center, surrounded by diffused image toward the edges of the picture. It can create an attractive "dream" effect.

Graduated Filter—One half of this filter is clear while the other is colored. Typically, the color gets gradually darker toward the edge farthest from the clear area. The filters are available in several colors. They enable you to change the color of half a scene without affecting the other. For example, with an orange or red graduated filter you can create a warm sunset glow in the sky without affecting foreground colors.

To avoid a giveaway that you're using such a filter, it's important to place the horizon line accurately. Otherwise, the sky color may extend into the foreground scene or not cover the sky totally. For this reason, I recommend that you use your camera on a tripod.

Star Filter—As the name implies, these filters produce star patterns. Depending on the filter you use, you can produce stars with four, six, eight or more points. The stars are formed by strong point highlights, so it's important to have these in the scene—and have them in the right place. Stars can be produced with such point-source lights as streetlamps, car headlights, bright reflections from surfaces like rippling water, or the sun itself. For the stars to be most effective, they should have a dark background.

Multi-Image Prism Attachment—One type gives you a central image of your subject, surrounded by a circle of identical images. In a movie, you can rotate the attachment on the camera lens while you shoot, to get the outer images to revolve around the central one.

Another type will give you several identical images in a straight line across the image area. If used spar-

ingly, and with appropriate subjects, these attachments can be very effective.

Ribbed or Stepped Filter—These lens attachments are designed to deliberately distort your image to create humorous or weird effects. You can achieve similar distortion by shooting a reflection in a flexible plastic mirror. Bend and twist the mirror to get the distortion you want.

Kaleidoscope—Shooting through a kaleidoscope can produce in a video movie multiple images such as we are all familiar with from our childhood. Obtain the largest possible kaleidoscope and one that makes it relatively easy to change the pattern seen through it. Aim it at a light source and aim the camera through the kaleidoscope eyepiece. Using the macro setting of the camera lens, focus the image and shoot.

8 Graphics

Graphics are those components of a movie that don't involve actual live scenes. Titles and credits are graphics. So are maps, charts and diagrams, drawings, posters, printed material and even still photographs. If you want your video movies to have a professional appearance, graphics are almost essential.

If your camera features a character generator, titles and simple credits can be produced electronically. However, you'll probably want to add special graphics of your own design. Here's some advice on how to set about the task.

FORMAT AND SIZE

As I've indicated earlier in this book, the height-to-width ratio of the TV screen is 3:4. All graphics must be designed to fit into this 3:4 *aspect ratio*.

You must also realize that the picture reproduced on a TV screen may show 10% to 20% less than the image seen in your camera's viewfinder. This is because individual TV tubes vary a little from each other. You must take this into consideration when designing titles, lettering or other graphics.

Observe Safe Area—The essential part of your graphics must always be located within the *safe* area, where it is bound to reproduce on any TV screen. Otherwise, you run the risk of losing the beginning and end of words or graphics. In general, never print titles or draw illustrations to the outside edges of a title card. Always leave a generous margin, as shown in the next section.

PREPARATION

For creating a graphic for a video movie, I recommend the following preparatory procedure:

As the base for your graphics, use 11x14-inch poster-board cards. This is a good *TV title card* size, easy to work with and readily available from art-supply stores. You can also easily make your own cards.

With a pencil, lightly mark off an area 9 inches high by 12 inches wide parallel to the edges of the card and centered on the card. This represents the total video area at your disposal.

The outline you have drawn marks the outside frame of your video picture. You can continue *unessential* graphic material, such as background design, out to this dimension. But keep lettering and all other essential parts well within the outline.

Next, mark off an area that lies 1-1/8 inches within the 9x12-inch maximum video area you had outlined on all sides. You will now have a rectangle of 6-3/4x9-3/4 inches, centered within the larger area. This is your *title safe* area. Keep all lettering and essential graphic material

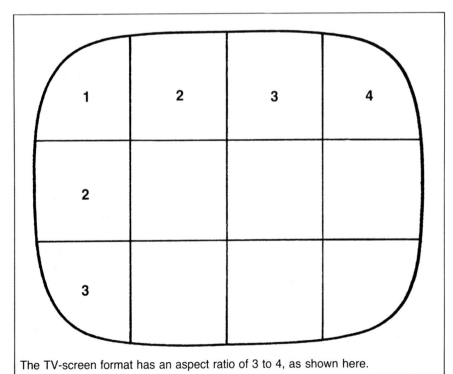

The TV-screen format has an aspect ratio of 3 to 4, as shown here.

within it. You can then be sure that all essential graphics will lie well within any TV screen's image area.

When your graphic is complete, carefully erase the guide lines you've drawn for total-picture and title-safe areas. As an alternative, you can initially draw these guide lines with a felt-tip pen on a piece of tissue or clear acetate and overlay this on the title card to help you design your composition within the proper areas.

HOW TO CREATE ARTWORK

There are several ways to prepare graphics. The easiest way is with a magic marker or a wide felt-tip pen. Keep letters large and uniform in size, thickness and style. If you're not an artist and want your lettering to look more professional, you can use press-on letters, available in a wide variety of styles and sizes from most art-supply stores. Apply the letters by simply rubbing their plastic support sheet with the dull end of a ball-point pen or some other dull instrument.

The rubbed letter adheres to the card. Special spacers ensure evenly placed characters. A mistake can be corrected by simply removing the letter with adhesive tape.

Here are some important points to remember when designing your graphics:
● For titles and credits, use no more than about 10 words per card. Running text should not exceed seven lines per card, each line containing no more than five words. If you were to put more on a card, the size reduction would make your graphics difficult to read. This would result in a loss of viewer attention.
● Letters and lines should be well separated from each other. Closely spaced patterns on a TV screen tend to interfere with the scanning pattern of the video system, causing a loss of clarity and readability.

● Letters and other graphics, including illustrations and charts, should be simple and bold. Avoid intricate detail.
● Three-dimensional letters make attractive graphics. For maximum effect, light them from the side to create well-defined shadows. Many word games and toys come with sets of interesting and colorful block letters. Many art-supply stores stock similar letters. The glue gun I mentioned earlier is ideal for affixing the letters to your card.

If the letters are somewhat large, use an accordingly larger card and adjust the framing with your zoom lens. Be sure to keep the dimensions of the graphic in the 3:4 aspect ratio in a horizontal format.
● Menu boards, having a felt base and grooves to hold special white or colored letters, can also be effective for your graphics. Magnetic letters on a metal board can also be used. If the magnets are strong enough, you can attach a sheet of material to the metal board and the letters will still adhere on top. Magnetic letters have the advantage of being very easily moved about.

HOW TO SHOOT GRAPHICS

Graphics cards can be mounted in a number of ways for shooting. Here are a few convenient ways:

Easel—The easiest method is to stand the card on an easel in front of your camera. If you're shooting a series of cards, you can stack them on top of each other and remove them one by one. You can do this while the camera is running, revealing each succeeding graphic with a wipe effect. To enable you to remove one card at a time without having to fumble, secure a tab firmly to the edge of each card. It's important that you re-

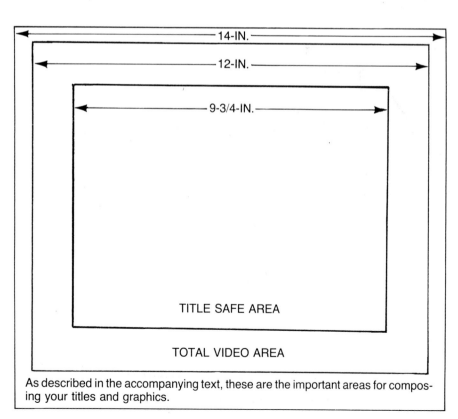

14-IN.

12-IN.

9-3/4-IN.

TITLE SAFE AREA

TOTAL VIDEO AREA

As described in the accompanying text, these are the important areas for composing your titles and graphics.

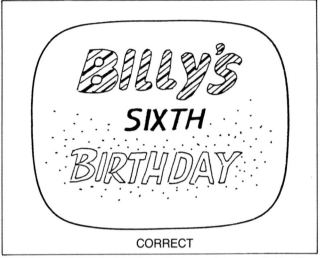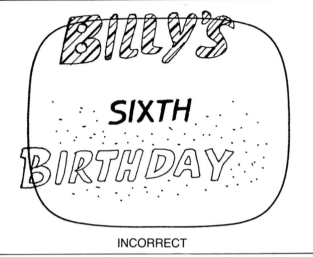

CORRECT

INCORRECT

Keeping your titles within the lettering safety area (left) will prevent problems (right).

move each card without disturbing the centered position of the others.

Flip-Chart Rings—You can mount your cards on an easel equipped with flip-chart rings. To do this, your cards must be hole-punched. This method enables each card to be dropped accurately into or out of the shot. If you design your graphics on heavy posterboard, each visual drops quickly, giving the effect of a series of *cuts*. If you use relatively lightweight art paper, the visuals float down more slowly, creating the effect of a series of fairly rapid *dissolves*.

Crawl Board—If you have a great deal of information to show sequentially, such as credits, acknowledgments and a written introduction, you can construct a vertical *crawl board*. Place all the graphics on a long vertical board, keeping within the title-safety limitations on the sides.

By slowly tilting the camera down over the board, from top to bottom, you can shoot the entire material in one continuous sweep. The written lines appear to *crawl* from the bottom to the top of your video picture. To keep the board at an even distance from the lens and to avoid image distortion as the camera tilts, curve the crawl board slightly inward.

Close-Up—If your camera has close-up or macro capability, you can type your titles or messages on 3x5-inch or 5x7-inch file cards with a typewriter. This method is quick and easy, although not very artistic or professional.

General Recommendations—Always make sure your camera is at right angles to the graphics card, with the lens axis pointing at the center of the card. This will avoid unattractive distortion. Check that the graphic is level with the top and bottom frame of your video picture, not sloping to one side or the other. Even a slight slant will appear very obvious and undesirable on the TV screen.

Be sure your lighting on the graphics does not cause flare or unwanted reflections. Ideally, use two lights, one on each side and pointed toward the center of the card at an angle of about 45°. If you're shooting in natural light, tilt the card until you see no reflections on your TV screen or in the camera viewfinder. After doing this, be sure to center the camera on the card again, as just described.

GRAPHICS WITH MOVEMENT

So far, the only movement I've discussed involves the simple scan of a card or the flipping of cards. You can also use more complex movements, of both camera and graphics, including the classic camera zoom, pan and tilt. When you do this, you must remember to observe the title-safe areas, just as before. If you don't, some important parts of your graphic may run off the TV screen.

Depending on the amount of visual information you want to convey and the area of material you want to cover, you may find it advisable to work with a larger card—perhaps up to 18x24 inches. That's about the maximum size I recommend. Anything larger tends to become unmanageable.

You can even introduce some animation into your graphics. I'll de-

94

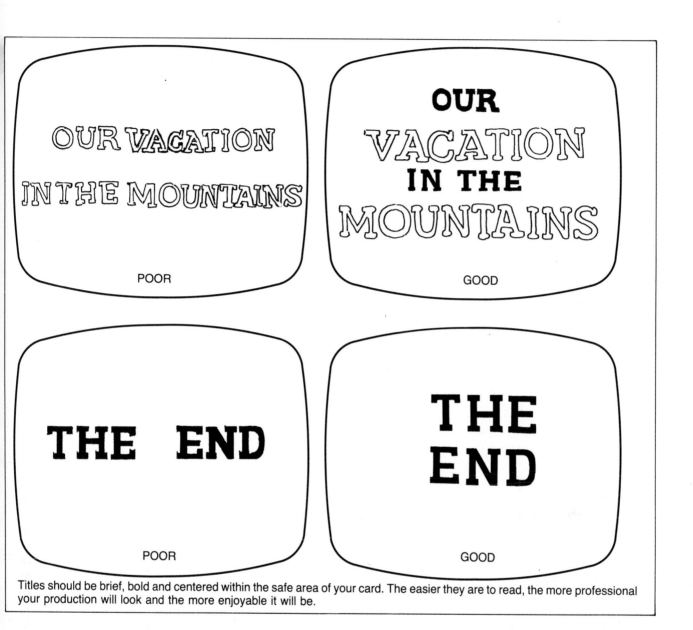

OUR VACATION IN THE MOUNTAINS

POOR

OUR VACATION IN THE MOUNTAINS

GOOD

THE END

POOR

THE END

GOOD

Titles should be brief, bold and centered within the safe area of your card. The easier they are to read, the more professional your production will look and the more enjoyable it will be.

scribe this a little later in this chapter.

Turntable—A record-player turntable—or even an ordinary Lazy Susan—provides an effective means of adding lively motion to graphics shots. It lets you spin your title or design or turn it slowly, until it reaches the desired position in your frame.

If you zoom in or out as your graphic rotates, you can achieve some eye-catching effects. You must

be alert to stop the turntable or Lazy Susan when a suitable point is reached so your graphic can be clearly seen and understood. It takes some practice to stop this motion in a way that ensures that the graphic is properly framed when it stops.

Position the rotating device on the floor and place the graphic on it. If the protruding central post on the turntable is not removable, you may have to put a thick pad around it to

provide a uniformly flat surface.

With your camera on a tripod, aim straight down at the artwork. Spin the turntable at slowest speed or rotate the Lazy Susan slowly. Zoom your lens in or out, as you desire, while recording the rotating and then stationary graphic.

By zooming toward the tele setting, you can make a rotating title appear to spin toward the camera. By zooming to the wide-angle setting,

you can make the title appear to spin away. You can shoot a sequence of titles, one after another, this way.

Follow this procedure: Place a large black card on the turntable to provide a uniform background. Focus your shot with the first graphic framed at a distance. Activate the turntable. Start recording. Zoom in and stop the turntable as your graphic reaches a visible position at full frame. Stop recording. Focus on the next graphic, spin it, start recording, zoom in again, and stop.

Repeat the sequence as necessary. As I indicated earlier, it will take some rehearsal and skill to stop the turning graphic at the appropriate spot. But you can achieve satisfying effects that simulate electronic transitions otherwise impossible to produce without elaborate equipment.

Animation—By moving individual cutout elements within a graphic, you can introduce real *animation* into your movies. Cutout paper puppets or animals can be made to move by concealed pull tabs, inserted from behind the background or from one side.

If you have a camera with single-frame shooting capability, you can move cutout figures between single-frame exposures. This method approaches true motion-picture animation, eliminating the need for pull tabs. However, it is a method that takes time, patience and practice.

In addition to moving whole figures, you can move individual arms, legs and heads. With real skill, you can even make mouths "talk" in sync with a voice-over performer.

Still Photographs—Another graphic element that can be effective in your movies consists of still photographs. Well-selected snapshots, pictures from magazines and books, or photos from travel catalogs can provide a new dimension and added

ABOVE: This is a typical setup for shooting title cards on an easel. BELOW: A tab at the edge of each card enables you to slide each one off smoothly, in the desired sequence.

Another approach to titling uses flip-chart rings. These rings permit each card to be dropped into the frame accurately—or lifted out—in sequence.

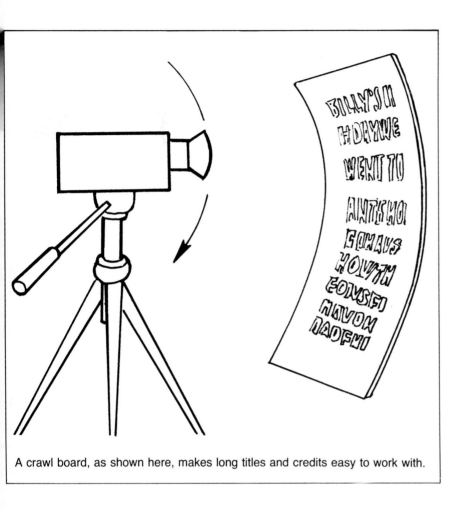

A crawl board, as shown here, makes long titles and credits easy to work with.

visual interest to your movies.

These additions are generally most effective if presented casually, in a believable setting. For example, it's much more effective to show photos lying casually, at various angles, on a table, next to a vase of flowers than to show them one after another, each carefully squared to the video frame and filling it.

VIDEO FEEDBACK EFFECTS

You can use some of the electronic effects offered by the video medium together with conventional graphics to create some striking visuals. At its best, the end result can look like professionally computer-generated graphics. See page 98.

Get some clear acetate and draw your graphics on it, or use press-on letters. Tape the acetate over the screen of your TV set. Turn on your camera and VCR and focus your lens on the TV screen with the graphics superimposed across it. What you'll see is the TV-screen graphic multiplied again and again, receding in a long tunnel into infinity.

To add to the effect, you can zoom your camera lens, tilt or pan your camera or change the camera position. You can also manipulate your color controls. You can create a sweeping hall-of-mirrors effect with multi-colored shifts and glows and a host of other kaleidescopic imagery.

The design of the graphic attached

to the acetate on your TV screen determines the flexibility of the feedback you can obtain. To get further control of the effects you're creating, adjust the TV set itself for brightness, contrast and color.

Monitor what you see in your camera viewfinder or play it back on a TV set. Make adjustments as you desire. The possibilities are almost unlimited. You can also add music with an appropriate rhythm.

SOME BASIC RULES
ON COLOR AND GRAPHICS

To be truly creative, you must be uninhibited. However, there are some basic rules and tips that will help you avoid mistakes and prevent

TAPED IMAGE

IMAGE SOURCE

VCR

This is the kind of setup you need in order to create electronic feedback effects.

you from doing things that just won't work. Here are some, for your guidance:

● Keep colored letters as large as possible. If you use colored letters against a colored background, outline the letters in black or white. Adjacent colors tend to blend, especially if the colors or tones are similar.

● Medium-tone colors reproduce best. Light colors and light gray tend to reproduce as white. Dark colors, such as maroon and purple, tend to reproduce as black. White, off-white and pale yellow are generally too bright for the video system and tend to *bloom*—or have halation around them.

● Either gray or a color complementary to that of the letters provides the best background. For example, red looks best with a blue-green background, yellow in front of blue and green against magenta.

● A black background makes all colors appear brighter.

● A bright, multicolored subject appears best against a uniform, neutral background such as gray or beige.

● Pure, strong, saturated color—such as deep red or deep blue—attracts attention. Pastels—such as pink or pale blue—are less obtrusive and are, therefore, well suited for backgrounds.

● "Warm" colors such as red and orange appear nearer than "cool" colors like blue and blue-green. This can be used effectively to add a feeling of depth to your graphics.

● Red, orange, yellow and gold appear lighter on a TV set than they do directly to the eye. Green tends to look darker on the TV screen than to the eye.

● Avoid overloading a graphic with many colors. Try and limit yourself to two or three that are complementary, such as blue, red and green, or yellow and blue.

● Some colors are difficult to distinguish on the video system. For example, red-orange and magenta tend to look about the same. Blue and violet also appear with little difference between them. Avoid red-orange together with red, and violet in combination with blue. The color nuances won't reproduce well.

Sound

In your video system, image and sound are recorded simultaneously, synchronized on the same magnetic tape. Because video is regarded mainly as a visual medium, the novice moviemaker tends to become totally involved with visual matters, both technical and esthetic, and to forget about sound.

However, the sound that goes with a video movie, whether commentary, dialogue, background sounds or music, must be audible and clear. It's a critical part of a successful production.

There are times when recording good sound is more difficult than recording a good picture. For example, when your subject is 30 feet from the camera, you can shoot an excellent picture but may have problems recording his speech, even when he raises his voice. That's because the microphone built into the camera must be relatively close to the subject. To pick up sound from more than a few feet away satisfactorily, you need a special microphone.

It will be helpful to you if I explain, briefly and simply, how sound is generated and recorded.

HOW SOUND WORKS

Sound is generated by variations in air pressure. These vibrations, or *sound waves,* are produced by a source such as a person's vocal cords or a musical instrument. When the waves reach the ear, they are sensed and the sensation is translated by the brain into what we perceive as audible sound.

HOW SOUND IS RECORDED

A microphone also "senses" sound waves, translating them into electronic impulses. A microphone detects the waves with a highly sensitive *diaphragm,* similar to your own eardrum, that vibrates in response to the air-pressure variations striking it. The vibrations are turned into electrical impulses in the microphone and relayed to your VCR to be recorded on tape.

When the recording, which contains both picture and sound, is played back, it regenerates the original image and sound. The sound part is recreated by reproducing the air-pressure waves that constituted the original sound.

MICROPHONE

Sound waves become weaker as they travel farther from their source. It's important to remember this because it tells you why the built-in microphone on your camera is not ideal for all sound-recording purposes.

Most built-in mikes on home video cameras do an adequate job of picking up voices within a short distance—four to six feet at most. If the camera—and therefore the mike—is farther from the source of the sound, the quality of the recorded sound is likely to be poor. The matter is made worse by the fact that most mikes built into cameras are *omnidirectional*—they pick up sound from all directions. This means they can pick up many undesirable background noises.

To obtain the best possible recorded sound under a variety of conditions, I recommend using an auxiliary microphone. There are several different types, each suited to a particular shooting need.

An auxiliary microphone is not an integral part of the camera and can, therefore, be positioned in-

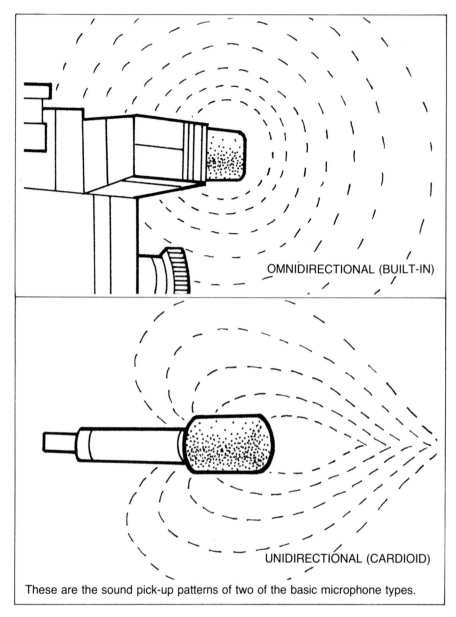

OMNIDIRECTIONAL (BUILT-IN)

UNIDIRECTIONAL (CARDIOID)

These are the sound pick-up patterns of two of the basic microphone types.

Omnidirectional Microphone— As the name implies, this type of mike has a wide, circular pick-up pattern that picks up sound fairly uniformly from all directions. Environmental sounds from air conditioning, traffic, airplanes and lawn mowers, and noises like creaks, bumps, scrapes and behind-the-camera comments can interfere with the sound coming from your subject.

This is a common type of inexpensive mike that comes built-in with most home video cameras.

Omnidirectional mikes are fine for recording the general ambient sound in the scene. However, they are not sufficiently selective for clearly recording speech coming from more than a few feet away, especially when there is considerable ambient noise.

To be clearly audible, a performer must be no more than four to six feet from a standard, built-in camera mike, and speaking toward it.

Boom Microphone—Some cameras have a boom mike, extending from a rod or boom. This lets you hold the mike away from your camera so it reaches closer to your subject. Other cameras feature a detachable mike that enables you to position it close to your subject or permits a speaking performer to hold it.

Lavalier Microphone—This is a small microphone you can hang around a speaker's neck or clip to a jacket, shirt, necktie, scarf or blouse. You can conceal it under clothing, but you must prevent it from rubbing against a garment when the performer moves because this would cause unwanted noise. Although it is omnidirectional, its proximity to the speaker enables it to transmit clear sound, giving the impression that the speaker is close to the viewer. It also permits considerable mobility for the speaker.

dependently of the camera. You plug it into the microphone jack on your camera or VCR. You can then place the microphone close to the subject, no matter where the camera is. Unless you deliberately want to show the microphone in your picture, be sure it is either outside the picture area or is hidden by some object.

When you use the camera's microphone jack, the built-in camera mike will not operate. Many top-of-the-line video cameras feature stereo capability, permitting you to record with two external mikes at the same time.

MICROPHONE TYPES

Here's a selection of microphones that will enable you to obtain optimal sound quality under a variety of conditions:

Unidirectional Microphone—This type has a narrow pickup angle and, basically, "hears" only what you want it to hear. Most high-quality handheld, stand or public-address mikes are unidirectional. The sound-recording quality produced is excellent. This mike is able to eliminate most of the distracting extraneous sounds that can interfere in a shooting environment.

Some video-camera manufacturers offer highly directional auxiliary mikes of good quality. These mikes pick up sound mainly from the direction in which they are aimed.

Cardioid Microphone—This is a compromise between the omnidirectional and unidirectional microphones. It has a heart-shaped response pattern that enables it to pick up sound very well from directly in front and moderately well from either side, but hardly at all from the rear.

Shotgun Microphone—Known also as a *super-cardioid* microphone, this type has an extremely narrow angle of pick-up and will pick up sound selectively and well from considerable distances. It makes a speaker or performer seem close to the viewer and listener, even when the mike is 30 or 50 feet away from him.

The best shotgun mikes are quite expensive. However, there are good ones available at moderate prices. Consult your local video dealer for a practical buy or a rental arrangement.

MICROPHONE ACCESSORIES

Following are some audio accessories you'll need for efficient and convenient use of auxiliary microphones:

Extensions—To connect your microphone to the camera or VCR and yet place it close to the speaker, you'll need extension cables, connectors and adapters. For best sound quality with your video equipment

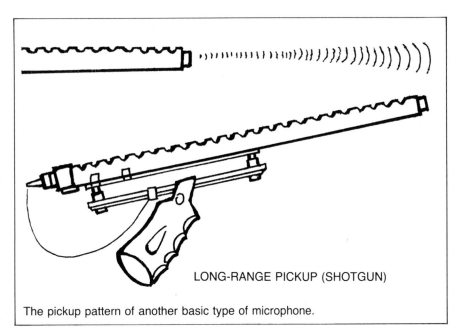

LONG-RANGE PICKUP (SHOTGUN)

The pickup pattern of another basic type of microphone.

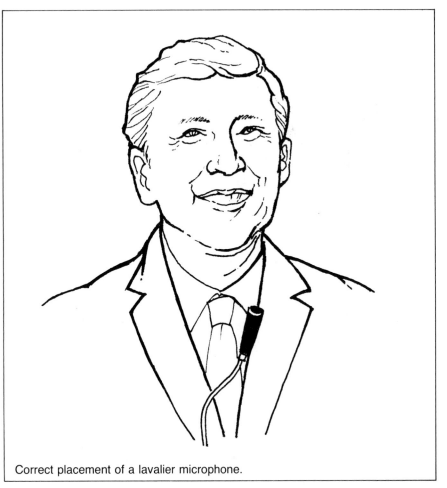

Correct placement of a lavalier microphone.

and to avoid damaging the equipment, it's essential that you get plugs of the correct size and configuration and cables that are compatible with the electrical outputs they'll carry. Get details from your video dealer, specifying the type of camera, VCR and microphone you have. Remember that connector sizes differ with the various formats—Beta, VHS and 8mm.

Wind Screen—If you're recording outdoors, especially on a windy day, a wind screen is essential. This is a foam-rubber cap that fits over the microphone. It protects the sensitive components of the mike from being affected by the direct wind, thus keeping wind noise to a minimum. In an emergency, a heavy sock, pulled over the mike, will do the same job.

Boom—When you don't want to have a microphone stand visible in a shot or don't want to pass a microphone among several people, a microphone boom is the answer. Basically, a boom is a long handle with a microphone attached to one end.

A careful assistant can hold a mike just above a performer's head but outside the picture area. You can get sound of good quality without seeing the mike. The boom microphone can be moved from speaker to speaker.

A boom isn't difficult to make. All you need is a broomstick or a long pole and a few extension and attachment accessories, available from radio stores or sound-supply outlets. It's important to attach the microphone in such a way that no vibrations or other noises are generated—and recorded—when the boom is moved about.

Microphone Stand—If you plan to shoot one or several speakers or performers on a stage or dais from a distance, you'll need microphone stands. They are available from radio and sound-equipment stores and video-supply stores, and come in floor or desk models.

Headset—When you use a TV set to monitor your pictures as you shoot, you must turn the sound on the TV all the way down while you're recording to avoid feedback squeal. The only way to monitor sound as you record is with a good headset or an earplug. These accessories are available from radio and TV outlets. Typically, headsets for miniature cassette recorders work fine with video cameras.

AUDIO MIXER

There may be times when you have several performers, each requiring his own mike, at a considerable distance from your camera. A typical example would be a panel discussion on a stage in an auditorium. To obtain good sound, you'll need to use matched microphones and blend their input with an audio mixer. Mixers are expensive to buy but can be rented at a reasonable cost from sound-equipment houses.

AUDIO-LEVEL CONTROL

Most VCRs and video cameras automatically regulate sound volume to give you a consistent level on your videotape. This is called *automatic gain control (AGC)* or *automatic volume control (AVC)*. If incoming sound gets too loud, the control automatically lowers it. If the level is too low, the volume sensor raises it.

Automatic gain control acts like a built-in sound engineer, ensuring uniform volume on your recorded audio track. It does this whether you're using your camera's built-in mike, an external mike or two auxiliary mikes plugged into your stereo jacks.

When recording sound, you should be aware that your camera's sound system is constantly adjusting to make audible the slightest noise occurring in and around the recording area. When your performers aren't

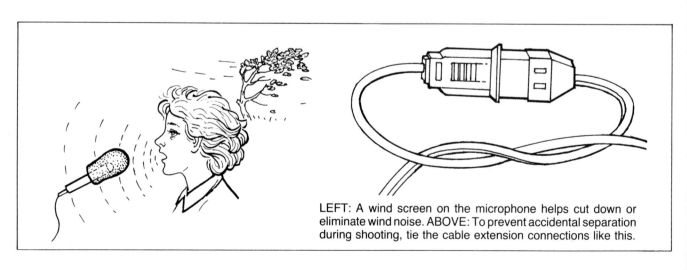

LEFT: A wind screen on the microphone helps cut down or eliminate wind noise. ABOVE: To prevent accidental separation during shooting, tie the cable extension connections like this.

speaking and there are no specific sounds generated by action in your scene, the automatic gain control increases all the background noises it can detect. Therefore, you must work as silently as possible behind and around the camera to avoid irritating and distracting noise intrusions into your recorded sound.

PRACTICAL APPLICATION

Here, I'll describe some typical shooting situations you'll encounter and give you some advice about when and how to use the microphones I've just discussed.

Single Performer—You have in front of your camera one individual, seated or standing, talking to the camera. He may be demonstrating a craft or hobby. You need minimal camera mobility to get your shots.

As long as you're no more than about six feet from the subject, the camera's mike will do a satisfactory job. However, a handheld auxiliary mike or a lavalier—concealed or visible, according to choice—is better. It lets you frame your shot from farther away, using a longer focal-length setting on your zoom lens. This generally makes for a more comfortable shooting environment and often yields a better-looking shot.

You may want to have a two-way conversation with your subject while shooting. Your camera mike will do an adequate job as long as you're shooting close to your subject, so you're both about the same distance from the mike. Two auxiliary mikes are better. However, with two mikes you'll also need an audio mixer unless your camera is equipped for stereo pickup.

Two Performers—You're shooting a dialogue between two people, perhaps one interviewing the other. They can be seated, standing or

For a single performer close to the camera, you can use the built-in camera mike for good sound.

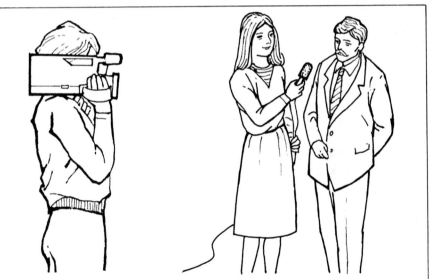
With two on-camera performers, it's often better to use an auxiliary mike for optimum reproduction of each individual speaker's voice.

strolling slowly. The essentials of the conversation should be planned although it will probably not be scripted. You may have some specific camera-movement requirements, but they will be minimal.

Here, too, the camera mike will suffice only if you're close to your subjects. You'll get better sound us-ing a handheld auxiliary mike. An omnidirectional type is OK if it's held close to the speakers' mouths. A cardioid type is more suitable. If you prefer not to have the microphone in the picture, use an overhead boom mike, held by an assistant.

The best choice would be a lavalier mike on each subject. However, un-

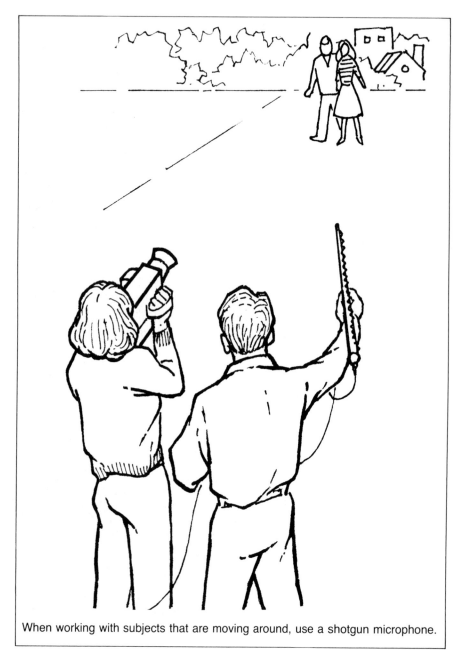

When working with subjects that are moving around, use a shotgun microphone.

less you have stereo capability you'll need a mixer to blend the two sources.

Active Group—A typical example would be kids or teenagers at a party or sporting event. You need maximum camera mobility to cover the action. There's no special dialogue to be recorded.

If you're shooting indoors, your camera's built-in mike is probably adequate. It will pick up general ambient sound from the group.

To pick up clearly audible exchanges between individuals, I recommend an auxiliary shotgun mike. This is especially true outdoors, where the camera's built-in mike will not pick up specific sounds well.

The shotgun mike will hamper your mobility somewhat because an assistant will have to tag along with you to aim it. An alternative is to attach the shotgun mike to the camera so it is automatically aimed in the same direction as the lens. Be careful not to include the mike in the picture area.

Static Group—This includes children or adults seated at games, conversations or other activities not requiring subject mobility. Some camera mobility is needed for shot and angle variations but not to cover unpredictable, random action. There's no planned dialogue but you want to capture spontaneous verbal interchanges.

The camera's mike will be adequate only if it can be positioned close to the group and at about the same distance from each speaker. If such a close camera viewpoint is likely to inhibit your performers, I suggest you use a shotgun auxiliary mike and move your camera farther away.

Another alternative is to use a cardioid microphone on a fixed overhead boom. If the room contains lots of soft furnishings and other objects

that deaden sound reflections, you can even use an omnidirectional mike on an overhead boom.

If you're shooting in a large room or hall, echoes from walls or ceilings can cause problems with an omnidirectional microphone. In such an environment, use a cardioid mike very close to your group, or else a shotgun mike. Otherwise, your recorded sound will have a distinct and undesirable "booming" quality.

Distant Stationary Subjects—If you plan to shoot a platform speaker, lecturer, a panel discussion group or musical performers before an audience, you'll need cardioid-type microphones with floor or table stands and long extension cables. When there are several participants, for best sound you'll need a separate mike for each performer. You must then combine the sound with a mixer system. You'll also need an assistant to operate volume controls for the microphones.

If you have two subjects and your camera has stereo capability, you can easily provide a separate mike for each performer. A shotgun mike is an alternative, although it won't give the same excellent results.

When you have four subjects, try and have them seated in such a way that two can share a microphone. The automatic balance system in your camera will maintain proper sound levels for the two microphones.

Distant Active Subjects—If you used your camera's built-in mike from the audience seating area during a stage performance, you'll get very poor sound with lots of unwanted audience noise.

You'll get best results if you can suspend one or two cardioid mikes near the center of the stage and a little forward toward the audience. You'll need permission, and probably some help from the theater's technical or

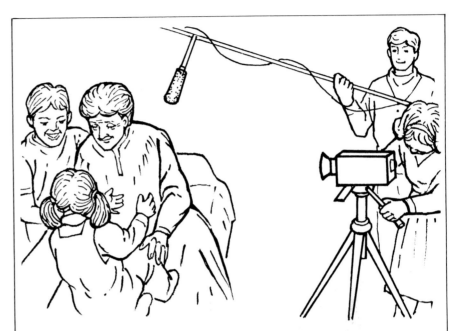

For a group that stays in one location, a cardioid microphone attached to a boom is appropriate.

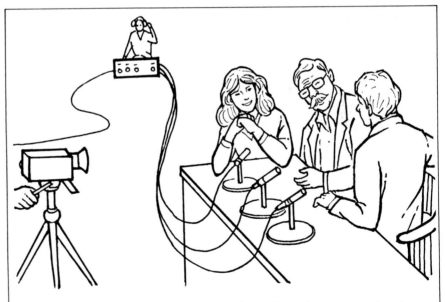

A sophisticated sound recording system for a discussion group, using three microphones and an audio mixer.

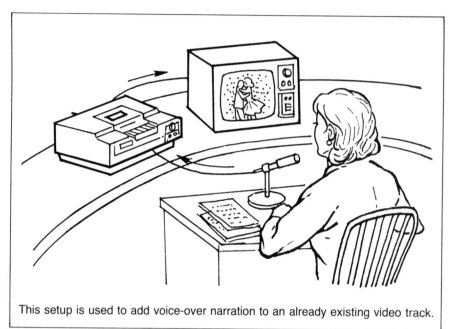

This setup is used to add voice-over narration to an already existing video track.

sound-amplification crew, to do it. The next-best alternative is to use a shotgun mike, aimed toward the source of sound.

A stereo-equipped camera enables you to use two shotgun microphones. You'll probably need two assistants to aim them. Have one assistant cover the left side of the stage and the other the right side. That way, you'll achieve good stereo reproduction for your movie.

You may also use fixed-position shotgun mikes on floor stands in front of the audience or cardioid mikes on desk stands at the footlights on either side of the stage. However, you may experience some "dead spots" outside the pickup areas of the mikes. When a performer enters one of these spots, you'll lose most or all of the sound coming from there.

To be sure of satisfactory sound coverage of the stage, make some tests before the actual performance you're going to shoot.

Musical Performance—When you have two performers, such as a vocalist with instrumental accompaniment, you need two microphones— preferably the cardioid type—for best results. Set up one microphone for the soloist and the other for the accompanist. If your camera doesn't have stereo capability, you'll need an audio mixer.

If a performer is accompanying himself, such as a singer with a guitar, you should still use two microphones—one for the voice and the other for the instrument. A single mike will not provide a completely satisfying balance.

If sound echoes are likely to be a problem in the performance room or hall, avoid omnidirectional microphones. It's worth pointing out, however, that a *little* reverberation can actually be advantageous to a sound recording. It reproduces sound authentically, as you actually hear it. So, if the surroundings are too "dead"

or unreflective of sound, by all means use two omnidirectional mikes, placing one close to the vocalist and the other close to the instrument.

If you're in doubt about how to get the best sound, make some tests before the actual performance, using various mikes and mike positions.

Large musical groups such as bands, orchestras and choruses are best covered using one or two overhead cardioids, located well out in front of the group. When a group is in a relatively confined area, a built-in camera mike may be adequate.

ADDING SOUND LATER

All the sound in your video movies need not be recorded at the time you're shooting. You can add narration, verbal description, music and sound effects at a later time. The *audio dub* feature on your VCR enables you to add sound without affecting the picture. As you add the new sound, the original sound is automatically erased.

Narration—If you want to add "voice over" narration to portions of your movie, it's best to write a brief script. That way, you can tailor the length of the narration to fit the video, and you won't hesitate when you do the narration.

When a microphone is close to the speaker, as in voice-over narration or intimate dialogue, the letter P may produce a popping sound in the recording. To avoid it, the speaker should talk across the mike at an angle rather than directly into it.

Music—When adding music, select a piece that, from your viewpoint, "fits" the mood or character of the scene. Then, play the music a few times while watching the video on your TV screen. That way you can best determine exactly where the music should lie in relation to the video, and how long the piece needs to be.

Sound Effects—A wide variety of sound-effect recordings are available from record and audio stores. With a little ingenuity, you can also make your own.

General sound effects, such as traffic noise or bird calls, can be added to a movie with relatively little precision. However, specific noises, such as thunder to accompany "lightning" you have shot in your movie, must be placed more carefully to be believable.

General Procedure—When you've rehearsed the narration, music or sound effect while watching the video on your TV screen, follow this procedure:

Connect an auxiliary microphone to the VCR through the microphone input. If you're using the camera's built-in mike, simply connect the camera to the VCR.

Pause your tape at the point where you want to begin recording new sound. Set up your music or your recorded sound effect at the point you want it to start. Or, prepare to record your narration. Turn down the volume on your TV set.

Push the AUDIO DUB control on your VCR. Release the PAUSE control and start talking into the microphone or playing the music or sound effect. When you've finished, stop or pause the VCR immediately.

Play back your tape to see if the new recording was successful. If you're not satisfied, repeat the process until you are. Be careful not to push the RECORD control, as this will erase both your original picture and sound.

Sound-On-Sound—Some VCRs offer you *sound-on-sound* capability. It is similar to audio dub except that you can add new sound *without erasing* the original audio recorded when you shot your movie. Sound-on-sound lets you mix new sounds with

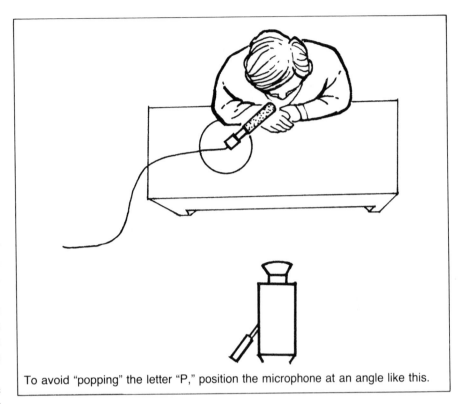

To avoid "popping" the letter "P," position the microphone at an angle like this.

existing sounds on your videotape. The basic procedure is the same as for audio dubbing.

EXPERIMENT

Effective and successful sound recording requires planning, just as shooting does. In preparation, don't be afraid to experiment with mikes to find the right one for a particular situation. Try a variety of microphones that are readily available, and make sound tests under the conditions in which you're going to shoot. If the sound is weak and indistinct, try another mike. When a mike gives you good and clear sound, with strong volume, use that one.

Take full advantage of your video system's capability to record clear conversation and narration, to capture the many sounds in your environment, and to combine pleasurable music with your pictures. Good sound, creatively used, can give your video movies professional polish that will impress your viewers.

10 Editing

The procedure of arranging videotape shots so they appear in a desired sequence is called *editing*.

Motion-picture film is edited physically by cutting and splicing. Videotape is edited by electronic means. Don't try cutting and splicing videotape. Cutting tape will render a videocassette useless. Pulling a section of tape from its cassette may damage the tape permanently. The only way to use videotape is by means of the controls on your VCR or camera.

TWO METHODS

There are two ways of editing video movies. The simpler method, requiring no additional equipment, is called *in-camera editing*. It involves shooting a movie in the order in which you want to show it.

Much more complex editing is possible with the use of two VCRs. *Two-VCR editing* enables you to move shots about after you have recorded them with the camera. It also permits you to eliminate or replace undesirable shots.

If you're prepared to invest in two VCRs, you can record the shots that constitute a movie in any order. At the editing stage, you can rearrange, eliminate, add or make any other change you want.

You can change picture and sound together or you can change just the picture or just the sound.

One of the VCRs used in editing is the *playback* machine. It plays the shots you wish to assemble on the second VCR, which is the *recording* machine. The second VCR records the shots in the desired order to make your edited master tape—the finished movie.

For very precise edits, such as synchronizing the gestures of a dancer from one shot to the next, a computerized accessory editing controller is needed. It enables you to select the exact frame at which you want to leave one shot and the exact frame that is to begin the next shot.

When you're going to do two-VCR editing, you can record each shot as many times as you like, to get it right. Select the best shots and electronically edit them together to achieve the desired sequences for your movie.

Two-VCR editing is relatively costly in equipment and can be time consuming. However, it can be very rewarding. With a little skill, you can produce a truly professional-looking movie. It is discussed in more detail later in this chapter.

Many video-camera owners don't want to invest the money or time demanded for the editing just described. The alternative is to carefully plan what you're going to shoot and the order in which you want to show your shots. You then shoot the movie accordingly, *editing in-camera* as you proceed.

For example, you may have planned a movie that is to open with a long shot to establish the setting for your theme. Next, you require a medium shot of three performers to set up their relationship to each other. After that, you want a close-up of one performer who is the main character in the movie. If you record the shots in this desired sequence, you are editing in-camera. You are taping the shots in the sequence in which you want to show them to the viewers in your finished movie.

Often it is necessary, and much more convenient, to record shots in an order that does not correspond to the final order in the movie. The final order can then only be achieved by two-VCR editing.

Because in-camera editing involves shooting the movie as you want to show it, you can only make each shot once and you must get it right the first time. With two-VCR editing, you can make each shot as many times as you want. It's easy to select the best version and place it in

the movie, ignoring all the other versions.

If, at some later date, you want to replace a shot in your final movie with one of the alternates you recorded originally with your camera, you can insert it from the original tape.

There is some difference in the appearance of your picture sequences between in-camera and two-VCR editing. Two-VCR editing enables you to produce very smooth and precisely continued action from shot to shot. In-camera editing requires certain adjustments and compromises in shooting style. However, the fundamental principles of logical picture continuity are the same for either method.

Because *every* video-camera user can edit in-camera, I'll discuss that method first.

IN-CAMERA EDITING

If you're not going to use two-VCR editing to rearrange your shots *after* taping, you must do all your editing *as you shoot*. The key to successful in-camera editing is *planning*. You must know the content of each shot and the sequence of your shots *before* you shoot.

Be sure your subjects know what to do and say. Know the distance and angle of each shot. Record your shots in the correct order.

Shooting in a manner that presents your shots with meaningful continuity is only one aspect of good in-camera editing. Another consideration is of a more technical nature and involves the smooth transition between shots. If you use the wrong technique, *glitches*, or undesirable picture breakups or distortions, can result.

Avoiding Glitches—The following recommendations, which are applicable to most video cameras, should

help you avoid glitches. If you have any doubt about procedure for your system, check your equipment's manual or consult a video dealer.

When you're ready to begin shooting, set your VCR or camcorder to *Record*. This will position the tape in recording position on the drum head. Actual recording will not occur, however, until you press the *Record* button or trigger on your camera.

To avoid glitches, use the *Pause* setting rather than the *Stop* setting between shots unless your camera automatically goes to the Pause mode when you stop shooting.

I recommend that you begin each sequence with a fade-in and end it with a fade-out, using the *Fade* button or the manual iris control.

To start a shot, cue your performers to begin action, press the *Record* button or trigger on your camera, and open the iris with the *Fade* button or manual control.

When the shot is complete, again press the camera's *Record* button or trigger to stop recording. Your VCR or camcorder will go to the *Pause* setting. The tape will stop but remain in recording position around the drum head, which continues to revolve.

The tape is now ready to record again, starting at the exact point where it was stopped by the *Pause* control. When the *Pause* control is released to begin the next shot, a clean transition—or edit—will result.

Depending on the model of VCR or camcorder you have, it may not remain in the *Pause* setting more than three to five minutes. Then, it will automatically switch to *Stop*. This prevents physical damage to the tape from excessively long contact with the spinning drumhead. It also prevents undue battery drainage.

To obtain a clean edit, it is impor-

tant to begin taping again from the *Pause* setting. Remember, you have only a few minutes for preparation between shots in a continuous sequence.

When the next shot is framed and ready, cue your subjects for action and press the camera's *Record* button or trigger to release the *Pause* setting and begin taping again.

When you reach the end of the final shot in a sequence, press the *Fade* button or close the iris manually and let the tape run for a few additional seconds. Finally, press the *Stop* control on your VCR.

Effective in-camera editing is really the same as good camera technique. To help you be a better in-camera editor—as well as camera operator—I'll give you some advice on how to get smooth picture progressions and good visual continuity in your movies. I'll show you some shooting methods for in-camera editing and some basic principles of true editing that you can use to good effect no matter which editing method you use.

THE EXTENDED SHOT

To avoid the stop-and-start problems you must contend with in a sequence of separate shots, you can vary camera angle and subject cropping while keeping the camera running. This gives you apparently different shots within what is actually one extended shot.

Zoom and Pan—The simplest method is to zoom slowly from wide shot to medium shot and close-up, panning the camera as the action moves through the scene. For the smoothest possible camera movement, have your camera on a tripod with a pan-and-tilt head.

Dollying and Trucking—You can change your camera position relative to the subject and the amount of the

scene included in the picture by dollying or trucking. All movements should be smooth and slow.

Shooting with Handheld Camera—If you can hold your camera steady and move about without jerks, you can walk with the camera while taping. As with zooming, panning and dollying, be sure to inform your performers of what to expect and what you expect of them at each point throughout the shooting.

If you make a single extended shot with thought and imagination, it can achieve the same result as a series of separate shots.

Before you make an extended shot, carefully examine the environment in which you'll be shooting. Be sure you can move as far away from and as close to your subjects as you want. Be mindful of the location of furniture and other obstructions so you don't unexpectedly bump into one of them. Rehearse the entire shot, at least in your mind, before you let the camera run.

While you're shooting, listen to dialogue or conversation as well as watching the action. Don't stop recording in the middle of an interesting comment or verbal exchange just because you're satisfied with the visual content of the shot. Let the sound part of the shot reach its conclusion, too.

Be sure you record visual images of objects being discussed or described by your performers. Your viewers want to be part of the action, so show them what your subjects see.

During the making of an extended shot, when camera and subject may be in constant motion, it's helpful to keep both eyes open while you shoot. The wider view—beyond the borders of the viewfinder—enables you to better anticipate developments in the action. Shooting with both eyes open may seem a little awkward at

1

2

3

4

If an extended shot is used creatively, it can contain all the different shots that would be obtained by complex editing. In this handheld move, as seen through a window from inside (1 and 2), the camera captures a medium shot of a woman approaching and entering the house; a medium long shot of her coming through the door into the house (3); a close-up as she moves up to and past the camera (4, 5 and 6). Next is a long shot of kids in the living room beyond, as the camera pans, following the woman (7); and a tight zoom shot of the group as they greet each other (8).

first. However, it's well worth the patience to get used to it because it greatly improves your shooting control.

SEPARATE SHOTS

If you prefer using separate shots to build your movie, the basic principles of editing become important. Your shots are like the pieces in a jigsaw puzzle—each must have its own character and all must fit together properly.

Subject Size and Camera Angle— The size of the main subjects should vary from shot to shot. The difference between a long shot, a medium shot and a close-up should be distinct. Don't make distance or subject-size changes that are barely noticeable.

The camera angle should also differ noticeably from one shot to the next. However, avoid changing the camera viewpoint so drastically as to confuse the movie viewers. Never reverse your viewpoint of the subject without providing adequate visual information regarding what you've done.

Of course, you will sometimes want to make a shot that's very similar to one you had made earlier, but don't do it in consecutive shots.

Continuity of Action— Keep the action moving from shot to shot in a clear, logical manner. In a continuous sequence of action, your subject should not be doing totally different things in consecutive shots. Be sure viewers can understand what's going on, even though they see only selected parts of the activity.

Long shot, medium shot and close-up need not necessarily always follow in that order. Consider carefully which order is most effective in each specific case and direct your performers accordingly.

Not all subjects give you the same

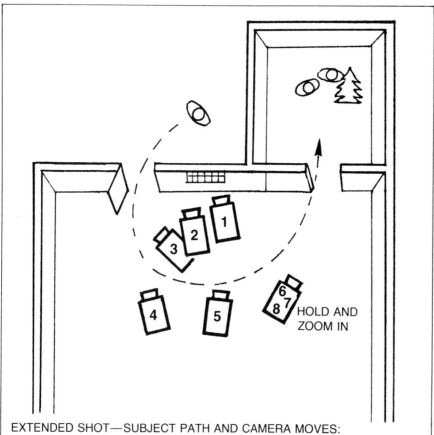

EXTENDED SHOT—SUBJECT PATH AND CAMERA MOVES:
This is the path of camera and subject positions for the extended shot sequence shown in the illustrations on pages 110 and 111.

For example, if you're at a football game, you know that the teams change sides at half time. However, if you watch a game on your TV screen and you suddenly see a member of your favorite team running toward his own end zone, you could be excused for feeling confused. Somehow, you need a visual message that the teams have changed sides. That message can be provided with a few shots of half-time activities.

Speed of Movement—Keep the pace of your subjects' movements consistent. For example, if a person is running in one shot and the next shot shows a continuation of the same basic action, don't suddenly show the subject walking in a leisurely manner. If you cut to a close-up of running feet, be sure they are running at the same pace depicted in a preceding full-length shot.

Continuity of Subject Position—Smooth continuity is also dependent on the proper placement of your subjects in the frame. For example, if one performer is on the left side and another on the right in one shot, maintain the same positions in the next shot. If you must change subject positions, follow the rule I've mentioned a couple of times before: Provide some visual clue regarding the position change.

When you're taping two people talking with each other but are showing only one person at a time in the frame, be sure not to change the direction in which each faces. For example, a girl may be facing to the right and a boy to the left. The viewer understands that they are conversing, even if they're not on the screen together. If you suddenly have the girl facing left and the boy to the right, the viewer may get the impression that they are now standing back to back.

amount of control over continuity. For example, when you're shooting children at play you rarely know what's coming next. You have to select long, medium and close-up shots on the spur of the moment for what you believe will give the best total movie of the event. A pre-planned and scripted movie, however, gives you total control of continuity.

To maintain smooth continuity, your performers' actions should have a logical flow from shot to shot. Match the action at the end of one shot with that at the beginning of the next. If the action changes drastically, be sure to provide visual information—perhaps in an addi-

tional shot—indicating what's happening.

Direction of Movement—Don't confuse the viewers of your movie by abruptly changing the direction of movement of your subjects. When a subject leaves the right side of the frame, have him enter the next shot from the left. Maintaining this left-to-right movement avoids confusing the audience. If a performer is to change direction of movement, show that change.

Remember, the viewer sees only what's on the screen, not the entire scene as you experienced it. If the direction of motion changes, be sure you clarify pictorially how it happened.

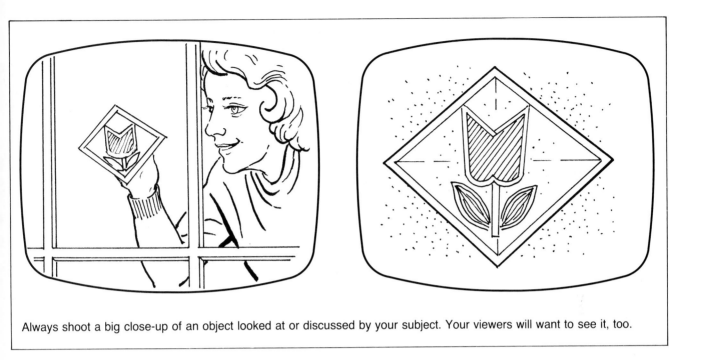

Always shoot a big close-up of an object looked at or discussed by your subject. Your viewers will want to see it, too.

Continuity of Appearance—The shots in a movie may convey a continuous, unbroken activity. However, the actual shooting may have taken place on different days. To maintain credibility, it's important to pay careful detail to continuity of appearance. Your performers must be wearing the same clothing and have the same hairstyle in each shot. Be sure that accessories carried by your performers are also identical.

You must also be sure that the location has accurate continuity. If a woman was sitting in a pink chair for the first shot, she should not be shown in a blue chair in exactly the same location in the second shot—even though one shot may have been made on Tuesday and the other on Friday.

To ensure accurate continuity, I advise you to keep a checklist of all details relating to the subjects and the setting. Keep a record of clothing worn, hairstyles, makeup, accessories and props.

Continuity of Lighting—Inconsistency in lighting can be just as disturbing as an abrupt change from a dress to a pair of jeans. Indoors, it's relatively easy to repeat a lighting setup. Outdoors, try to shoot at the same time of day, with the sunlight coming from the same direction, in each shot. Compromises will often be necessary—but make every effort to maintain the smoothest possible continuity.

Shot Duration—The average shot should run from 5 to 15 seconds. If you make your shots too short, the movie will appear jerky and the viewer will not get much information or enjoyment from it. If your shots are too long, the movie can easily become boring.

TRANSITION SHOTS

A dissolve from one scene to the next indicates a transition—a change of time and place. However, to make a dissolve, where one image gradual-ly disappears as the next emerges, you would need three VCRs, an auxiliary editing controller and an electronic device called an "effects board."

Swish Pan—An alternative transition shot that can be achieved by any video-camera user is the *swish pan*, described in Chapter 3. A swish pan is effective in imparting to a scene a feeling of speed or drama.

Pan the camera rapidly in a horizontal direction to create a totally blurred image. Begin the following scene by first backing up the last few seconds of tape you've recorded in your VCR or camcorder. Taping of the next shot will then begin about the middle of the blur. Start the new shot with another swish pan, moving the camera in the same direction as during the first pan.

The pan should end with the desired framing of your subject in the new shot. It may take a few practice pans to learn to stop precisely on the right framing.

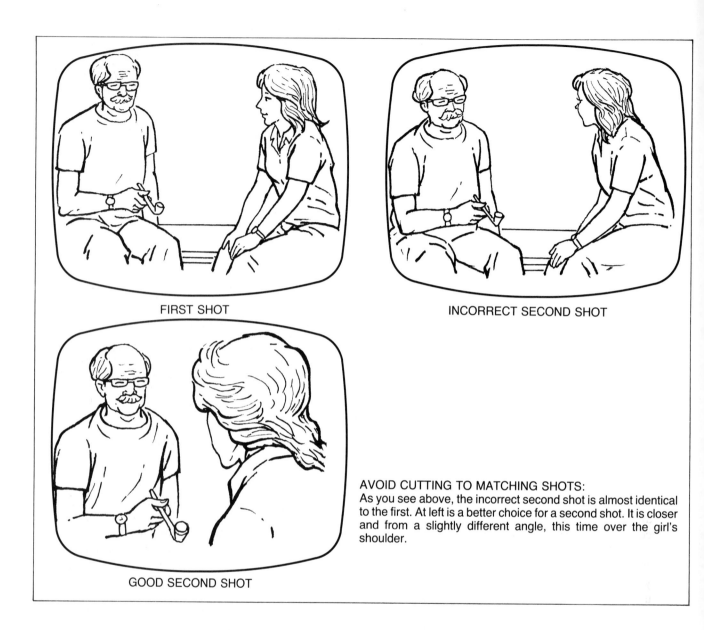

FIRST SHOT

INCORRECT SECOND SHOT

GOOD SECOND SHOT

AVOID CUTTING TO MATCHING SHOTS:
As you see above, the incorrect second shot is almost identical to the first. At left is a better choice for a second shot. It is closer and from a slightly different angle, this time over the girl's shoulder.

Focus In—Focus Out—This provides another effective transitional device between shots. Using the manual focus control, bring your shot completely out of focus. Press the *Record* button on your camera and, after a couple of seconds, signal your subjects to begin the action. Bring the image smoothly into focus. At the conclusion of the last shot in the sequence, bring your picture again completely out of focus and then stop

recording. Some cameras even have an automatic control to achieve this effect.

You must be careful not to begin the defocusing until the important part of the action is complete. However, your performers should continue with the action, and not "freeze," until the defocusing is complete. Your performers should also begin movement for the following shot as you begin to bring sharp focus

back. However, the significant action of the shot should not commence until the scene is in sharp focus.

To achieve the correct timing, it's important to instruct your performers about what you're going to do, and to give effective cues at the right moments.

Focus Shift—This is another technique for achieving a scene opening or closing or a shot-to-shot transition. For example, let's assume that you

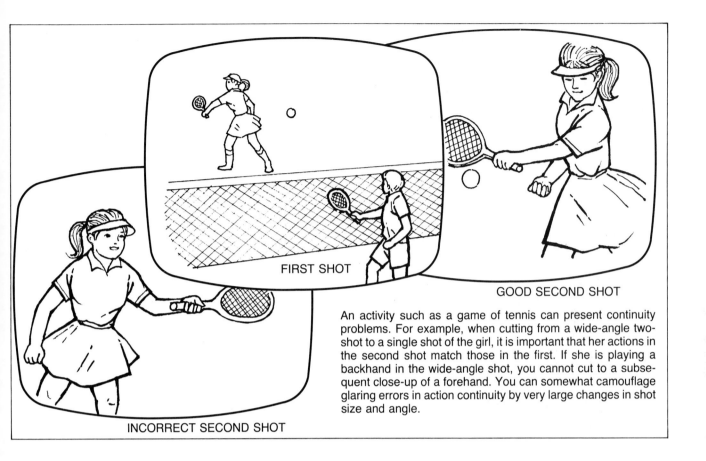

FIRST SHOT

GOOD SECOND SHOT

An activity such as a game of tennis can present continuity problems. For example, when cutting from a wide-angle two-shot to a single shot of the girl, it is important that her actions in the second shot match those in the first. If she is playing a backhand in the wide-angle shot, you cannot cut to a subsequent close-up of a forehand. You can somewhat camouflage glaring errors in action continuity by very large changes in shot size and angle.

INCORRECT SECOND SHOT

wish to associate a rose with a girl for whom the flower has a particular significance. Rather than employing cuts between the two, you can associate the rose and the girl in the following way:

Set up the rose in a tight foreground shot close to your camera. Position the girl six to eight feet behind the rose and slightly to the side of it. Focus on the rose. The girl will be totally out of focus and invisible beyond the rose. After taping a few seconds of the rose, shift focus smoothly to the girl. The rose will disappear and the girl will come into view.

Continue to tape the girl's action. For example, you may have her move to the rose, lift it from its vase and sniff it.

Cut-In—This is a transition from a medium to a close-up shot to show detail in an object that is visible in the main action of a sequence. The purpose is to convey important information in close-up.

For example, you may be shooting a cooking demonstration. You open with a medium shot of your performer as she sets out ingredients. She shows a measuring cup containing one of them. Your next shot is a *cut-in*—a tight close-up of the measuring cup containing the ingredient.

As the demonstrator adds the ingredient to a mixing bowl, you cut to a medium shot again. You would continue to use cut-ins to show detail as the demonstration progressed. Always be sure to match action in a cut-in with the action in the previous

general view to obtain a smooth flow of activity. For example, if the performer's hand picks up a knife to slice an onion in the medium shot, continue that action in the cut-in at the point where it left off in the previous shot.

Cut-Away—This is a convenient device for indicating the passage of time in a movie. For example, you may have taped the preparation of a chocolate cake. The cake has just been put in the oven. The next thing you want to show is the finished cake coming from the oven. Somehow, you have to indicate to the viewers the passage of time between the two shots.

Cut away to a shot that has some connection with the main shooting environment but isn't immediately

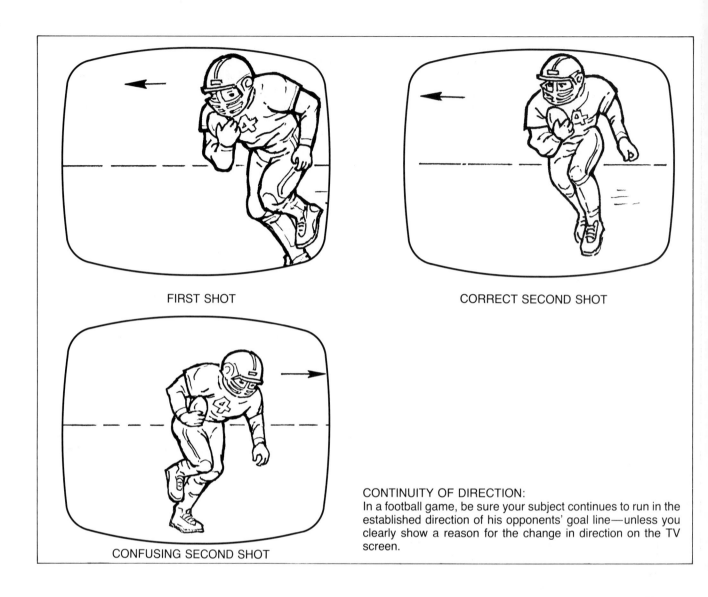

FIRST SHOT

CORRECT SECOND SHOT

CONFUSING SECOND SHOT

CONTINUITY OF DIRECTION:
In a football game, be sure your subject continues to run in the established direction of his opponents' goal line—unless you clearly show a reason for the change in direction on the TV screen.

related to the action. For example, record seven or eight seconds of a bird pecking seeds on a feeder or a squirrel nibbling nuts on a branch outside the kitchen window. Then cut back to the main subject—the finished cake emerging from the oven. This way, you can avoid an abrupt jump from preparation to finished product.

PERFORMER ADDRESSING CAMERA

Sometimes the "action" of a movie involves nothing more than a speaker addressing the viewing audience. It's similar to a newsreader on TV. Even in an apparently simple situation such as this, you can use special techniques to add a professional touch. Don't make the mistake of shooting

the whole event as one long shot. Vary your distance and camera angle, just as with any other movie.

Before you begin shooting, direct your performer not to look at the camera. Have him look down and ahead, or to one side. As you start the shot, cue the performer to turn to the camera and begin to speak. This avoids a glassy stare at the camera

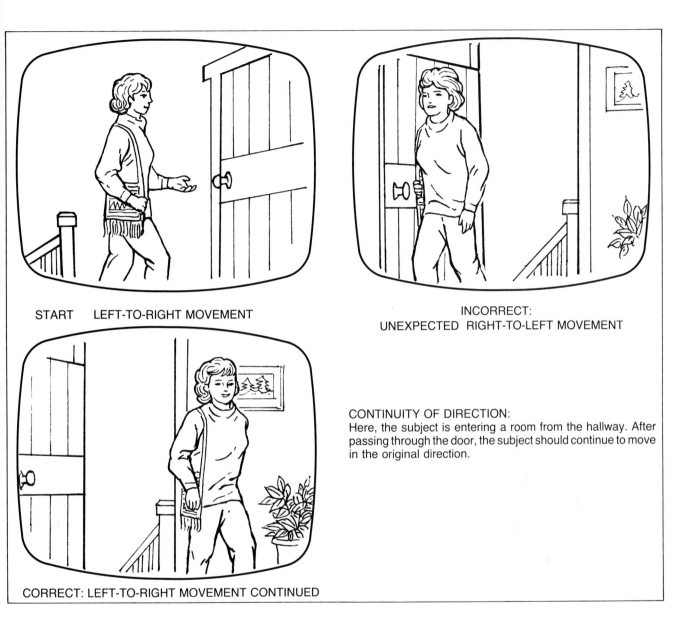

START LEFT-TO-RIGHT MOVEMENT

INCORRECT:
UNEXPECTED RIGHT-TO-LEFT MOVEMENT

CONTINUITY OF DIRECTION:
Here, the subject is entering a room from the hallway. After passing through the door, the subject should continue to move in the original direction.

CORRECT: LEFT-TO-RIGHT MOVEMENT CONTINUED

while the performer waits for the signal to commence.

When you change to a new shot from a different camera position, direct the performer to face in the same direction he was facing at the end of the previous shot. This means the performer is not looking at the camera as the new shot begins.

Direct your performer to turn toward the new camera position and resume speaking as you release the camera from the *Pause* setting by pressing the camera *Record* button or trigger. You'll have to cue your performer with a prearranged hand signal because a voice command would be picked up on the sound track of the tape. A few minutes of rehearsal for this action is advisable before be-

ginning to tape the sequence.

Repeat this procedure, changing camera angle and subject distance for each shot. This technique provides good visual variety, making the viewer feel that he is spoken to directly.

As you become more expert at directing and taping this kind of activity, have your subject begin a turn

| FIRST SHOT | CORRECT SECOND SHOT |

away from camera toward the new angle *just before* the end of a shot. Stop recording in the middle of the turn by setting your camera on *Pause*. Set up your new camera position. Begin the new shot with the performer repeating the turn from the previous position to the new one, starting to record again in the middle of the turn.

When you view the resulting edit, you'll see the appearance of a continuous turn from the first shot to the second. This is called an *action cut*. It can be very effective and isn't difficult to achieve.

TWO-VCR EDITING

One great advantage of two-VCR editing is that you can tape your shots in an order that is most expedient, regardless of the required shot order in the finished movie. For example, you can tape all shots calling for a specific lighting setup together. Later, you can edit them into the movie wherever they belong.

If a movie demands shots of a scene 60 miles from your home near the beginning of the movie and then

| FIRST SHOT | INCORRECT SECOND SHOT |

INCORRECT SECOND SHOT

CONTINUITY OF DIRECTION:
Here you have a subject moving from right to left in a room. Unless you have a specific reason for her changing direction in your next shot—and handle it correctly—be sure to have her continue her movement as the viewer would normally expect it to occur.

again near the end, you needn't make the trip twice. Simply shoot everything you require at that location at one time. By electronic editing, you can easily place the scenes where they belong in the movie.

You can tape each shot for a movie as often as you like. You can vary the lighting or shooting angle a little for each and can direct your performers

to change the action a little, too. At the editing stage, you can choose the best shots for insertion in the movie. **Scope for Creativity**—As you can see, two-VCR editing can be a fascinating and highly creative endeavor. By imaginative positioning of shots, you can create exactly the effect you want to convey to your viewers, no matter in what order your

shots were originally made or the context in which the original action occurred.

For example, your finished movie may start with a shot of your aunt at the beach. She's wearing an attractive bathing suit and waving and smiling coyly at the camera. The next shot shows a handsome lifeguard, looking toward the camera and wav-

CORRECT SECOND SHOT

CONTINUITY OF SPEED:
Continuity of speed is more subtle than continuity of direction. If a subject is walking in one shot and running in the next, no degree of angle change or shot size will disguise the error.

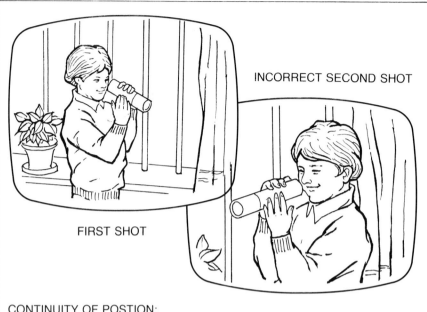

INCORRECT SECOND SHOT

FIRST SHOT

CONTINUITY OF POSTION:
A common continuity error is a reversal of position. Here, the boy is positioned in opposite ways in consecutive shots. The resulting impression is that there are two similar people facing each other.

Here's a typical movie log:
Scene: 2
Shot: 4
Take: 3
Action: Lucy moves into frame from left;
she moves into close-up and sniffs a flower;
she picks flower and holds it in right hand;
she moves away from camera and out of frame at right.
Footage: 00—12—32—15 to 00—14—20—08

Slate—For easy shot identification, some of the data in your log should also be recorded at the beginning of each shot. Use a standard-size sheet of paper on a clipboard, a large pad or an actual slate. Professional slates can be purchased at camera and video-supply stores at a moderate price. They contain identification categories and spaces for you to mark in shooting information. A slate is the equivalent of the familiar *clap board* used at the beginning of each shot in a conventional movie.

Be sure your writing is large and bold enough to be easily legible on tape. Scene and take numbers are the key information to include on your slate. Fill the image frame with the slate and record it for about four seconds before beginning each shot.

TAPING PROCEDURE

Here's the procedure you should follow when shooting scenes for a movie that will be edited electronically after all taping has been completed.

Record the Slate—Set your VCR or camcorder to *Record*. Hold the slate close enough to the lens or zoom in to fill the frame. Focus on the slate. Press the *Record* button or trigger on your camera and tape the slate for about four seconds. That's long

ing both arms. This is followed by a shot of a fireworks display. Finally, you show a car driving away from the camera. The back of the car has a "Just Married" sign and is trailing colorful ribbons and some tin cans.

Your viewers will get the impression that your aunt has fallen for, and married, a handsome lifeguard. But you know better! The shot of your aunt was made on a vacation on Cape Cod. The lifeguard was taken on the beach at Fort Lauderdale. He was signalling a shark alert. You shot the fireworks on the Fourth of July in your home town. Finally, the "Just Married" shot was taped at your best friend's wedding.

This creative positioning of motion picture shots in particular sequences to produce an illusionary reality is the power and the pleasure of editing.

Be Systematic—Although two-VCR editing gives you total freedom to tape your shots in any order, I recommend that you still try to shoot scenes as nearly as possible in the order in which they belong in the movie. This will save searching time when you try to locate the shots you need as you assemble them for your finished movie.

Keep a Log—To help you locate shots after they've been recorded, keep a detailed record or log. Use a large note pad or individual sheets of paper on a clipboard. Write down important data as you shoot. Include such information as scene number, shot number within that scene, take number—the number of times you've taped that shot—a brief description of the action, and the reading on the camera's or VCR's footage counter. Write down the footage readings at the beginning and end of each shot.

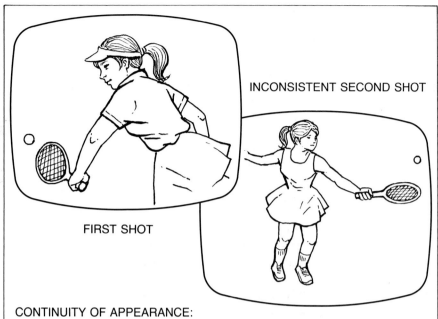

INCONSISTENT SECOND SHOT

FIRST SHOT

CONTINUITY OF APPEARANCE:
Inconsistency in appearance is a common error, especially in a dramatized movie. Here, the subject has removed her jacket between shots, giving an impression that two different people are playing or that there has been an obvious time shift.

enough, especially when you can stop the picture playback with a *Pause* control on the VCR.

Prepare to Record the Action— Remove the slate and frame and focus on your subject. Press the *Record* button or trigger to start your tape rolling again. If you plan to use an auxiliary edit controller, shoot at least 10 seconds of tape before cueing your performers to start the action. This is necessary because in two-VCR editing using an auxiliary edit controller, your VCRs will back up tape approximately that amount of time before running forward again to the edit point you have selected. This is because the VCRs must be running at proper recording speed when the edit controller makes the edit, and a few seconds are required to achieve this speed.

When the playback and recording VCRs have attained recording speed and the selected edit points are reached, the edit controller will add the new shot to your assembly or insert it in the desired place.

Shoot the Action— Cue your subjects to begin the action and record the shot. When the shot is finished, let the tape continue to run for at least 10 seconds before you pause or stop recording.

Conclude the Shot— When you have taped the final shot in a consecutive sequence, you can fade out the picture, using the camera's *Fade* button or manually closing the iris. Or, you can use one of the transition shots I described earlier in this chapter. It's a matter of esthetic preference.

At the end of the final shot in your movie—or the conclusion of closing titles—I recommend using the fade-out. It brings down the final "curtain" on your movie.

EDITING PROCEDURE

Place the recorded videocassette in the *playback VCR*. Locate each shot as you want to add it to the final movie tape and record it onto that tape on the *recording VCR*.

Preferably, the two VCRs should be *edit-capable* types. This means the VCRs contain a sensing system and electronic memory that permit them to begin recording a new shot precisely at the end of a video frame at the programmed cut-point. This produces a clean, glitch-free edit. If an edit were made in the middle of a frame, a momentary picture break-up or glitch would result. However, with many VCRs this is the only type of edit you can achieve.

Picture and sound are normally edited simultaneously. Good edit-capable VCRs, however, permit picture and sound to be edited separately using video and audio dub and sound mixing controls. I described some sound editing methods in Chapter 9.

Use Fastest Recording Speed— When you plan to do two-VCR editing, it is important to record all shots using the VCR's fastest recording speed. That's generally the *Normal* setting on the VCR—the one that delivers the shortest recording time on the videotape cassette.

The fastest movement of the tape across the recording heads spaces out the electronic information most widely along the tape. This permits greater accuracy in making precise edits than slower speeds, which would crowd the information more closely. As an added bonus, picture quality is best at the fastest recording speed. To ensure the best quality you can get, you should also use the best-quality tape you can buy.

Assemble Editing— This is the basic method of editing videotape. It is a simple linear assembly of shots transferred from your original camera tape

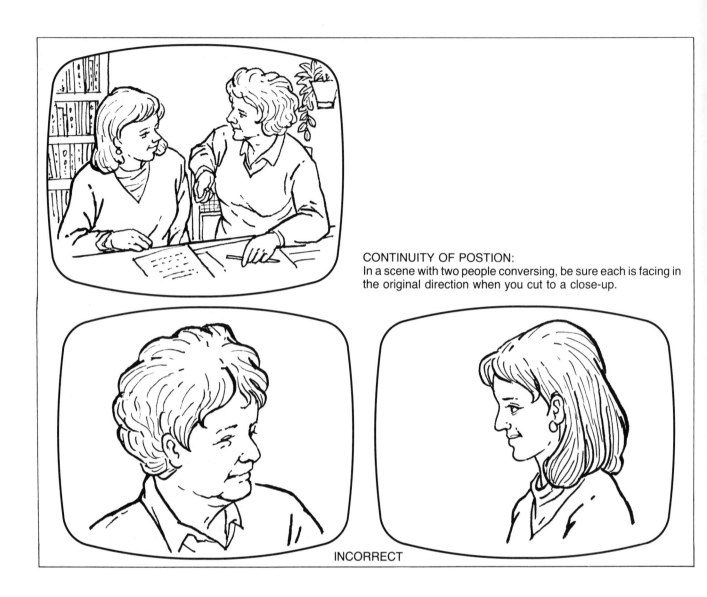

CONTINUITY OF POSTION:
In a scene with two people conversing, be sure each is facing in the original direction when you cut to a close-up.

INCORRECT

to a second tape called an *edited master tape*. For example, an assemble-edited tape consists of shots 1, 2 and 3, in that order. You may not have recorded them in this sequence. The first shot on your camera tape might be shot number 3 for your master assembly.

Insert Editing—This method enables you to replace a shot—or a series of shots—in an original camera tape or an assemble-edited tape. It is achieved by recording a preferred shot on the tape space occupied by an undesirable shot in an existing assembly.

Insert editing requires more sophisticated VCR editing capability than assemble editing. However, that capability is becoming more and more readily available for the home-video user. Home editing controllers, providing electronic control of both playback and recording units of your two-VCR editing system, are also available.

Read VCR Manual—Before you begin any kind of two-VCR editing, I recommend that you read your VCR's instruction manual. Be sure

CUT-AWAY SHOT:
A cut-away is a special shot inserted between two shots of the overall action. The cut-away relates to the master action but is not part of it. Here, grandmother is putting a cake in the oven while the little girl anticipates eating a piece. The cut-away shows the family kitten at its milk dish. In this way, a time interval is conveniently compressed. The cut-away is followed by a shot of the little girl receiving her cake.

5	4	2	3	1

ORIGINAL TAPED SCENE SEQUENCE

1	2	3	4	5

ASSEMBLE EDIT

1	2	▦	4	5

BETTER SHOT INSERT EDIT

you are aware of all the capabilities and operating procedures of your equipment. If you need additional information, see your video dealer.

Locating an Edit Point—Ideally, one shot should follow the next as smoothly as possible. There should be no sign of a jolt, jump or sudden change of pace in the transition from shot to shot. Therefore, in selecting

ASSEMBLY AND INSERT EDIT:
An assembly edit is re-ordering an original tape in the desired sequence of shots, beginning with the first shot and working down to the last. In an insert edit, a desired shot is inserted to replace a less desirable one. Illustrated here are original camera tape—shots in random sequence; assemble-edited tape—final, desired sequence of shots; insert edit—preferred shot replaces an existing one.

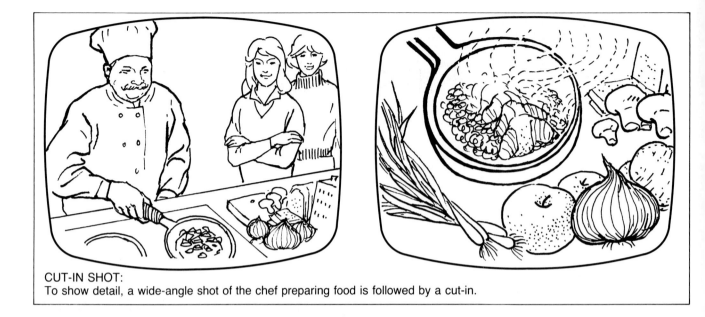

CUT-IN SHOT:
To show detail, a wide-angle shot of the chef preparing food is followed by a cut-in.

your cutting points, you must consider both the shot that is being moved and the location in the tape to which it is being moved. Composition, speed, direction of movement and other aspects of smooth continuity must be compatible in the two shots.

Action cuts require the greatest care. For example, if you're cutting from a long shot of a woman walking to a close-up of her legs, she must be on the same foot when you begin the close-up as she was when you left the long shot. She must be walking at the same speed and in the same direction in both shots.

There are not likely to be more than two or three video frames in which the required match occurs. It is up to you to find the compatible editing points. Examine carefully the two shots to be joined on each of your editing VCRs. Run the VCRs forward and in reverse, using the *Search*, *Frame Advance* or *Stop Action* settings, depending on the specific features your VCRs have.

When you're satisfied that you've located the best joining points, rehearse the edit a couple of times and then actually record it.

To edit directly from one VCR to another, proceed as follows: Back up the tape on the playback VCR to 5 to 10 seconds ahead of the edit point. Pause the VCR on Play. Position the tape on the recording VCR at the desired starting point for the new shot and set that VCR to Record/Pause.

Start the playback VCR on Play and watch carefully for the edit point to appear on the TV screen. When it appears, immediately release Pause on the recording VCR to record the new shot. Record a few seconds more than you think you'll need, then Pause both VCRs. Continue in a similar manner with succeeding shots.

Play the edited version back and examine it. If necessary, repeat the procedure until you're fully satisfied with the result. Remember, however, that you'll have to cut a few seconds from the end of a shot on the recording VCR each time you redo an edit to obtain a clean transition to the new shot. This is the reason for recording more than you actually need the first time around.

If you're working with an edit con-troller, you'll be able to preview the edit and adjust it until you're satisfied before recording it. After that, the edit controller does it all for you automatically.

QUALITY LOSS IN DUPLICATION

A copy or duplicate tape always suffers some loss in picture quality. When you make copies of your tapes for friends or family, always make them from your edited master tape—never from a copy of it. Don't give away your edited master tape—it is literally a "master" that enables you to produce more copies.

The tape you record directly with your camera is called a *first generation* tape. No reproduction from it will ever match its quality. When you edit this onto another VCR, the new tape is of *second generation*. A copy from that one would be a *third generation* tape. I advise you not to copy from any tape beyond a second generation if you hope to retain acceptable picture and sound quality in the copy.

11 **Family Movies**

Video is an ideal medium for preserving a living record of your family. With video you can record everyday activities, special events and occasions, holidays, parties and celebrations with lightweight, portable equipment. It lets you capture the action in color and with sound. And, you can enjoy viewing your movie immediately after shooting.

A family movie is essentially a documentary and, generally, you should use the documentary approach I recommend in Chapter 5 for planning and shooting.

Aim to capture the spontaneous, unaffected behavior of your subjects. Endeavor to preserve the natural atmosphere—in appearance and sound—of each situation. Construct a movie that has interesting and informative content and good visual continuity. Remember that you're producing a *movie* rather than a detached series of *snapshots*.

Make your movie just long enough to show a well-documented event or tell an entertaining story—and no longer. Twenty minutes is generally about the maximum you should aim for when making a family movie. If you can justify a movie that will run longer, make it. However, always remember that "short and sweet" is better than "long and dull"!

BABIES

Babies can't be directed and, therefore, can't be anything but natural. They'll either "perform" for you or they won't. It's up to you to do everything you can to put them in the mood for performance.

A BABY'S NEEDS

When a baby's basic needs are met, he will be comfortable and most inclined to be a good performer. Be sure the following requirements have been met before you begin shooting.

Comfort—Babies are happy, and therefore cooperative, when they're comfortable. They like to be warm, but not overheated under glaring lights. Be sure lights shining in the eyes aren't causing the baby to squint, turn away from your camera or rub his eyes.

If baby makes a fuss to make his discomfort known, take notice. If the light is a problem, change the lamp positions or use soft or bounced light. If there's enough ambient light for an acceptable picture, avoid using artificial light altogether.

Babies prefer familiar surroundings, objects and people. And, they always prefer being dry.

Don't persist with your taping if baby clearly is not in a cooperative mood. Avoid attempting to push him beyond his endurance just to tape one more perfect shot.

Food and Sleep—Babies tend to be irritable and uncooperative when they're hungry or tired. Under these circumstances, you won't get the characteristic, cute behavior you're hoping for. If baby becomes irritable during taping, it's likely that one of these needs has to be satisfied before you can continue successfully.

Of course, there are exceptions to every rule. For example, if you want to show a ravenous baby getting food all over its face, you must wait until the baby is truly hungry.

Some babies tire easily but are just as quickly refreshed by a short nap. Others may perform for longer periods of time but then require a good two or three hours' sleep before they're ready for your camera again. You must respect each child's specific needs.

Human Contact—Many babies are content to be by themselves in a place that is warm and softly lit with diffuse or indirect lighting. Others are little clingers, preferring close contact with a familiar person—generally their mothers—and you may be able to get good shots of them only when they are in this reassuring company.

Toys—Babies are fascinated by col-

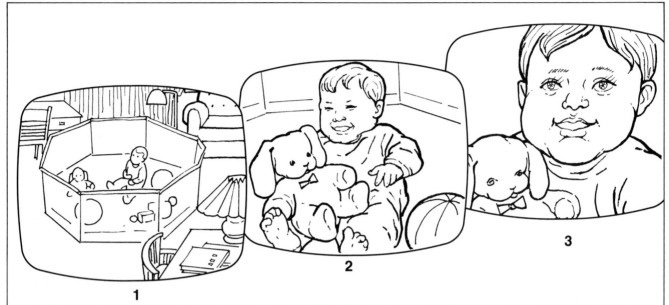

Here's the opening sequence of shots for a movie entitled "Our Baby:" Shot 1 shows baby in his environment—a long shot; Shot 2 sets up baby and his favorite plush animal; Shot 3 gives us a big, close look at baby. Now we know where he is and we've seen something of his appearance and personality—and the movie continues.

orful objects and will play with them if they're within reach. If you want to record a baby in such a situation, avoid other distractions in the shooting area. Avoid objects, movement and noise that may prove more interesting to the baby than the toy in front of him. Shoot from as far away as possible and use minimal lighting. Use an auxiliary mike positioned near the baby for sound pickup.

Rapport—Any good photographer will tell you how important good rapport is between his subjects and him. A fine photographer "brings out" the best in the people he photographs. The same kind of rapport is essential between you and the baby you're taping—even though you can't converse like adults.

The baby instinctively knows when you truly have his interest at heart and will perform for you accordingly. A pleasant environment contributes significantly to a satisfying record of your baby.

Determine whether you'll obtain a more characteristic "performance" with baby seated in mother's lap, playing with her, or whether he can be happy and responsive all by himself in a crib, playpen or on a rug in the middle of the room.

Baby may feel happier outdoors, on the patio or in the grass. Position him where you feel you'll get the most cheerful, cooperative attitude.

STORY IDEAS

If you want a good story line for your movie—providing a distinct beginning, middle and ending—try shooting a "Day in the Life of . . ." type of production. Cover all the activities in the baby's day— awakening, bathing, being dressed, feeding, sleeping, playing with mother and so on, to bed time.

Another good theme would be "Coming Home from the Hospital." Begin by showing preparations for the homecoming—the readying of

crib, bath, playpen, little garments and booties. Cover the event itself— leaving the hospital, first glimpses of home and the first steps of settling in. End with the new arrival peacefully asleep.

When you're expecting several family members to visit, you could shoot "Visiting Day," showing all the admiration and attention being showered on the youngest family member.

PLAN YOUR SHOTS

Start with an establishing shot of the environment. For example, if a movie is to begin in baby's room, set your zoom lens to its shortest focal length—or widest angle—and shoot a general view of the room, having the baby clearly visible.

If you can't show the entire setting in one view, you can either take a second establishing shot from a slightly different angle or slowly pan through the scene. Avoid a rapid pan through the room with the lens set to a

1 2 3

USE THIS EASY EFFECT TO BEGIN A NEW SCENE:
In Shot 1, the frame is completely filled with the mother's back—resulting in a blank, dark TV screen. In Shot 2, the mother moves away from the camera's lens into the room, toward the baby, while the camera remains stationary. As the mother moves away from the camera, the full scene comes into view. To make this shot, you would frame the full scene as desired first; then position the mother in front of the lens, blotting out the scene. Start recording and direct the mother to move toward the baby. Continue shooting as the scene unfolds.

relatively narrow angle of view.

Next, change the viewpoint—but not by more than about 45°—and tape a medium shot of baby in crib or playpen. This will clearly establish your subject—the baby—in his environment.

Change the viewing angle again and give your audience a good, detailed close-up of the baby.

This is the standard establishing shot progression I gave you in Chapter 3. As I informed you then, you can often break the rule and tape a sequence in reverse with excellent results. Like all rules, the better you understand it, the more likely you are to break it at the right times, for the right reasons.

ZOOMING

If you're editing in-camera and want to keep your shooting technique simple, you can tape the entire introduction I've just described in one zoom shot from one position.

However, to get the establishing shot as wide as possible and the close-up as large as possible, zooming alone may not be enough. You may also need to change your distance from the subject. This is due to the limited focal-length range on most video-camera zoom lenses.

Home video cameras generally offer a 6:1 zoom ratio. This means that the longest focal length of the lens is six times greater than the shortest focal length. For example, a typical lens may zoom from an 8mm wide-angle setting to a 48mm telephoto setting—a relatively limited zoom range. Many professional lenses cover 20:1 zoom ratios and higher.

A few home video cameras now offer a 12:1 zoom ratio—a very useful improvement. Using a lens like this, you can tape a wider shot of the room and a closer view of the baby from one shooting position.

SHOT PROGRESSION

To add excitement and sophistication to your movie, use some of the transition techniques I described in the previous chapter. Use cut-in shots to detail action and pertinent objects. For example, go to a cut-in to show mother's hand washing baby's hand, baby attempting to put his foot into his mouth or a rattle shaking in baby's hand.

For pleasing transitions from one activity to another, use cut-aways. For example, as an introduction to a breakfast scene, cut away to a bottle for a few seconds. Or, cut away to the bathtub for a transition to a bathing scene.

Here's a novel and effective way to shoot a transition: Begin your sequence with a full-frame shot of baby's or mother's back—a completely dark, blank image. Then direct mother to carry baby away from camera into the scene where the new sequence begins. This creates an

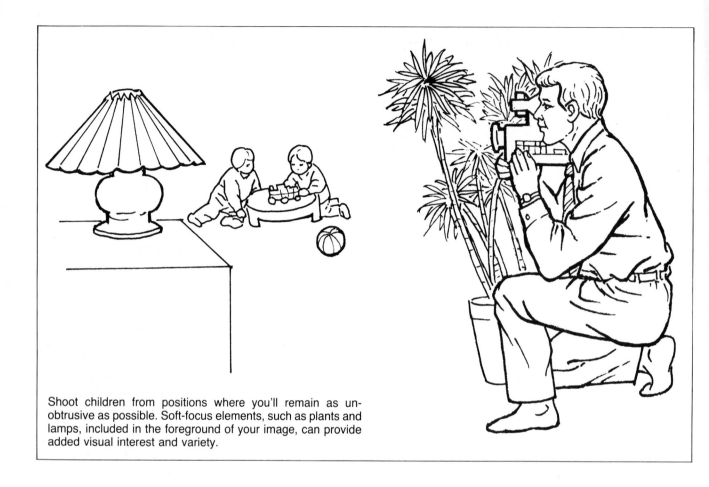

Shoot children from positions where you'll remain as un-obtrusive as possible. Soft-focus elements, such as plants and lamps, included in the foreground of your image, can provide added visual interest and variety.

effective fade-in on the new scene. You can fade a scene out similarly by having the mother walk toward the camera until the entire image area is covered by a uniform dark tone.

SOUND

Although baby can't talk, sound is still an important part of your movie. Your camera's mike will pick up the cooing, laughing and gurgling of the baby. Be aware, however, that your own voice behind the camera, encouraging reactions from baby, will also be recorded. So, too, will the voices of others in the room. To avoid a confusing sound track, caution others in the room to remain quiet unless they are an integral part of your scene.

Whatever sounds you or other family members make in communicating with baby should be a deliberate part of the sound track. Don't attempt to hide your communication from the sound track by whispering. The mike will pick it up anyway and the result will be an annoyingly indistinct murmur in the background.

If you need to coax a baby—or any child—audibly to get the look or reaction you want while you shoot, you can replace that section of the sound track with appropriate music, using the audio-dub feature on your VCR.

It's a good idea to include a shot of the person who is encouraging responses from the baby so that clear

identification of the voice is established. If baby looks toward that person, as he undoubtedly will, it is even more critical for your viewers to understand to whom baby is responding.

TODDLERS

Toddlers differ from babies in that they are much more mobile and are able to communicate verbally. This makes the job of the moviemaker at the same time more difficult and easier.

At the ages of about 18 months to 3 years, children are brimming with curiosity, a desire for exploration and an abiding pleasure in their newly acquired mobility. Aim to record them when they are unaware of you

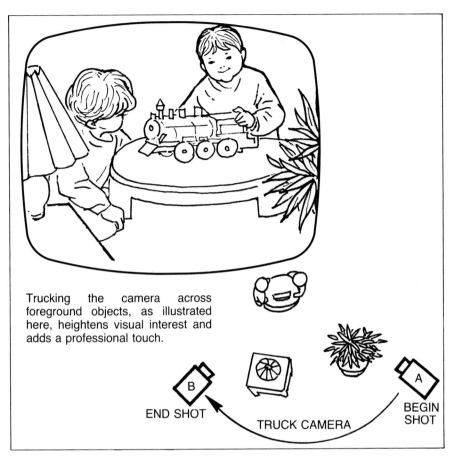

Trucking the camera across foreground objects, as illustrated here, heightens visual interest and adds a professional touch.

B
END SHOT
TRUCK CAMERA
A
BEGIN SHOT

shooting around a chair or table, through a staircase railing or between the leaves of a large plant.

AUTOMATIC FOCUSING

If your camera features automatic focusing, you may sometimes have to disengage the auto setting and focus manually. It depends on the autofocus system used. For example, the ultrasonic or sonar type focuses on the nearest object it sees. If you aim the camera at a window, balustrade or fence, or past a lamp, it will focus on these objects rather than on a child beyond.

FOREGROUND INTEREST

Besides helping to conceal your camera, foreground objects can be used in the picture area to frame the image. These objects can be in sharp focus or you can place them so close to the camera that they record as a blur. Foreground objects are also useful devices for image transitions. For example, at the start of a shot you can shift focus from object to child. To end a shot, reverse the procedure. You must use the manual focusing control for this effect.

CAMERA MOVEMENT

Use camera movement to bring life to your movies. Follow a child's movements and explorations with your camera, panning past foreground objects like lamps, chairs or plants. Raise the camera as you're shooting, to reveal the water activity in the bathinette. Outdoors, move across a fence, past flowers or over shrubbery for action shots.

Camera Steadiness—Movement of the camera must be accompanied by camera *steadiness*. Although this may sound contradictory, it really isn't. Panning, tilting and dollying are desirable techniques. However, they must be executed smoothly,

and your camera's presence.

SHOOT FROM A DISTANCE

Position yourself and your camera as unobtrusively as space and circumstances permit. While it's a delightful experience explaining something new, like a movie camera, to a small child, your objective is to observe the child—through your camera—and not have the child preoccupied with your equipment.

Use the telephoto setting of your zoom lens and get as far away from the action as possible. This way, you'll record the undistracted activity of a child happily preoccupied with his own pursuits. The activity can include other children of a similar age or parents and siblings.

CONCEAL YOURSELF

Uninhibited action is much more easily recorded outdoors, where you have room to move and lots of opportunity for hiding. Put your camera on a tripod at a low level and position yourself to shoot through or around a convenient object. You can set up the camera behind some shrubbery or other appropriate screening. Shoot between branches, through a fence, from a porch, from behind a tree trunk or around the corner of a house.

Indoors, you'll generally find it very difficult to actually hide from children. However, you can take up a position that makes you least conspicuous. First, get as far away from the action as you can. Then, conceal yourself in the best possible way. Try

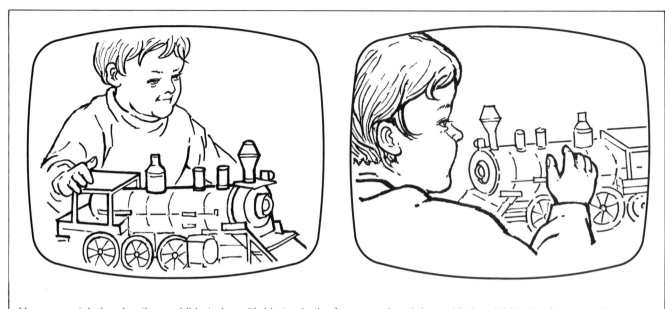

Vary your style by shooting a child at play with his toy in the foreground and then with the child in the foreground.

without jerks. To achieve this, you should place your camera on a sturdy tripod with a smoothly operating pan-and-tilt head. If you're using a makeshift dolly, it should support the camera firmly and be easily movable.

Camera steadiness is particularly important when you're working at the telephoto setting of your zoom lens. The longer the focal length of the lens, the more evident will be any unsteadiness of camera movement in the final image.

When working close to your subject with the lens at a wide-angle setting, you can generally use the camera handheld. With a little care, you can walk your camera smoothly past foreground objects, around corners and even from one room to another, as your toddler moves about.

USE TOYS AS A THEME

Toys, games and other objects that attract a toddler's attention and curiosity are excellent thematic devices around which to build a movie. Record a child's total preoccupation with blocks, books, dolls, stuffed animals, games or musical toys and you can hardly fail to produce an attractive movie sequence. When you've established the setting and subject of your movie, use close-ups generously. Cut between tight face shots and close-ups of objects held in little hands.

Set up a toy in the foreground, placing the child a couple of feet behind it. Frame to see the blurred face just beyond the sharply focused toy. To relate child with toy, shift focus from the toy to the child's face and back again.

Then, change to a child's-eye view of the toy. Position your camera behind the child, at about his shoulder level, for an over-the-shoulder shot of the toy in the child's hands. This will require some cooperation from the child. If he's sufficiently fascin-

ated by the toy, he's likely to cooperate. If he isn't, maybe a more exciting toy is called for.

You can use a toy as a central theme, linking together the other events in a movie. Begin the movie with mere anticipation of play. Combine shots of the toy with shots of more important early-morning duties such as getting up, dressing and having breakfast.

You can then show the child at play with the toy and perhaps include a conversation with the child about the toy. Ask him to demonstrate it to you. Intersperse with the toy shots other regular daily activities—meals, naps and perhaps a shopping trip with mother. End with the evening bath and bedtime and with the toy's being put in a "safe place," near the bed, until morning.

SMALL CHILDREN AND PRE-TEENS

From the age of about four or five, children are much more mobile, tending to interrelate much more with youngsters beyond their own homes. Their communication skills, both verbally and by other subtle means, are more developed. They are more independent and more inquisitive.

Between the ages of about four and ten, a child moves and thinks faster and faster. If you and your camera are to keep up with him, you have to be pretty fast and alert, too. This is especially true on birthdays and special holidays, when anticipation and excitement speed everything up even more.

Kids Like Acting—Most children watch enough television to know what acting is all about. They think acting is fun and will readily perform. Their childlike imagination and lack of inhibition give them an additional advantage. As their "director," you must know the difference between subtle encouragement and needless interference.

How to Direct—Be clear in your requests. Be patient, if the response isn't exactly what you expected. It's important to strike a balance between getting the results you want and permitting your performers to be spontaneous. Indeed, be on the lookout for unexpected results that may be even better than what you had in mind.

Remain enthusiastic at all times—it's infectious. Directing kids is about 80% encouragement and approval, such as "You can do it!" or "That was just great!" and 20% instruction, such as "Move over there!" or "Stand up slowly and turn around!"

A Useful Directing Tip—It's a great temptation for children—and even adults—to give an occasional sideways glance at the camera while they're performing. The best documentary movies are those in which the viewer is totally unaware of the presence of a camera. Encourage children to forget about the camera and simply get on with the action, and not to glance at the camera during taping.

Instruct and direct your performers fully before you start shooting. When performers know precisely what's expected of them, the tendency to look at the camera—for direction or approval—will be lessened.

Of course, if you are taping a scene in which a child demonstrates an object or accomplishment specifically for the audience, eye contact with the lens is appropriate and desirable.

"DIRECTED" DOCUMENTARY

Most movies involving children are basically documentaries, as defined in Chapter 5, but require some direction. Let's assume you want to tape two children building a house with blocks. Suggest it to them and, in all probability, they'll be happy to do it for you. Instruct them briefly in advance regarding the shots you're planning to take and what their best relative positions are for a good composition. Then let them get on with it without further interference.

The more engrossed they become in the activity and forget the camera's presence, the better your movie is likely to be. End the movie with the finished construction and the look of achievement and pride in the children's faces. In a similar way you can encourage children to draw or paint, study a picture book, tidy up a room or bathe a dog.

If you miss a good shot, children will frequently help you recreate it. For example, you may have missed a little girl's delighted reaction as she unwrapped a new doll. She'll probably be willing to reenact it for your camera—and do so convincingly and unselfconsciously. Sometimes you can even persuade a child to delay the opening of a gift until you have had time to set up your camera as you want it.

PARTIES AND HOLIDAYS

Special occasions such as a birthday party and Christmas morning present a lot of fast-paced, random activity. However, you can anticipate approximately what's likely to happen. Prepare by listing possible or probable highlights you'll be able to record, and plan suitable opening and closing sequences.

Birthday Party—You can shoot scenes for your movie even before the party begins. For example, an excellent opening sequence would consist of the secret planning of a surprise party. Stage a scene in which phone calls are being made, invitations written and envelopes sealed.

Check that the lighting in the party room or area is adequate. If necessary, increase the wattage in existing lamps and fixtures or add bounce light aimed at walls or ceiling.

I strongly recommend the use of an auxiliary, unidirectional microphone in place of an omnidirectional camera mike. Parties tend to get noisy. This type of mike will help you pick up selectively the sound you want and avoid extraneous background chatter.

When the party begins, remain as unobtrusive as possible right from the start. This is important because children are most shy and insecure during the early stages of a party, when the environment and the people are still unfamiliar.

Be sure to identify the birthday child early in the movie and make

him or her the central theme. As the party progresses and inhibitions diminish, move about freely for hand-held shots and intimate close-ups with conversation.

Find out when and where gifts are to be opened, so that you don't miss this important part of the celebration. Also record the cake before it is cut.

Then, record the cake-cutting ceremony. This will probably be the key scene of the entire movie. Start with a tight close-up of the cake from a high angle. To record the candles being blown out, go to a lower angle, shooting through the flames to the face beyond. Use manual focus to shift from flames to face. Automatic focus control may concentrate sharp focus on the closest part—the candles.

Shoot the birthday child's point of view of the cake, as he is cutting it, by shooting over his shoulder. From this angle, show the first slice being cut, handed to a guest and savored with delight.

End the movie with a shot or two of the birthday child, looking tired but happy amid the party wreckage.

Christmas—Here, too, preparation for the event makes for an excellent opening sequence. This may include wrapping gifts, trimming the tree, hanging up the stockings, and mom and dad secretly filling them after the children are in bed. Of course, if you don't want to give away who the "real" Santa Claus is, you should omit this scene!

Your Christmas Day coverage should begin with the kids tumbling downstairs to retrieve the stockings and discover their contents. My own children always beat me to it, but were usually most cooperative in rehanging the stockings and beginning all over again. They did it with surprising authenticity, too.

Christmas is a magic time for little

A Christmas tree calls for a low angle—a child's point-of-view shot of the tree, followed by a close-up of the child's face.

Use cut-away shots to bypass lengthy gift unwrapping. Begin with the child's first flurry of activity (shot 1). Cut away to a different but related scene (shot 2). Then cut back to the happy child, holding one of the unwrapped presents (shot 3).

children. To emphasize this, introduce the brightly decorated and lit tree through a child's eyes. From a low angle, shoot a close-up of the top of the tree. Then tilt the camera downward slowly and zoom to a wider lens setting until you're showing the entire tree. Cut to a close-up of a spellbound child's face.

End by showing a close-up of one special ornament. While the camera is running, have a little hand come into the picture area and touch the ornament.

These are just my suggestions. Use your own imagination to shoot the kind of movie you want, and the kinds of shots that are appropriate for the specific conditions confronting you.

When the kids are unwrapping their new toys, I advise you to use the extended-shot technique described in the previous chapter. Keep the camera running and change your viewpoint by panning, zooming and moving with your camera. Alternate between general views of the scene, close-ups of a child's face, of a toy, of child and toy, and views showing interaction with another child.

To maintain smooth continuity between widely differing shots, use cutaways, described in the previous chapter. Use appropriate holiday-related objects such as a music box, a sprig of holly or mistletoe, or a specially attractive ornament on the tree.

Many Christmas scenes—especially those involving presents and toys—are similar to those found at birthday parties. Use the same basic shooting techniques as described in the previous section.

Sound Tip—When shooting at a bustling location like a party, wear a set of earphones, plugged into your camera's headset jack, to monitor the conversations you're recording. It's the only way you can accurately evaluate your sound pickup as you'll hear it played back on your TV set.

TEENAGERS

Young people aged from about 12 to the late teens tend to be more self-conscious than young children. When confronted by a camera, they tend to either ham it up or clam up. In other words, they either overact or won't act at all. You need all the directing skills you can muster to be able to record them behaving naturally.

If you concentrate on activities that are important and meaningful to the youngsters you plan to record, half the battle is won. Depending on their specific talents, shoot them making music, playing sports, engaged in hobbies such as model-spacecraft building, collecting unusual or rare objects, painting or drawing, dancing or even studying their favorite subject. Avoid contrived situations.

INVOLVE YOUR SUBJECTS

To maintain the interest and enthusiasm of your performers, get them actively involved in both the planning and shooting of your movie. Invite their comments and suggestions. Once your camera is recording, remain as unobtrusive as possible.

INTERVIEW TECHNIQUE

It's generally not difficult to interview a teenager. With a topic that genuinely interests him, you'll get eager responses. The self-consciousness and awkwardness will quickly be forgotten. It can be an

enjoyable—and informative—experience for both of you.

Avoid questions that elicit no more than a "yes" or a "no." For example, don't simply ask, "Did you enjoy the party?" Ask questions that will bring a response of interesting information or comment. To achieve this, the above question could be rephrased, "What was special about the party?"

Instead of interviewing one person, you can film a discussion group. Put a question to the "panel" and let them discuss it among themselves as you shoot. Act as moderator, when necessary, to keep the participants on the subject and keep the pace moving.

ADULTS

Adults who are not accustomed to facing a camera are often concerned about appearing unattractive and acting foolishly. It's up to you to reduce these self-conscious concerns.

SKILLS AND TALENTS

One of the most effective ways of putting adults at ease is the one I just suggested for teenagers: Record them at something they like and are genuinely good at. Concentrate on special interests, skills and hobbies. For example, if dad fancies himself as a fine chef, record him preparing his favorite specialty.

If mom has a "green thumb," produce a mini-documentary of her skill. With editing, you can extend such a production over a full season, if you like. Begin in early spring with seed selection and planning. Show soil preparation, planting and the continuing care of the sprouting seedlings. Record the full-grown plants and, finally, the enjoyment of the product, be it fruit, vegetable or flower.

Do some research within your own family to determine what talents

there are. Some, you'll undoubtedly know about already. However, there may be others that have been hidden away since college or even early school days.

Directing—When a person is expert at something, he needs little direction from you. In fact, he will probably help you make such decisions as what's best shot in close-up, and which angle gives the most informative picture.

Your main concern should be with the camera and its operation. When you need a performer's cooperation—by turning, or moving, or holding a pose for a few seconds—discuss it before you start shooting. If it is necessary while the camera is recording, give clear but *silent* cues regarding your needs. Remember, your voice would be recorded on the sound track.

SENIOR CITIZENS

The older generation in your family offers special opportunities for your family tapes. Its members can recall family history with snapshots, memorabilia and stories. Tape grandparents, recalling events from their own lives and stories told them by their own parents and grandparents.

SETTING

Seat your subject comfortably in a chair or on a couch in an attractive corner of your home. Use available light from a nearby lamp for authentic, subdued lighting. A table lamp just above eye level is best. A light source that's too high can cause unflattering deep shadows in the eye sockets. To soften all shadows a little, you can use a white reflector card to throw some of the lamp's light into the shaded areas.

Unless you plan to shoot the entire movie at one session, avoid window light. The illumination can vary too

much in brightness, contrast and color from day to day. This would disturb the smooth continuity of your movie.

Use an unobtrusive background. It should not be too bright or colorful, so as not to distract attention from the main subject.

CAMERA WORK

Mount your camera on a firm tripod. When you're shooting the subject seated in one place, tighten the pan-and-tilt controls for continued, steady framing. If the subject moves a lot although seated, or uses hands expressively, you must either leave enough space around the subject in the first place or be prepared to adjust the framing as you shoot.

When shooting this kind of movie, you need no special visual tricks. Simply let the camera run as your subject reminisces.

Don't Intrude—Position yourself beside the camera and have your subject talk to you. Remain unobtrusive, asking questions and giving direction only when necessary.

Use Cutaways—To shorten overlong pauses or cover interruptions, false starts or mistakes, use cutaways and insert editing, as described in the previous chapter.

A video family history obtained through the recollections and reminiscences of the older generation can be among the most cherished videos you'll record.

PETS

Taping pets such as dogs and cats—which are particularly accustomed to human contact—requires much the same approach as taping people. The best pet movies generally will *include* people.

STORY LINE

Build the story line for your pet

movie around familiar activities like eating, sleeping, walking and playing. If the pet is able to do something special, include that. For example, if your dog is an expert Frisbee catcher and retriever, you have the material for some excellent scenes. Shoot in places the animal is familiar with and where it feels at home.

"TALKING" ANIMALS

You can make amusing animal movies by dubbing in human speech. You've often seen dogs and cats "discussing" their excellent foods in TV commercials.

Here's an example: Record intimate shots of two puppies exploring a new home—a large, cushioned basket. Position your camera as near to eye level with the puppies as possible. Tape a sequence of shots as they prowl or tumble in and out of the basket. End the movie with the puppies drowsy or even asleep in the basket.

During the above sequence, you should periodically shoot extreme close-ups of one or other of the animals with its mouth open. Those are the shots into which you dub the human speech, using the *Audio Dub* feature of your VCR. Your script should be funny and appropriate to

the setting. It should also, as nearly as possible, lip-sync with the mouth movements. Replay the tape a few times to familiarize yourself with the mouth movements. Then prepare and rehearse your script until it fits in the best possible way. Finally, combine image and sound on tape.

You can induce mouth movements by getting a dog to bark or a cat to meow, by having the animal eat or by being lucky enough to catch a yawn or two.

PET PERSONALITY

Different animal species have different mannerisms and temperaments. When you have lived with a pet for a little while, you'll begin to recognize specific, individual personality traits, too. Try and record these on tape.

CAMERA LOCATION

Pet pictures are generally most effective when taken from the animal's eye level. This means getting your camera and yourself down on the floor. When people are to be included, they should be on the same level. Small children can easily be placed on the floor with the pet. With an adult, the easiest solution is often to have the person hold the pet.

Begin with a wide shot that includes the pet on the floor and the standing person. Then move in for a close-up of the two as the person moves down to the pet or raises the pet to his level. Alternatively, you can begin with a tight close-up of a puppy or kitten and tilt the camera upward as a child raises the animal toward his chest or shoulder.

SMALL PETS

Your moviemaking need not be limited to the larger pets. You can tape your guinea pigs, gerbils, white mice, hamsters, goldfish and canaries. Because these pets are so small, the most effective movies of them also contain people. Involve children in the feeding, petting, cleaning or simply admiring of the small creatures.

You can effectively establish the connection between animal and owner by having the two at different distances from the camera and changing focus from one to the other.

Use close-ups, medium shots and wide shots. However, because of the small size of the pet, don't go too wide on your shots, or the animal will look insignificant.

Goldfish and tropical fish don't offer much scope for human communication. Tape them on their own. Be sure the glass of your aquarium is spotlessly clean. Check that the lighting is attractive and bright enough. Avoid unwanted reflections toward the camera. Then, simply fill the image frame with a pleasant shot of the aquarium, start your VCR and let your camera run.

To keep all fish within almost the same distance from the camera, and avoid depth-of-field problems, you can carefully insert a large glass plate into the tank in such a way as to limit all fish to a narrow corridor within the tank.

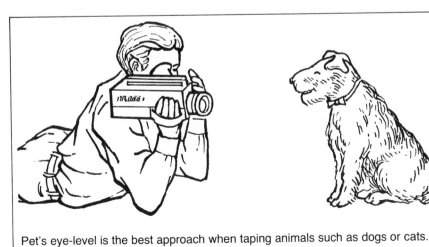

Pet's eye-level is the best approach when taping animals such as dogs or cats.

Formal Ceremonies and Festivities

Religious ceremonies such as weddings, christenings and confirmations, as well as formal festivities like anniversaries and reunions, take place in settings that can present physical and social restrictions for camera coverage. In houses of worship, public halls, club rooms, dining halls, auditoriums and other places of social activity, mobility and camera positions are limited, not only by the location but also by the number, positions and activities of participants.

Most formal ceremonies follow a fixed sequence of events. You must record the occasion with satisfying shot continuity in spite of many obstacles.

PREPARATION

Careful preparation is essential to the production of a well-documented formal event. You must understand the geography and characteristics of the location and the sequence of events that will take place. Here are some steps you should follow for best results:

LIST THE ACTIONS

Write down the specific actions that make up the event. List them in the order in which they will occur and note the location where each will take place. This way you'll be in the right place at the right time.

LOCATION

Familiarize yourself with the location before you go there to shoot. If necessary, get permission to walk through the area a few days before the event. Following are some things to look for and conditions to deal with.

Camera Position—Check for the best camera positions, shooting angles and placement of auxiliary microphones. Note where the entrances and exits are. Determine where there will be subject motion and where the event will be fairly static. Look for power outlets, if you think you'll need them.

Plot your camera moves from one position to the next. Decide whether you'll need extra help to transport your camera, VCR, lights and mikes. Remember that you'll need to move quickly and quietly.

When shooting a wedding reception, be sure to include all of the memorable activities, such as cake cutting, garter throwing and bride dancing with her father. Photo courtesy of Larson Enterprises.

Available Light—Evaluate light conditions. If daylight is available, determine whether it's likely to be a help or hindrance. For example, sunlight from the front or a 45° angle from the side can be great if it covers the entire shooting area. It may, however, create strong contrast between lit and unlit areas. This can cause the video image to briefly become dark and indistinct when you shift from a brightly lit area to a dark one. If you shift from a darker to a brighter area as you follow a subject, the image may briefly become too bright and washed out.

The automatic iris in your camera will quickly make the necessary adjustment, provided there is a sufficient level of illumination to produce an adequate picture in the darker areas. However, there will be a brief, but noticeable, shift in the quality of the image as the iris adjusts to compensate for a sudden change in illumination.

Sunlight shining through a window and back lighting your subjects can be a problem, too. Cameras that have a *back-light switch* can be quickly adjusted to compensate for back light by opening up the lens iris. If your camera doesn't have such a switch, open the iris manually.

Consider also the changing position of the sun during the course of the event. If the event lasts for several hours, the effect of the daylight may change considerably while you're taping.

Supplemental Light—Determine whether you'll need supplemental lighting. In most places of worship you'll have to shoot by available light, even if it's not very bright or consists of mixed lamp types. Fortunately, most home video cameras and camcorders provide an adequate picture in extremely dim lighting.

If added lighting is permissible in the shooting location, there are several ways of supplementing existing light. You can use quartz-halogen lights to spotlight key activity or to raise the general level of illumination. For large areas, such as reception halls, you'll need two or three 500-watt or 750-watt quartz-halogen lights. For smaller areas, one or two 300-watt or 500-watt photoflood lights or photo bulbs in reflectors can be used. If you don't own lights, you may be able to rent them from local video-supply outlets or large photo stores.

Check the picture on a monitor or in your camera's viewfinder. Then add to, or adjust, the illumination as necessary. With video you have the advantage of being able to preview the image and improve it *before* you commit it to tape. You can't do this with a film camera.

Bounce Surfaces—Look for suitable bounce surfaces for the supplemental lighting. Bouncing light from walls and ceiling provides uniform, general illumination. The bounced light is softer and more pleasing than the harsh, direct light. It is also less irritating to your subjects' eyes.

When you look for bounce surfaces, avoid colored walls or ceilings. The color will reflect onto the subjects, causing a color imbalance in the affected areas. White or light-gray surfaces make the best light reflectors.

When you bounce light, a lot of it is wasted. Be sure to have sufficient light to reach an adequate brightness on the subjects. As a general rule, at a wedding reception or large party you'll need four times the light output for bounced illumination as you would for direct illumination.

Bounce light is most effective in relatively small rooms with light walls. In large, dark-walled areas, too many lights may be needed to make bounce lighting practical.

Mobility—A camera-attached light is your best option if your main objective is mobility while you're shooting. Many cameras have a hot shoe to attach to such a light. Because the light always points in the same direction as the lens, your subjects will always be lit, as long as they're not too far away or too spread out.

On-camera lights have some disadvantages you should know about. They don't provide the most esthetically pleasing illumination. Being frontal, the light gives little modeling to subjects and can cause disturbing shadows on nearby backgrounds. Moreover, a direct light shining in your subjects' eyes is likely to make them squint, frown or look away from the camera to avoid the glare.

These problems can be partially cured by using an extension that raises the light and places it to the side of the camera. This lamp position provides some modeling and reduces glare in the eyes of a subject who's looking at the camera.

A separate, portable light source, such as a 200-watt or 300-watt photoflood lamp in a handheld reflector, is an even better alternative. You'll need an assistant to carry and aim the light. Position it slightly to one side and about a foot higher than your subject's head. It will give you attractive illumination together with good mobility.

Mixed Light Sources—Avoid mixed lighting, if possible. If the fixed illumination in a hall is fluorescent and you find it necessary to add supplemental incandescent light, you'll be shooting in mixed light. You can correct the color rendition for one or the other, but not for both at the same time. Your alternatives to remedy the matter are minimal. Here are three:

- You can use fluorescent supplemental lighting instead of incandescent lights. To do this, attach fluorescent light fixtures to stands and aim them at your subjects. You don't need to bounce this light because it's inherently soft. Aim it at your subjects directly.
- Cover your incandescent supplemental lights with blue-green colored gels that approximate the predominantly blue-green color of most fluorescents. This will give a better match between the light sources.
- Simply white balance or color adjust your camera as best you can. Depending on where you make the adjustment, some areas will appear to have a *decisive* imbalance. Or, if you make a compromise adjustment, all areas will have a *slight* imbalance. However, this compromise often works adequately for a satisfying picture.

Sound—Evaluate sound-pickup conditions. Check the acoustics by clapping your hands or snapping your fingers and listening for any echo. Too much echo, such as you might encounter in a large, empty hall, church or temple, can muddy the clarity of your sound track. However, a small amount of echo sounds realistic and can result in a pleasant sound quality.

The presence of many people in an enclosed location helps to deaden echoes to a large extent. Take this into consideration when you evaluate the acoustics of a hall.

How much echo is acceptable and how much is detrimental is a relatively subjective matter. If you encounter what you consider excessive echo in a location, consider an auxiliary microphone. A shotgun type is directional. It will pick up sound selectively from a small area at a relatively long distance. Another alternative is a lavalier mike, attached to the front of the speaker's clothing.

Avoid omnidirectional mikes, such as the one built into most home video cameras. When at a relatively long distance from the sound, they produce an indistinct sound track, picking up too many unwanted noises from the surrounding area.

WEDDINGS

A wedding has two basic parts: The formal, predictable events and the casual, social interaction. In addition, there are some events before and after the festivities that should be part of a good wedding video. They include, but are not limited to, the bride's and bridesmaids' last preparations, the groom anxiously waiting and the departures for reception and honeymoon.

You can open your movie with a shot of the wedding invitation. It's best to place your camera on a tripod to get an accurately framed and steady shot.

Record the bride's shower and the groom's bachelor dinner or party. The latter will probably be held in a formal setting, presenting shooting considerations similar to those at the wedding reception, which I'll discuss in a moment. During both events, good coverage requires action shots of the principal subjects enjoying the occasion and close-up reaction shots of guests.

CEREMONY

Shoot the rehearsal for the wedding ceremony. This can be valuable preparation for you as well as the bride and groom. It will enable you to evaluate camera positions, lighting, sound pickup and timing for movement from one position to the next.

From the moment the bride arrives, you'll be kept busy. When you've covered arrivals, you should take up a position that lets you get shots of the ceremony and of the congregation. If possible, go to an elevated location such as a side balcony. Perhaps there will be one in front of the bride and groom so you can record their faces during the ceremony. You will probably have to obtain special permission to use such a vantage point.

Otherwise, elevate your camera as much as possible with a tall tripod. Be sure to get a clear view, not only of bride and groom, but also of family members and friends. You may have to settle for a profile shot of the officiating minister or rabbi. When one camera must cover the entire event, some compromises are unavoidable.

Good "reaction" shots are an important part of a good wedding video. Try to obtain as many as you can during the walk to and from the altar and during the ceremony. Zoom and pan smoothly, avoiding rapid or abrupt moves that viewers will find distracting.

Two Cameras—If possible, use two cameras to tape a wedding. Try to combine forces with a friend who owns a camera and VCR or camcorder using the same tape type and format as yours—half-inch VHS or Beta, or 8mm. Divide the coverage so one of you concentrates on wide to medium shots of the overall action. Mount that camera on a tripod, positioned high, as I've suggested, for a good overview of the event.

The second camera should be used handheld. Move unobtrusively to concentrate on close-ups of principal participants, including clergy, family and guests. If you're familiar with the sequence of events, you're most likely to be in the right place at the right time to obtain close-ups of important action and reaction.

The operator of the handheld camera should record separate shots

as the ceremony progresses. The operator of the tripod-mounted camera should obtain a continuous recording of the event. Both camera operators should at all times be concerned about sound as well as video.

Later, you can combine shots from the two cameras by editing them to provide a coherent movie. Include the key events of the ceremony: The arrival of the groom, the bride's walk to the altar, the exchange of vows, the traditional kiss and the departure for the reception, amid the throwing of rice.

RECEPTION

Two of your main concerns at the reception will be proper lighting and good sound pickup. If the ambient room lighting is too dim, separately illuminate key activities, such as toasting, speeches, cutting the wedding cake, bride and groom dancing, and the tossing of the bridal bouquet. Use one or two 500-watt or 750-watt quartz-halogen lights or photofloods. If the walls are white or of neutral tone, bounce the light off walls and ceiling.

Sound—Good sound pickup is particularly important at the reception because the toasts and speeches must be clearly understandable on the tape. Because the speakers will be stationary, an auxiliary microphone on a floor or table stand is ideal. You can also use a shotgun microphone for individual speakers as well as for subsequent guest interviews. You'll need an assistant to hold and direct that microphone as you operate the camera.

Assistance—Ideally, you should have one or two assistants, not just to help you with microphone and second camera, but to give general support. The less you need concern yourself with all of the technical responsibilities, and keeping clear

space between camera and the subject you're shooting, the more you can concentrate on shooting the movie. Of course, if you have a camcorder you are spared the burden of a separate VCR and your mobility will be increased accordingly. Even so, try to have at least one helper on the scene.

BAPTISMS

Taping a baptism is generally less complex than recording a wedding. Typically, it involves fewer people, smaller space and less movement. Camera coverage, with its lighting and sound requirements, is confined to a small area in the church.

PLANNING

Examining the scene and planning the shooting are essential steps before recording all family events, even those that are apparently easy to shoot.

List the anticipated events that will take place before, during and after the christening ceremony. Understand the physical layout of the area where the ceremony will take place. Consider camera positions, lighting and sound pickup needs.

CAMERA POSITION

You must be close enough, and at the appropriate angle, to get good close-ups of a tiny baby. The minister or priest, parents and godparents, and other guests, must also be recorded in good close-ups during the ceremony.

Take up a position to the side of the group where you'll get the best view of baby's face. If you have any control over the grouping, place the key members in the event so you see them all frontally or in profile. In case you can get only a back view of the minister from your location, prearrange a path that will enable you to quickly move around to get a frontal or pro-

file shot of him.

Baptism services are short, and you'll have to work fast. Some compromise may be necessary. However, you can achieve a lot from a well-selected viewpoint, using your zoom lens wisely.

SHOOTING TECHNIQUE

Keep your VCR or camcorder taping throughout the entire ceremony. If you stop recording to change a shot size or angle, you may miss portions of the key event—sound and picture. If you have electronic editing facilities, you can tidy up the movie after the event through editing.

The need for editing will be minimized if you keep your shooting smooth and deliberate. Avoid fast pans and zooms across the group from face to face or in and out from group shot to close-up. As you shoot, try to anticipate the next shot and move smoothly to it.

If you're going to shoot from one position, I advise you to mount the camera on a tripod. You can still pan, tilt and zoom, and you'll get the clearest and steadiest picture possible. If you must use the camera hand-held, concentrate on holding it as steady as possible.

LIGHTING

If available light is insufficient, use one or two 750-watt photofloods or quartz halogen lights. If there are bright walls or a ceiling nearby, bounce the light for a soft effect. If there are no suitable bounce surfaces nearby, reflect the light from large, white cards.

You can also use one or two 500-watt or 750-watt photofloods in wide metal reflectors, each covered with a heat-resistant diffuser.

If sunlight is available through a window, you can try to reflect it onto the scene from a large, white card.

If there's no alternative to shooting by dim, available light, do so. As I've said before, modern video cameras can work wonders in remarkably dim light. But use the best tape you can afford and the fastest recording speed.

Under no circumstances should you shine the light from any bright source directly at the baby. This would certainly cause him to close his eyes tightly, squirm and fuss.

SOUND

Your camera's built-in microphone may be adequate, provided you can shoot close to the ceremony. Drapes and carpeting on walls and floor will help deaden echoes. If you need an auxiliary mike, your best choice is the shotgun type. As second-best, I would recommend a lavalier. Avoid microphones on stands. They would look inappropriate in an intimate baptism scene.

Whatever you do with the camera, lights and microphone, you must be quiet and unobtrusive. You'll be working in a small group of people participating in a relatively quiet event. Even minor commotion will be noticed. Avoid it.

TELL A STORY

A movie of a baptism should not be limited to the ceremony. Tell a story, including events before and after the key moment in the church.

Your opening shot can show the invitation. Then, shoot a sequence of baby being prepared, bathed and dressed for the important event. Record the parents leaving for the church with baby. After the ceremony, tape the congregation leaving the church. Then capture the spirit of the celebration.

Always keep in mind the basic purpose of the event, and feature the baby prominently throughout the movie.

SPECIAL RELIGIOUS SERVICES

General religious services, whether regular, weekly celebrations, seasonal holiday services or services for one specific event, have some basic things in common: There is generally a static audience, activity with limited motion at the altar and sometimes a procession down the aisle.

The best single position from which you can tape all the activity is from the side, between altar and congregation. From there, you can get general shots of the congregation and pick out individual faces by zooming in. You can also get a clear side view of the activity at the altar. Any procession making its way up the aisle can also be recorded clearly.

As with most public events, a raised camera position is best. Suggest the position you want to take up to the appropriate authorities, and see if you can get permission to set up there.

An alternative position would be a balcony at the back of the church. From there, with your zoom lens, you can get general shots of congregation and altar as well as close-ups of the activity at the altar.

Wherever you're located, look for the less obvious but interesting shot. For example, get a shot of the organist at work or of the choir singing. Close-up shots of unsuspecting choir boys or girls can be particularly attractive—or amusing.

During the service, you must be totally unintrusive. This rules out the use of auxiliary lighting and a lot of camera movement.

To get a continuous sound record of the service, be careful to stop the camera only when there's a break in the event.

For general sound coverage, a shotgun mike is best. However, to get the best recording of instrumental or vocal soloists, I suggest you use mikes on floor stands near the performers.

If you can connect your VCR directly to the public-address or sound-amplifying system of the house, you should get the best sound of all. Discuss the possibility with the custodian or house electrician.

At a memorial service, record the eulogist and other speakers, and any special choral or instrumental music. To present some aspects of the subject's life and achievements, I recommend taping brief interviews with family members, friends and business associates. An effective additional touch would be to include appropriate photos of the subject during various stages of his life.

CONFIRMATIONS

Confirmations, bar mitzvahs and bat mitzvahs require preparation and treatment similar to other affairs occurring in a place of worship. Thorough location scouting, awareness of the sequence and timing of events, and careful camera and microphone positioning are all essential to the production of a satisfying video.

CAMERA

Adopt a camera position that gives a clear view of the principal participants and the congregation. Get a variety of shots from the one position by panning and zooming. If you can move about freely, or use two cameras, you have wider scope. To get a clear view in all directions, provide some way of raising the camera higher than the heads of people surrounding you.

SOUND

For best sound reproduction of the ceremony, use an auxiliary shotgun microphone.

To obtain a complete sound record of the ceremony you must not stop recording between individual shots. You'll have to pan and zoom with a smooth, steady motion until a break in the ceremony lets you pause your VCR or camcorder. At such times, shift your angle or shooting position as desired.

As soon as the ceremony resumes, begin recording again so you don't lose important music or speech.

LIGHT

As with many religious ceremonies, unless you can get permission to introduce auxiliary lighting, you'll have to work with the ambient light. If possible, shoot a brief test a few days before the ceremony to determine whether or not sufficient light is available.

VARIETY

As with the other ceremonies discussed in this chapter, introduce variety into your movie. You can begin with a shot of the invitation, a close-up of some childhood photos of the subject, and shots of the subject engaged in some of his current interests. Tape the festivities after the ceremony, including speeches and toasts, dancing and conversation.

ANNIVERSARIES AND OTHER OCCASIONS

Here's an excellent opportunity to make fine video movies that will be appreciated for years to come. People love to have keepsake videos of anniversaries, "milestone" birthday parties, reunions, retirement parties and award presentations.

Typically, these events take place at formal locations such as dining rooms at restaurants, ballrooms or clubs. Activities include dining, dancing, speeches, presentations, music and lively conversation.

The formal part of the event usually consists of a meal, followed by speeches and presentations. Use auxiliary lighting on the main subjects, if possible. If the restaurant or hotel provides microphones and sound amplification, the microphone built into your camera may give you adequate sound reproduction. If the hall is very large, you'll get better sound if you can connect your VCR directly to the installed sound system. If the premises offer no sound system, use a microphone on a stand in the speaker's location or a shotgun mike at camera position for best sound reproduction.

If you're limited to one camera position, I suggest a place near the back of the room where you can zoom in on the major participants and also get a general view of the audience.

Always give special attention to the people being honored at the event you're taping. Get more close-ups of them and their reactions, and record them in conversation with guests.

To record the informal activities, such as dancing and general conversation, move about freely with your camera handheld. Conduct interviews with guests. Avoid questions such as "Are you having fun?" They merely elicit a "yes" or "no" answer. Rather, ask questions like "What's the most outstanding quality of this 60-year marriage?" They will elicit opinions and possibly amusing and touching anecdotes.

CONCLUSION

In this chapter, I've discussed some of the more common festivities and ceremonies. Of course, there are many others and it's impossible to write about all of them here. However, the information in this chapter is applicable to a wide variety of occasions and conditions. Follow the directions I've given on such topics as camera position, lighting, sound and other techniques that apply most closely to the shooting situation confronting you.

The occasion happens once and can't be reshot. Take a lot of tape and use it generously. Be sure to have plenty of battery power. Later, you can edit your tape down to a short and sweet presentation.

13 School Events

If you have school-age children, you'll probably shoot many of your video movies in classrooms, auditoriums and on playing fields. The events you'll record may include graduations, parties and proms, stage presentations, debates and class reunions. I discuss these in this chapter.

Sports are another big part of school life. However, sport is such a big subject in itself that I have given it an entire chapter.

GRADUATION

Graduation ceremonies consist principally of speeches and presentations. This calls for good close-ups and good sound reproduction. You'll need close-ups not only of speakers but also of your specific graduate. Record him or her during the opening procession and during the ceremony. Above all, get a good close-up of the graduate when the diploma is presented.

Shoot plenty of candid material following the official ceremony. This will present fewer recording problems than you'll experience during the formal part of the affair.

CAMERA POSITION

Shoot from near enough to the stage to obtain tight close-ups of speakers and graduates. Select a position that gives you a clear line of sight to subjects without obstruction from spectators' heads or objects in the auditorium. Avoid blocking aisles, exits and the view of others in the audience.

The angle from which you shoot should permit at least a good three-quarter view of participants. A head-on view is preferable. If you can, select a position directly in front of the stage.

When you select a side angle, be sure it is from the side toward which the graduates will be facing when they receive their diplomas. Otherwise, you'll tape the backs of heads at the crucial moment. Be sure the graduate is not hidden by the presenter as he is given his diploma.

A balcony position at the back of an auditorium gives a clear line of sight to participants on the stage. However, in most auditoriums this places your camera too far from your subjects for adequate close-up shots and sound pick-up. Unless you can set up your camera in front of the stage about 20 feet or less from the main action, I recommend a side position near the stage.

To ensure steady pictures, be sure to place your camera on a tripod. This is especially important because you'll need to use the telephoto setting of your zoom lens for close-ups.

LIGHTING

Usually, there is little you can do to supplement the available light. Small schools are likely to be lit by fluorescent light. In larger auditoriums and on stages, incandescent stage lighting will probably be used.

Outdoor graduation ceremonies may be held in daylight hours or in the evening under flood lighting.

Color Balance—White-balance the camera under whatever lighting conditions you encounter. If your camera has continuous automatic white-balance capability, it will do this for you.

If the general illumination is dim, concentrate on close-ups in key positions that are lit more brightly.

Depth of Field—In dim light, the lens iris will be relatively wide open. This gives limited depth of field. Under such conditions, you must focus accurately—unless your camera does this for you automatically—to be sure of a sharp image.

SOUND

You probably won't be able to place your own auxiliary microphone directly in front of speakers. An ex-

cellent alternative is to use an auxiliary shotgun-type microphone. Aim it carefully at the speaker or sound source you are recording. Your camera's built-in omnidirectional or semi-directional mike will be ineffective at distances greater than six to eight feet in a large, open area or outdoors.

If you can position your microphone close to a loudspeaker of a public-address system, you can use that source to record sound from a distant stage. However, I recommend this procedure only if you have no other way of getting adequate volume. Sound from an auditorium speaker system is generally not of high quality.

If you do use a public-address system, place your mike within 10 feet of the loudspeaker. If the distance between speaker and mike is too great, the sound you record will not synchronize with your speaker's lips. This is because of the relatively slow speed at which sound travels.

When you're far from home plate at a baseball game, you'll hear the crack of the bat a moment *after* the player hits the ball. The same effect occurs when you're recording sound from a loudspeaker 50 or 60 feet from your microphone. The delay between the image of the lips and the spoken words in your recording will then be about 1/20 second—long enough to be noticeable.

You'll get the best sound reproduction by connecting your camera to the auditorium sound system and thus using the stage microphones. See if you can arrange it with the house electrician or sound engineer.

VARIETY

Don't limit your taping to the graduation festivities. Start with early photos of your graduate at important points in his or her school career. Include shots from a class yearbook, earlier videotapes or 8mm film scenes. Also, show some views of the school. Conclude with a look to the graduate's future goals and aspirations through interview sequences. A suitable end to the movie would be a close-up of the diploma.

DEBATES

Debating and discussion groups generally occupy relatively small areas. Because there is little movement, you have a lot of control during such events.

The camera position must permit good close-ups of participants, and your microphone must deliver sound of good quality.

CAMERA

Set up your camera in a frontal position, so you can easily get close-ups of all participants. In a debating environment you should have little difficulty occupying such a location. The camera should be at subject's eye level so participants can look directly into the lens. This best simulates viewer participation. For a steady picture, place your camera on a tripod.

LIGHT

You should have little difficulty using supplemental lighting. Under most circumstances, two 500-watt or 750-watt lights should be sufficient to provide a good-quality picture. When using two lights, place one on each side of the speaker being recorded.

Avoid shining lights directly into the debaters' eyes. Use bounce light off walls or ceiling or from reflective umbrellas designed for the purpose.

If you must use direct lighting, use a diffuser to soften the light and reduce irritating glare. If the light level is sufficient from existing sources, a reflector or a relatively weak fill light may be the only supplemental source you'll need.

SOUND

An auxiliary microphone on the speaker's stand will give you the best possible sound reproduction. Or, use a shotgun mike aimed at the speaker from your camera position. Don't use an omnidirectional camera mike unless you're going to shoot from no farther than about six feet from participants.

BACKGROUND INFORMATION

Supplement your movie with some background information about the subject debated. Do this through interviews with teachers and participants or with photographs obtained from school reference books, magazines, newspapers or other sources. Be sure to obtain a solid conclusion or resolution of the debate, including interviews with winning and losing debaters.

STAGE PRODUCTIONS

The main difference for the moviemaker between a concert and a theatrical production is movement. Actors or musical stage performers are constantly on the move. This calls for different lighting conditions.

EXPLOIT THE BEST LIGHT

Place your camera close enough to the stage to permit good close-ups with your zoom lens at its maximum zoom setting. This is particularly important where the overall stage lighting is dim. For example, in a dramatic presentation key performers are generally spotlighted separately.

Musicals and other "spectaculars" are usually lit more brightly over the entire stage. That's because interest

is more often directed at an entire event rather than at specific locations on stage. In such cases, you can pan and zoom more freely without hitting unpleasant dark areas. However, don't forget the power and impact of the close-up.

SHOOT SEVERAL PERFORMANCES

If a production is presented several times, take advantage of this and shoot on each occasion. You can also shoot at the dress rehearsal. This provides an opportunity to record the event from different angles, including the wings. Select the best shots and reassemble them later on a master tape.

SOUND

You'll get the most uniform sound pickup from the entire stage by using two cardioid microphones. Mount them on table stands and place them one third of the way in from each side of the stage front. The sound can be fed into your camera through stereo jacks or by means of an audio mixer.

A single cardioid mike, suspended over the stage or near the front of the audience, will also provide satisfactory sound, provided it is no farther than about 20 feet from the performers. In any event, it will provide much better results than your camera's built-in, omnidirectional microphone.

To pick up individual speakers on stage, you can use a shotgun mike from a central position in the audience. For clear and uniform sound pickup, however, this mike must be aimed accurately.

PLAN YOUR MOVIE

Your creativity need not be limited by the fact that you're taping someone else's production. For example, you can begin your movie with a close-up of the printed program. Show first the cover and title. Then, turn the page and show the detail of acts and scenes, and names of performers.

If there's an intermission, you can tape some of the activity at that time—people getting snacks and talking with other members of the audience. End the movie by showing the cast taking bows and, if there's enough light, audience applause and reaction. Show the curtain coming down.

For more details on stage productions, see Chapter 5.

MUSICAL PRESENTATIONS

Movies of musical events are different in one important aspect from other movies: Sound quality is more important than visual content. Whether you're taping an orchestra, band, instrumentalist or singer, get as much variety as possible into the video, but don't compromise on sound quality.

Because music is popular and commonly performed everywhere, not just in schools, it is discussed more fully in Chapter 5, *Documentary or Staged Production*.

CLASS PROJECTS

Classrooms tend to be bright and evenly lit. General light level, therefore, should present no problems. This will enable you to concentrate on shots and good shot continuity. If the lighting is fluorescent, use the camera's white-balance and color-adjust controls to get the most pleasing color balance you can.

If overhead room lighting causes unflattering shadows on faces, use white cardboard reflectors to brighten the shadows in close-up and medium shots. For wider views, use supplemental bounce light or soft direct light.

When you're recording a student who is active with his hands but is in a relatively stationary position, it's important for your camera to be absolutely steady. Use a tripod.

Shoot an introduction to the activity being taped. This can be an explanation by a teacher or student. Be sure to get overall, medium and close-up shots from several angles. Include reaction shots of other students.

If necessary, tape the various aspects of the project at random and edit them into a coherent master tape later.

Be sure to obtain good close-ups of everything discussed or done by the students. Your viewers will be frustrated if they cannot see a clear shot of objects discussed or handled.

As long as you're no farther than four to six feet from your speaking subjects, your built-in camera microphone should be adequate. When shooting from a distance—such as a child at the blackboard with your camera at the back of the room—you should use an auxiliary cardioid or shotgun mike.

STUDENT ELECTIONS

This aspect of school life is best recorded through the interview techniques described earlier. Select a host or hostess to establish the issues on which the candidates will run and to conduct the interviews. Prepare your questions in advance to ensure smooth, effective interviews.

In addition to the candidates, tape interviews with students chosen at random, to obtain their reactions and views. Shoot at the balloting scene and interview students as they leave the polls.

Get shots of the winning and losing candidates as final results are an-

nounced. Interview them again to get their final opinions and future plans.

Before you begin an interview, be sure to give a full introduction of the person being questioned. Provide name, grade and part being played in the election.

You can open your movie with introductory graphics, election banners and posters, together with appropriate music. Conclude with the winning candidate's celebration. Show a pile of discarded campaign posters, ticker tape, spilled confetti and a photo of the successful youngster—together with the movie's theme music.

CAMERA TECHNIQUE

Use a tripod for formal interviews. However, because much of the movie is likely to be of the news-gathering variety, handheld camera work is acceptable for most other shots. Concentrate on very tight close-ups during interviews.

The interviewer need not be on camera while posing each question. Alternate between questions coming from off-camera and others with the questioner in the picture.

If you wish to shorten a candidate's statements for your final master tape, cut to the host and then back to the candidate at a later point in his statement when you edit. You can also use this technique to insert comments or questions from the host or hostess after the shooting is over.

Over-the-Shoulder Shot—An alternative way of shooting an interview is to aim the camera over the host's shoulder. Begin by showing a partial back view of the interviewer and a frontal view of the candidate beyond. Then, zoom smoothly and slowly to a close-up of the candidate.

LIGHTING

For formal interviews indoors, use the portrait lighting described in Chapter 6. For informal interviews out on location, you'll probably have to work in available light. When necessary, use reflector cards to lighten shadows.

SOUND

As long as you're no farther than about five feet from your subject, your built-in camera mike should be adequate. However, you'll always get better sound with a good cardioid mike, held by the interviewer. For formal interviews in a fixed location, a lavalier or table microphone is ideal. For distant speakers, campaigners and demonstrators, use a shotgun mike.

PARTIES AND PROMS

These school events basically resemble the parties I told you about in Chapter 12. Shoot several overall establishing shots and then concentrate on close-ups of individuals or couples. Include a sequence of shots of the band.

Dance halls are generally dimly lit. If you can, set up a special illuminated area, using one or two 750-watt quartz-halogen lights. Coax individuals and small groups that you want to record into that area. If you want to be more mobile, use a hand-aimed 500-watt photoflood in a reflector or a small, camera-mounted spotlight to illuminate your subjects.

Use the interview techniques described earlier to round out your record of the affair.

Be sure to have a good beginning and ending for your movie. Open with preliminaries and preparations—the young couple leaving home for the event, arriving at the school and entering the dance area. End with goodbyes and the couple leaving. If there's a private party after the public event—and you can get admission—include that in your movie.

CLASS REUNIONS

These are parties, basically similar to proms. Use a handheld camera and available light for candid shooting. Where you have control of the situation, use a tripod-mounted camera and separate lighting. Include interviews with reuniting graduates. Use a host or hostess—perhaps a class president or popular member of the class—to tie it all together.

14 Sports

For video purposes, sporting events should be divided into three basic groups: Team sports, one-on-one contests and individual performances.

TEAM SPORTS

Team sports include baseball, basketball, football, hockey and soccer. You must record the interaction of two groups of contestants.

If possible, shoot a large proportion of the action from a high angle. Position your camera about midway along the playing area. Stay on the same side of the field, court or rink. If you were to switch sides, and have players suddenly moving in the reverse direction, it would confuse viewers of your movie.

Record the main action as well as detail shots. This means you must be prepared to zoom and pan at the right moments. I'll discuss this in more detail under the different sports headings.

ONE-ON-ONE CONTESTS

The second group consists of such sports as tennis, boxing and wrestling, in which two individuals are in direct contest.

Tennis is best shot from one end of the court rather than the center. The camera position should be high.

Ideally, boxing should be covered from both high and low angles. Wide shots from a high angle are best to show general action. Shots from a low angle emphasize the size of the fighters and their power.

If you can shoot from only one position, try to get a place near ringside where you won't obstruct other spectators, and others won't block your view. To vary your shots you must rely largely on zooming. Treat wrestling basically the same as boxing.

INDIVIDUAL PERFORMANCES

Finally, there's the group in which, although there's competition, each performer displays his skill individually. Such sports include golf, gymnastics, certain track and field events, auto racing, diving, skating and skiing.

In some sports there's a certain overlap of the above groups. For example, in a race—whether on foot or in a racing car—competitors are generally proving their abilities without direct confrontation with their opponents.

LIGHTING

Playing fields and stadiums used after dark are lit adequately and uniformly, so extra light won't be needed. Indoor sports locations are also usually lit well. If the light's bright enough for the participants to perform, it will be bright enough for you to shoot in. Therefore, supplemental lighting should never be a requirement. Lighting in modern sports arenas is usually even color-balanced for TV.

Because audience areas in sports arenas are left unlit, they serve as a dark background that allows the action to stand out well.

SOUND

To capture the atmosphere of the scene, you must record the sound of audience excitement and participation. In a large arena or stadium, a cardioid microphone is best. In a smaller area, such as a hockey rink or basketball court, the camera's omnidirectional mike is generally adequate.

If you want to record sound from specific individuals, such as the grunt of a server in a tennis match or announcements by a referee in a football game, use a shotgun micro-

phone. Aim the mike carefully in the direction of the sound you want to record.

Interview key athletes before and after games or events. This adds interest and information to your movie.

CAMERA WORK

The fundamental technique in shooting sports is to catch the *main* action while also recording *secondary* action. This means using zoom and pan skillfully. For example, you must be prepared to follow the forward action of a contest, yet not lose sight of a charging competition that may reverse its progress. I'll give you tips about this in specific detail when I discuss sports individually.

Here are some camera-handling tips to follow when shooting sports:
● To maintain the feeling of action, zoom in or pan to a close-up only of a player who's active. Such a transition to a static player would be meaningless and anticlimactic. An exception would be to catch a player's delight at a teammate's success or his frustration at a blunder.
● When panning with a moving player, leave more space in the frame in front of the player than behind him. If he's going left to right, for example, keep him just to the left of frame center. The faster a subject moves, the more space you should leave in front of him.
● Anticipation is important. Be prepared for players' movements. It's essential to understand the rules of the game you're recording and to be familiar with its playing. Watch for tell-tale head, hand or body movements that indicate a player is about to move or change direction.
● Keep players in focus as they move toward or away from you. The closer you are to the subject, or the closer you zoom in on him, the more critical focus becomes. Bright light is

your ally because it provides a relatively small lens aperture and accordingly greater depth of field.
● To "punctuate" your movie, cut away to a quick shot of the scoreboard after a team or player has scored or include referee signals and the down indicator in a football game. Intercut close-ups of spectator reaction following a score or when a score is threatening.
● Pause your camera with the *on-off* button to eliminate dull periods between action such as huddle breaks during a football game. Resume shooting when the action resumes.
● If you think you're reaching the end of a cassette, eject it during a break and replace it with a fresh one. You don't want to run out of tape in the middle of the game's best play.

INSPECT THE LOCATION

Familiarize yourself with the shooting location before the event. Select the most advantageous camera positions. If the event is outdoors, bear in mind the position of the sun.

At an indoor location with windows, such as a basketball court or swimming pool, try to avoid sunshine backlighting your shots. If this occurs, your subjects may record as expressionless silhouettes. If your camera has a backlight switch, use it in such conditions to increase exposure on the main subject.

ANNOUNCER

With an auxiliary mike plugged in to your camera, you can be your own announcer. It's easy and fun. Describe the action as you shoot.

Alternatively, you can have someone else provide the commentary. For this you'll need a small, battery-operated monitor so your announcer can see what you're taping and synchronize his commentary. A third option is to add commentary later, using

the audio dub feature on your VCR. Add music, too.

FOOTBALL

Locate your camera at an elevated position on the 50-yard line. This provides equal coverage of both sides. The ideal position is a press box, high up in the stands. While shooting the game, use your camera on a tripod. It saves you from carrying the camera for extended periods and also gives you the smoothest pans and tilts. To capture spectator reactions, you may need to use the camera handheld.

At the beginning of a play, frame the ball carrier to one side of your screen with the blockers in front of him on the other. As he passes the line of scrimmage, gradually center him so you get the action both ahead of and behind him. If he makes it through the secondary defense, let him move to the leading edge of your frame to reveal following action behind him.

Keep a passer in the frame until he throws the ball. Then pan to the receiver while zooming out to a wider view. If the ball is caught, hold the wider shot to show the other players around the catcher.

Stay with a kicker until he kicks the ball. Then widen, pan to the catcher and gradually tighten on him until the play is ended.

On an extra-point or field-goal attempt, frame the kicker off-center with space in front of him. This should include the charging defense at the other side of your frame. Follow the ball as it is kicked.

Open and close the movie with several close-ups of spectator activity and enthusiasm.

BASKETBALL

Set up your camera on a tripod at an elevated position overlooking cen-

ter court, much as for football.

Go for a medium close-up on the starting jump, then widen smoothly as action gets under way.

Follow the ball in medium to medium-wide shots. Because action is fast and continuous, attempts at close-up shots may lose you coverage of an important point or lead to a dizzying series of sudden zooms and pans.

For variety and drama, move briefly to a position giving you a low-angle shot upward toward a basket. You may not be able to tape continuous action there, but you should get some spectacular shots of players converging under the basket and leaping to dunk the ball.

If possible, get a big close-up of a basket from an elevated position and wait for some action. Again, you may lose some game continuity but you will add excitement and heighten visual interest with some exciting shots.

ICE HOCKEY

Here, too, a centered, elevated camera position offers you the best coverage. Action is very fast, so medium to wide shots are the rule rather than close-ups. Otherwise, you could never hope to follow the puck and contain the progress of the game.

You can start with a close-up shot of hockey sticks at a face-off. Zoom out as soon as the referee drops the puck. Then follow the ensuing action in medium shots.

Zoom in on the defending goalie when a shot is about to be attempted. You'll see the outcome even though you may lose the shooter's action in the process.

To add atmosphere and extra interest, record spectator activities, too.

SOCCER

As in most other field sports, soccer requires coverage from an elevated, midfield position. Because the action takes place over a much larger area than ice hockey or basketball, it appears relatively slower. Therefore, you have more opportunities for tighter shots without losing important action.

Open with a wide shot of the field at kick-off. Tighten in as action gets under way. For variety, you can sometimes begin a kick-off with a tight shot of the kicker and then widen the shot as the action spreads out.

Zoom in for head-to-toe shots of players dribbling the ball. Zoom smoothly out and pan as the ball is booted downfield.

Occasionally attempt a rapid zoom shot to the goalie as he dives to save a goal. Avoid overdoing this shot, however. Done excessively, it can lose its impact and even become annoying to viewers.

BASEBALL

This is probably the most difficult sport to cover with a single camera. That's because action can happen in several places simultaneously.

The best place to set up your camera is directly behind home plate and as high as possible. This gives you a good view of the action involving three key people—pitcher, batter and catcher. It's also a good location for widening the camera's view when a hit is made.

On a high, fly ball you'll have time to zoom smoothly in to the fielder who makes the catch—or misses it. Then widen and pan to get the action of runners.

To simultaneously record a fielder and base runner on different sides of the field, zoom to a wide shot. If necessary, also pan the camera. Al-

ways concentrate on the most important action, whether it's at home plate, one of the other bases or elsewhere in the field.

There are many possible play situations in baseball. It makes the game exciting but also sometimes difficult to record. I recommend you think over a variety of common game situations and try to determine how you can cover them best. In addition, always be ready for the unexpected.

Don't neglect to capture spectator enthusiasm and other typical features, such as hot-dog, soft-drink and ice-cream vendors.

VOLLEYBALL

Here's a sport you can shoot effectively from low as well as high angles. Position your camera at a low angle, just off the court and near the net. Cover the action from there, following the ball in a medium shot. You'll get great shots of action together with the expressions on players' faces.

For variety, change your position to a high angle at one end of the court, slightly toward the side from which you originally shot. Get some hand-held close-ups. They'll convey a sense of participation in the game. To prevent viewer disorientation, again shoot from the side on which you first set up your camera.

TENNIS

For all the "side-to-side" games discussed so far, I've advised you to shoot from the center of the long side of the playing area. This gives a comprehensive view of most of the game activity.

With tennis it's a little different. The nature of the game is such that the best view is from a high angle at one end of the court. This way you'll get the clearest picture of the court and most of the action, including

serves and "outs." It also avoids the intolerable panning back and forth that would be needed from the mid-court position.

You should position your camera behind the court at a distance that provides a shot wide enough to cover the entire court and narrow enough for clear close-ups of the player at the far end.

Choose the better end of the court to shoot from and stay there. Your choice will depend on the position of the sun and, sometimes, on background considerations. Because the players change ends regularly, you'll have ample opportunity to obtain head-on close-ups of both contestants.

When the player at the far end serves, begin with a close shot to show the service action. As the ball is served, zoom out wide to cover the return and catch the subsequent exchanges. When the player nearer to the camera serves, maintain the wide shot. It will give a close view of the server and a sufficiently wide view of the court to show the ensuing action.

The advice given here applies equally whether you're taping singles or doubles.

Be sure to capture the traditional, humorous shot of audience heads moving back and forth in unison as all eyes follow the ball during an exchange.

TRACK AND FIELD

These events can be covered more easily with a single camera than the sports already discussed. In team games, you must often choose between relatively unexciting overall coverage and more exciting, but incomplete, close-ups. In track and field events, it's relatively easy to concentrate your attention, and camera, on the solo performer and his immediate environment, and capture

all the important action.

Foot Races—Select a fixed, elevated camera position near the finish line. In events long enough to use the entire track, this will usually also be the starting line. Mount your camera on a tripod so you can follow the runners with a steady sweep.

If the starting line is some distance away, use your tele lens setting to record the start. Gradually widen the view as runners move out and the field spreads. Then concentrate on leaders and challengers. Tighten in to catch the winner at the finish.

Races covering one or more laps allow enough time to move your camera for different viewpoints and yet have you back at the finish line for the dramatic end.

Shoot some dashes from beyond the finish line, looking down the track toward the start with runners coming directly toward your camera. Use your telephoto setting as they leave the blocks. Zoom out gradually as they approach, holding them in a tight shot. Right after the finish, zoom to a close-up of the winner. You'll get some exciting action and facial expressions using this technique.

If you're in doubt about your right to occupy certain positions, obtain permission from track officials beforehand.

Jumping Events—The high jump and pole vault are best seen from a low angle to emphasize height as the subject soars toward the bar. Set up your camera on a tripod, at a low angle, close to where the contestant lands following his jump. From there, with careful panning and zooming, you can tape the entire event. Record the running approach, the jump and the landing and finish with a tight shot of the athlete, showing his reaction to his effort.

The long jump may also be taped

from a low angle for visual excitement. However, you must follow this shot with another, higher view to show the distance of the jump. It's easy to accomplish this with one handheld camera. Stoop to a low position and tape the jump from there. Then, while still recording, rise smoothly to full standing height, aiming your camera down to show the length of the jump.

Throwing Events—Throwing the discus, javelin and hammer, and putting the shot, are also taped effectively from a low angle. Position your camera so you will see the thrower's face at the moment he propels the object forward. You can then pan and zoom with the object to its landing. However, it's often more interesting to record the contestant's final effort or follow-through.

Because thrown objects fly a considerable distance, you'll have to record a second shot of officials announcing the result. Follow with a shot of the athlete's reaction.

GYMNASTICS

Gymnastic events generally are viewed most effectively from a low position. Much of the action takes place above floor level, making low-angle shooting easy.

I recommend a camera position that records a frontal view of the gymnast at the start and end of the routine. Hold the performer in a full-length shot during the entire performance. If the gymnast moves toward or away from the camera, you need adequate depth of field to maintain image sharpness. Otherwise, you must follow focus carefully as you shoot—not an easy task. If you shoot from the side, pan and tilt smoothly to keep the gymnast in a well-framed shot.

A wide variety of camera positions will provide an acceptable shot be-

cause of the elevated nature of most gymnastic exercises. Use your own creativity to select angles that provide interesting and unusual views. A varied sequence of shots during the competition will provide a visually exciting tape.

SWIMMING

To shoot swimming events, you need a high camera angle that clearly shows the relative positions of competing swimmers. For the start, place your camera at one side of the pool, looking along the start/finish line.

Move along the side of the pool to record the race. Pan smoothly with the swimmers or have an assistant "truck" you in a wheelchair or other suitable carriage. Tighten in on leaders as the contest progresses.

Shoot along the finish line to record the finish. Capture the winner's reaction in a tight close-up.

If the event is long enough, cut away to the audience a couple of times, to record its enthusiasm and cheering.

DIVING

Adopt a three-quarter view from one side and slightly in front of the diver. Frame the diver in a head-to-toe shot as he or she balances on the board. Follow in a smooth tilt and pan as the dive is executed and the contestant enters the water. Hold the shot and record the diver surfacing and emerging from the pool. Then zoom smoothly to a close-up for his reaction.

High-diving boards offer an opportunity for spectacular low-angle shots and soaring action. Place your camera far enough in front of the diving platform to enable you to see the diver's face and body, unobscured by the board. To ensure a smooth pan and a steady shot, use the camera on a tripod.

Begin with a medium shot as the diver approaches the end of the board or platform and prepares his position. Widen to a full shot as he is about to execute the dive. Follow the dive smoothly to the water and tighten as the diver emerges from the pool. Follow with a shot of spectator reaction.

If the pool has underwater windows, try some shots of a diver entering the water from this view. Intercut them with your above-water shots at the point your diver meets the pool. To make an in-camera edit, pause your tape at the required point in the first shot, move to the window and resume taping the next dive there. Or you can make the edit later, using a second VCR.

Unfortunately, the video camera does not enable you to record slow motion—a spectacular feature for recording dives. You can achieve this effect, however, if your VCR offers slow-search and freeze-frame capability. Try it when you replay your diving video.

FIGURE SKATING

A combination of high and low angles provides the most satisfying video tapes of this sport. Figures on the ice are best shot from a high angle, to show the pattern created. Set up your camera on a balcony or the highest position you can manage. You'll capture attractive light reflections and moving shadows on the ice in addition to the skated figure tracings.

Leaps and spins are most spectacular when viewed from a low angle. This requires a camera setup on or at the edge of the ice rink. If you can get permission to set up on the ice, be sure the skaters are informed beforehand—and be careful not to slip and damage your equipment!

Figure skating involves expression with the entire body, so be sure to include the entire body in most shots. However, to give a tape variety, especially during a lengthy performance, zoom in occasionally to a medium close-up of the performer's face or feet.

For a face shot, try to select a moment in which the body is momentarily relatively still. This might be during a glide or at the end of a spin before the next figure is started. A small, intricate pattern is a good point to move in for a close-up of the feet. To execute these shots effectively, it is important to be familiar with the skater's routine before attempting to tape it.

Because figure skating is performed to music, sound is an important aspect of your movie. Since several speakers usually fill the rink with sound, your camera mike may give you adequate pickup. I recommend a standby cardioid or shotgun microphone, however, that can be quickly plugged into your camera and positioned or aimed at a convenient speaker.

If possible, check your audio with a brief playback of your tape on a portable, battery-powered monitor. Or, listen with headphones to the audio track as you record. Then make any necessary adjustments or modifications.

As with other sports, add variety and interest by occasionally cutting to spectators, and other performers who're watching. Also record the scoring.

GOLF

Of all the sports I've described, golf is the easiest to cover satisfactorily with one camera. Not only is it a solo sport, but the performer also moves relatively little and does so slowly and predictably.

For an effective tee-off or iron shot, position your camera so the

golfer is facing your lens. He or she will then drive the ball to camera right. From this position, you'll get a satisfying view of swing and follow-through.

Normally, your lens should be approximately at eye-level. If you're striving for a dramatic effect, shoot from a little lower.

If you prefer to see the direction in which the ball flies after it is hit, position your camera facing the golfer's right shoulder. This way you can avoid a wild pan and zoom in an attempt to follow the ball from the first position I've described. However, it provides a less satisfactory view of the golfer's stance and form. To give your movie variety, use both viewpoints.

A good putting shot requires a high position for your camera. In case you can't find a vantage point to stand on to raise your camera, I recommend that you take a small, wooden box with you when shooting golf. If you can persuade an assistant to come with you and carry the box, it'll make your work much easier.

Position yourself in line with the cup, in the foreground, and the player, beyond the cup. After the putt is made, zoom in smoothly to a close-up of the ball as it rolls successfully into the cup—or misses it. Pan up to catch the golfer's reaction.

A nice alternative putting shot involves setting your camera almost at ground level. This gives a worm's-eye view of the ball rolling into a big close-up and disappearing into the cup—or perhaps missing it. Be prepared to move away quickly, if necessary, so as not to obstruct the ball.

You can make a golfing tape additionally attractive by taking advantage of the typical beauty at and around courses. Occasionally shoot through trees or frame your shots with bits of soft-focus leaves or flowers in the foreground.

Take some wide shots showing the general scene, distant spectators and blue sky. Look for bold angles and striking compositions where sunlight and shadow play across your pictures. Early morning or late afternoon is ideal for this type of shooting.

TAPES FOR COACHING

Sports videos can be useful training tools besides providing family records and entertainment. They enable players to watch and analyze form, position, stroke or stride. Use the basic shooting methods I've described. However, select camera angles that best show the moves or techniques you and the athletes want to study.

In many respects, coaching tapes are easy to make. You aren't concerned about audience reaction or special creative effects. To study such simple actions as your golf swing, you can be both sportsman and moviemaker. Simply set up your camera on a tripod in the back yard, start recording and move out in front. Some cameras have a remote-control switch to help you do this. Later, review your tapes and learn from what you see.

For team sports such as football, basketball, baseball or hockey, concentrate your shooting on overall action, keeping the entire team visible in a wide shot throughout the period of play. When desired, single out particular individuals for study, following their action regardless of contribution to a particular play or situation. In this way, both team and individual performances can be reviewed and evaluated.

To analyze individual-performance sports like track and field, gymnastics, figure skating, tennis and golf, it's generally best to tape an athlete in a full-figure shot. Shoot from several viewpoints, regardless of normal viewer orientation to the game. Such a tape will enable a player to view his performance from several angles, enabling him to make a comprehensive evaluation of his technique.

When shooting a single runner, concentrate on style. When shooting an actual race, include the nearest competitors. They will permit analysis of the runner's game-plan execution relative to his immediate challengers.

Underwater shots through windows in a pool permit excellent evaluation of swimming techniques.

Use the slow-motion and freeze-frame capabilities of your VCR to give viewers the best analysis of their sports performances.

15 Travel

Modern video equipment is amazingly portable and inexpensive to use. These features make video an ideal medium for recording your travel experiences and vacation fun away from home. In this chapter, I tell you how to make travel and vacation movies you'll treasure.

EQUIPMENT

It's important to take the right equipment without carrying too much. Here are some things you'll need, in addition to your camera and VCR or camcorder:

Carrying Bag—To protect your equipment, carry it in a waterproof and shock-resistant bag. It should have a foam lining and dividers to prevent items from banging against each other, and should be designed to give you easy access to all the items.

Video equipment is attractive to thieves. Don't advertise what you're carrying. Avoid using specially made video-equipment bags that carry a manufacturer's name in large letters.

Power Supply—A VCR and camera won't run much longer than one hour on the VCR's internal battery. Take a power pack, extra batteries and a battery recharger.

Tripod—Be sure to take a tripod. A lightweight, inexpensive tripod is adequate for most purposes.

Handheld Microphone—I recommend you include an auxiliary microphone with your equipment. With your camera on a tripod, the handheld mike enables you to enter the picture for making commentaries or conducting interviews.

Camera Light—To enable you to shoot close-up subjects in dim light, go prepared with a camera light that fits on the shoe of your camera. To conserve battery power, use the light only when really necessary.

Videotape Cassettes—Take at least two videotape cassettes, preferably more. If one develops a problem, at least you won't be stuck. And you may want to shoot more footage than you had anticipated.

Neutral-Density (ND) Filter—These filters, available in various densities, reduce the light transmitted through the camera lens without affecting color balance. An ND filter is useful in extremely bright conditions, such as are found on a sunny beach or in a snow scene. The filter can also protect the picture tube from damage.

Battery-Powered Monitor—If your camera does not provide playback capability through an electronic viewfinder, it's useful—although certainly not essential—to have a battery-powered monitor.

Luggage Carrier—To help transport your equipment, use a lightweight luggage carrier with wheels.

EQUIPMENT CARE

Here is some advice on caring for your video camera and accessories:

Carry Your Equipment—Always carry your equipment with you. Don't check it at airports or allow others to handle it. If you must ship equipment, package it carefully—preferably in its original container.

Avoid Heat and Humidity—Protect your equipment from extremes of temperature and humidity. Never leave camera, VCR or videotape in a car on a hot day. When shooting under midday sun in summer or in a tropical location—especially at the beach—shade camera and VCR with an umbrella.

Prevent Condensation—When dampness penetrates your VCR or camcorder, it may not function properly. Most VCRs incorporate a *dew-*

warning system. It either warns you of excessive dampness in the unit or prevents the unit from being used under those conditions.

When you move your VCR through an extreme temperature range, such as from a winter exterior to a heated interior, condensation may form. Wait until the dew warning goes off, or for at least an hour, before using the equipment.

SHOOTING TECHNIQUE

Begin your movie early—even before you leave home. Record the planning and preparations. Shoot a map showing the itinerary, the places you plan to visit, events you expect to witness.

When you tape the trip itself, use good visual continuity. End with the return home. Add appropriate theme music. If your camera has electronic lettering capability, include opening and closing titles. You can also use captions for each individual scene.

Here are more tips that will help you produce a satisfying and professional-looking movie of a trip:

Panoramas—In your travels, you'll frequently encounter sweeping panoramas that you want to record. There's a natural temptation to pan your camera in a broad sweep across a scene, seeking to take it all in with one exhaustive, panoramic shot.

To make such a shot effective, I advise you to do three things:

1) Have your camera firmly mounted on a tripod. This will give you a smooth pan.

2) Pan the camera slowly. A pan through 45° should take at least five seconds. Begin and end the pan with a stationary shot of at least a couple of seconds.

3) Try to have a person in the foreground, moving steadily with the pan across the scene. This person can point out locations of special interest as he traverses the scene.

Instead of one panoramic sweep, you can shoot a sequence of views, each depicting a particular aspect of the area or landscape you wish to show. This can comprise a long shot, a couple of medium shots and perhaps a close-up or two of key points of interest.

Correct Exposure—Good images result from correct exposure. When you're traveling in distant places, you don't easily get a second chance. You must get the picture right the first time—or lose it. Evaluate each scene carefully in the camera's viewfinder to make sure the automatic iris is set for best exposure of the most important part of the scene.

For example, when a scene contains a dark landscape with brilliant cloud formations above it, the camera's automatic light sensor will adjust the aperture for the brightest portion of the image—the clouds. As a result, the landscape you may wish to see in clear detail will be dark and indistinct. In such a situation, use the camera's backlight switch or disengage the automatic iris and adjust the iris manually for best exposure.

Snow and Sand—At the beach and in snow, especially in bright sunlight, a foreground subject of average tone will have a much brighter background. To record the foreground subject accurately, use the camera's backlight switch or disengage the automatic iris control and set exposure manually. If you don't, you'll get a well-exposed background with your foreground subjects in silhouette.

Wooded Areas—Foliage and branches of trees can break up direct sunlight into bright and dark patches. While you can't avoid this effect in the overall scene, you can with individual foreground subjects. Place your subject in positions where he is lit uniformly.

Generally it's best to put subjects in bright patches of light rather than in shaded areas. Expose for the foreground subject. Most of the remainder of the scene will record a darker tone. If you placed the subject in the shade and exposed for that area, other parts of the scene would be burned out, lacking detail and color.

When a subject moves slowly through areas of sunlight and shadow, the automatic iris can adjust for the brightness differences. However, avoid detailed shots of subjects having a bright and dark speckled appearance caused by sunlight coming through foliage and branches.

Scale and Perspective—Placing people in the foreground of scenic views does more than simply add human interest. It helps to establish a size relationship with the scene. For example, when you put a person in front of a giant redwood tree in California, the Sphinx in Egypt, a Dutch windmill or an old whaling ship in a New England port, you give the viewers of your movie useful information about the dimensions of the recorded subjects.

The same applies when you record tiny objects such as a sea shell or a bird's egg. To show their true size, include a hand or finger to establish size. Any other object whose size is generally known—such as the tip of a pencil—will also do the job.

Placing a person in the foreground of a scene also enhances the feeling of depth. For example, any picture of the Grand Canyon is likely to appear spectacular, simply because of the grandeur of the scene. However, by placing a person in the foreground, you give the picture an added dimension. The viewer suddenly becomes aware of the actual distance and space between the camera and the far rim of the canyon.

CITIES AND TOWNS

To present a comprehensive movie of a city, town, hamlet or village, include overall views, individual buildings such as churches and town halls, close-up detail of shop windows, fountains and statues, and people. Try to show the local lifestyle, customs, occupations and recreation.

Conduct interviews with local people. If you're friendly and explain your interests, most won't hesitate to cooperate.

To associate people with their environment, use the telephoto setting of your zoom lens. It contracts distance, putting people in intimate contact with their surroundings. A wide-angle setting tends to deepen perspective, visually disassociating people from their immediate setting.

The telephoto setting has the added advantage of enabling you to shoot from a distance. This makes it easier to get candid shots of people in natural activities.

Architecture—To get an entire building into the image, you'll often need to use the wide-angle setting of your zoom lens. However, even when it's not necessary, this setting is often advantageous. It makes a building look more massive and impressive. Cut to close-ups to show distinguishing details.

If you plan to follow an exterior shot with interior views, zoom in to a door or window and then cut or fade to the interior view.

MOVING VEHICLES

When you're on a moving vehicle, such as a train, bus, aircraft or boat, or are a passenger in a moving car, shoot handheld. Your body absorbs much of the vibration and unsteady movement of the vehicle. If you were to use a tripod, most of the vibration would be transferred directly to the camera through the tripod.

A handheld camera also gives you much more control in aiming the camera while you're in motion.

To minimize image unsteadiness on an erratically moving vehicle, such as a ship on rough water or a fast-moving train, use the wide-angle setting of your lens. If you want to use a tele setting to record a distant scene as large as possible, concentrate on keeping the steadiest possible aim on the scene.

When on a boat, keep waterproof coverings around the camera and VCR to protect them from spray.

It's also good insurance to fasten a lanyard to the camera and have an assistant hold one end. For your own safety—in case you go overboard—do not tie the camera to yourself.

ENTERTAINMENT

The alert traveler can find many sources of entertainment far from home. To cater to tourists, there are amusement and theme parks, fairs, parades and rodeos.

The rides and other activities at fairs and amusement parks provide many opportunities for eye-catching sequences for a travel movie.

When you visit a theme park, such as Disneyland or Walt Disney World, organize your shooting carefully. It's all too easy to tape random snapshots rather than an organized movie. Begin at the entrance and work your way through the more exciting activities so one leads logically to the next. Explain or diagram your progress.

Shoot signposts and signs for well-integrated, clarifying titles. This will give your viewers a sense of participation in the experience. Conclude with shots that sum up the theme and highlights of the tour.

At a fair, record the barkers, games of chance, vendors, and crowd reaction. Use the tele setting of your zoom lens. It will provide an enhanced sense of involvement with the people and activities. Tape them in the daytime and at night. After dark, concentrate on figure shots in well-lit areas.

In parks or at county fairs that feature Ferris-wheel and carousel rides, try shooting from the ride itself. Begin by taping the family climbing on. Then join them with camera and VCR and shoot from the ride. If you can, also shoot the reaction of family members as they experience the ride.

You can try the same technique on pony or elephant rides, too. A camcorder is best for this type of taping.

To record children on a moving carousel from the outside, shoot as the children approach the camera. You can extend the shot by panning with the child as he passes you and disappears on the far side. Don't aim your camera head-on at the carousel. This viewpoint will give a quick glimpse of a child passing by but won't provide the real sensation of a carousel ride.

You can take impressive shots of Ferris wheels and carousels at night, with their many colorful lights in motion.

Fireworks—Fireworks are part of many festivities. To record them, mount your camera on a tripod and frame the area of sky where the display is to occur. Control both the aim of the camera and the zoom setting to capture the effects you want. Don't overdo the zooming, however. It could distract attention from the fireworks themselves.

The camera's auto iris will initially open for the dark sky but will then adjust for the showers of light, especially when you are shooting close-ups of the bursts.

PARADES AND MARCHING BANDS

Parades are popular all over the

world. Whether the purpose of the event is historical, cultural, sports-related or religious, each one is unique. They offer a variety of delights, including marching bands, floats, horses, dancers and many other colorful participants.

If you're fortunate enough to encounter one of these events in your travels, don't miss the opportunity to record it. It can provide you with an exciting movie section, full of local color and tradition.

When shooting a parade, maintain a consistency of direction. If you start shooting a parade moving from left to right, keep shooting it that way. Otherwise you'll confuse the viewer of your movie. If you want to change the direction of the movement, include a shot that clearly indicates you've changed your position.

A good location to shoot a parade is at a corner, where you can see the marchers coming at an angle to you and then turning to almost approach you. This way, you can shoot both a side view and frontal view. You'll also have the marchers in good view for the longest possible time.

If you can, get high and low shots. Unless you have a second camera operator and camera, you'll have to move fast. If you can stand in front of the parade and have the marchers go past you on both sides, all the better. This kind of shot is best made from a low angle.

SOUND

Sound is a very important part of your travel movies. Capture the local noises, be they of traffic, industry or animals. Record the chatter of the people in the streets and markets, even though you may not understand the language. It will add an authentic atmosphere to the movie.

Interview people on camera, when they have interesting or amusing stor-ies or viewpoints to offer. When the movie is finished, and perhaps edited, write and add a narration. Also, add appropriate music.

GOING ABROAD

If you plan to use your video camera outside the United States, you should be aware of some special needs and cautions.

Customs—Register your basic equipment—camera and VCR or camcorder—with United States Customs. Do this at the airport or border station from which you leave the country. On your return, the registration slip will be proof that you had taken the equipment with you from home and are not importing it. This can save you confusion and delay in re-entering the United States, and may even save you from paying unnecessary duty.

Most countries will let you bring in one video camera and VCR and up to a dozen cassettes intended for your personal use. If you want to take in more equipment, you may need special permission—and an export license to get it out again.

Before leaving home, ask the nearest consulates or official tourist offices of the countries you plan to visit about import and export regulations and possible restrictions regarding the use of video equipment.

Airport Security—Videotape, un-like photographic film, is not subject to damage if exposed to X-ray inspection at airport security checkpoints. However, tape can be affected by magnetic energy, although it must be very close and more powerful than that normally emitted by the doorframe devices through which air travelers pass. Nevertheless, to safeguard your tapes, I suggest you ask attendants to hand-inspect your videocassettes outside the devices as you pass through airport security.

Special Equipment—Besides your camera and VCR or camcorder, here's some special equipment you'll need when visiting certain countries:
● A battery-charger adapter or converter, to recharge the batteries that power your equipment. This is because some countries use direct current (DC) while domestic equipment uses alternating current (AC).
● A voltage transformer, for use in countries where the power supply is 220 volts instead of the standard 110-volt supply in the United States. This is available at electrical and travel-goods stores.

Converter Plugs—These are needed for many types of foreign outlets. They are available at electrical and travel-goods stores.

Don't forget to take abroad with you the accessories I mentioned earlier for all your moviemaking travels. They include a spare power supply, light tripod, auxiliary microphone and a lightweight luggage carrier on wheels. Finally, take enough videotape cassettes to meet your needs, especially to countries where they may be hard to obtain. They are readily available throughout Western Europe and Japan.

INTERNATIONAL COMPATIBILITY

Most foreign video and TV systems are incompatible with domestic systems. To be sure you can view your tapes abroad, you need a camera with a built-in electronic viewfinder and playback capability. Or, take a portable monitor with you.

Most foreign TV sets will not be able to play your tapes. The United States and Japan both use the NTSC system, so there's compatibility there. However, most other countries use the PAL system. France uses its own system, SECAM.

16 Other Video Applications

Your video camera and VCR have many more applications than those described. In this chapter, you'll learn how easy it is to transfer movie and slide images to videotape. You can also have fun combining the capabilities of your home computer and your video camera. Or, you can get involved in producing programs for your local public-access cable-TV station.

Other applications involve the cataloguing of property and records rather than making entertaining movies. Such tapes can be used for insurance, business, legal or educational purposes.

Some uses of your video equipment may even give you an opportunity to earn money.

TRANSFERRING FILM TO TAPE

By transferring your 8mm movies and 35mm slides to videotape, you can enjoy your family picture records on one easily accessible medium. There are several ways to accomplish this:

Record a Projected Image—One way is simply to record your film movies and slides off a projection screen. Set up the screen and movie or slide projector as you would for normal viewing. Position the projector close to the screen so you have a small, sharp picture not more than two feet wide.

Set up your video camera on a tripod close beside the projector's lens. From this position, the camera gets a head-on, undistorted view of the image.

Darken the room. Record the slide or movie images just as you would any other subject.

Tele-Cine Converter—A more sophisticated way of transferring photo images to videotape is by using a *tele-cine converter*. You can use it for copying slides or movies.

The key components are a translucent screen and a front-surfaced mirror. The image is projected onto the screen from one side. Your video camera picks up the image from the other side of the screen via the mirror. The mirror reverses the image, giving a right-reading image on the side of the screen farther from the projector.

Tele-cine converters are inexpensive and readily available from video-equipment supply stores.

Macro Copying of Slides—If your video-camera lens has macro capability, you can tape your slides directly, without projection. Cut a rectangle the size of a 35mm slide in a piece of 11x14-inch black cardboard. Some video supply outlets offer a slide-holding device that attaches to your camera for this purpose.

Tape the mounted slide over the opening with black masking tape. You can backlight the slide with daylight or tungsten illumination.

Place your camera on a tripod and use the lens' macro setting. Fill the video frame with the 35mm slide. White-balance the camera. Then start your VCR recording. Record each slide for 10 to 15 seconds. After recording each slide, pause the VCR and replace the slide with another, continuing until all slides have been taped. You may want to use fades between slides.

Add Sound—Video enables you to add sound to your silent 8mm movies and slides. Add live narration and background music according to my recommendations in Chapter 9.

If you're copying projected images, add the sound later because the projector noise may spoil your re-

cording. If you're macro copying slides, you can add the sound at the same time.

If the narration or description for a slide takes longer than the recommended 10 to 15 second recording time, shoot the slide for an accordingly longer time.

VIDEO INVENTORY

Your video system is a wonderful tool for making and storing pictorial inventories of all kinds. An inventory can be a convenient way to show your home and possessions to friends. However, it can serve a really useful purpose when you make an insurance claim or want to sell property or possessions.

For a comprehensive record of your home, begin with views of the exterior. Show the location of the house relative to neighboring houses. Then show the house from various angles. I advise you to use your camera on a tripod. Use progressive shot sequences, beginning with wide-angle and working in to close-ups. If you use pan shots to record an area, pan the camera slowly and smoothly.

Record features in the grounds, such as a swimming pool or patio. Don't forget to record your car or cars. Also, show close-up detail of important parts of the house.

Next, inventory the interior. Tape the rooms, furniture, rugs, art and valuables—especially the silver tableware and jewelry. Place small items of silverware or jewelry on a matte, black background and use the macro setting on the camera lens.

In the event of burglary, fire, flood or vandalism, you'll be glad to have proof of the extent and condition of your property before the incident.

You can keep the tape safely in your bank vault or keep a duplicate in a location other than your home.

Sound—Use sound to fill in those details the picture doesn't show, such as an item's value or history. You can add the sound either as you shoot or later.

Titles—If your camera has an electronic titling feature, use it to show the date and time the record was taped.

MAKING MONEY WITH YOUR VIDEO SYSTEM

Because so many homes now have VCRs, the videotape cassette has become a popular form of social record-keeping. Many people who are not interested in owning and using a video camera like to have home movies of special events that they can play on their TV sets.

Whenever there is a celebration—wedding, birthday, confirmation, bar mitzvah, anniversary or job-promotion party—there's an opportunity for an enterprising video-camera owner to earn some money. Such earnings can help finance your video system, and enable you to add to it.

Begin with friends. Word-of-mouth recommendations generally lead to additional assignments.

For elaborate occasions such as wedding receptions and large parties, I recommend at least a two-person, two-camera crew. Team up with a friend who also owns a video camera. Later, edit the material shot by both of you into a coherent movie.

You may also be able to get commissions to record inventories, as discussed earlier, for both individuals and businesses. Real-estate companies regularly need attractive pictorial records of property they have on the market.

Businesses have other needs for which your videotaping services may be useful. They include recording special meetings and banquets, and

preparing sales or technical presentations.

Schools, as well as businesses, regularly need training and informational tapes. To make such tapes, you must work in close collaboration with the organization using your services. Be sure you understand clearly the purpose of the tape. Gather all the information you are to convey. Know what the viewer is expected to gain from the presentation.

Among other events you may be called upon to tape are fashion shows and beauty contests. Usually suitable, flattering lighting will be provided. Your challenge is to make the people, and clothing, look as attractive as possible by selecting the right angles and moments.

Be careful in selecting narrators for your soundtrack. Choose people who speak clearly and without hesitation and have a pleasant on-camera manner.

PUBLIC-ACCESS CABLE TV

When you think you're ready to show your creative efforts on *many* screens throughout your community, try public-access cable TV. Cable companies must offer free use of a public-access channel to the public. It involves providing channel time for free use to individuals and groups residing in the area. The facility is offered on a first-come first-served, non-discriminatory basis.

If you have produced a tape, or would like to produce one, for cablecasting in your community, get in touch with the cable-system operator in your area. He can tell you about technical requirements, time availability, access procedures and rules.

Assistance and Equipment—A cable-system operator can also inform you of assistance available to

you. Many cable-TV systems offer expertise in program development and production and practical technical guidance. Technical facilities such as cameras, lights, special-effects equipment, recording decks, VCRs, titlers, microphones and full audio control may also be available to you. The extent of equipment available depends on the sophistication of the studio you're dealing with.

Your cable operator may even provide you with equipment for location use. Editing and other completion facilities may also be provided by the system operator.

If your production is to be live, you may need more than one camera. A pre-recorded program can be shot with one camera, with shots recorded out of sequence and edited together later.

Courses—Many cable-TV operators offer special courses where an interested individual can obtain practical, hands-on experience in all aspects of equipment operation and program production. These include camera-handling, switching, lighting, audio, editing and multiple-camera directing techniques for studio and location shows.

Use all the help you can get from the cable operator. In conjunction with the advice I've given you in this book, that help should make you well-equipped to start producing your own shows. As you gain experience, you can make your presentations more sophisticated. Eventually, you may even be able to persuade the operator to let you produce a regular series!

COMPUTER IMAGES TO MUSIC

Here's a fun thing you can attempt when you want a respite from ordinary video moviemaking: Transfer a favorite song or musical composition

to videotape and add abstract, moving computer images. With a little experimentation and practice, you can produce some intriguing tapes.

What You Need—First, you must have a VCR with *video insert* capability. It can record picture only, leaving the sound track unaffected. Many current VCRs have this feature, which is the video equivalent of *audio dub*.

You also need a home computer that uses video-game cartridges. From a video or computer store, buy a graphics cartridge for the computer. The VCR you use must have audio-dub and video-edit capability. Finally, you need a video camera and a TV set.

You can capture the computer images with your video camera or, using the VCR's video-edit capability, with the VCR alone.

Control Track—To combine music and computer graphics on a master tape, that tape must have a *control track*.

Any continuous video recording contains a separate series of regularly spaced pulses. These are the control track. They correspond to the sprocket holes on motion-picture film. With a control track, you can match video-synchronization pulse signals from another source, such as your camera, another VCR or your computer, with those of the tape on which you are recording. Your tape and any video signals reaching it will be kept in constant synchronization. This permits clean edits at any point on your videotape.

A blank tape does not have a control track. Until one is placed on it, precise, clean video and audio insert edits cannot be made.

Placing a control track on a videocassette is a simple matter. All you have to do is record picture and sound on it. Any picture and sound

will do. Record a portion of a program off the air. Be sure to record a little more than the length of the music you plan to use. If your song runs five minutes, record at least six. Or, you can use a tape containing programs you no longer wish to keep.

Record Music First—First, record your music using the audio dub procedure I explained in Chapter 9. Choose something simple for the first experiment—a song that has a verse-chorus-verse-chorus pattern, for example. Until you're ready to try something more complex, this will make it easier for you to synchronize the graphic patterns with the music. Be sure your audio level is adequate and consistent.

At this point, you have the right music—but as yet the wrong picture. That comes next.

Add Computer Effects—Connect the computer to the antenna terminals on your VCR as you would to play a video game. Set up your camera, connected to the VCR, and aim it squarely at the TV screen. Turn the computer on and observe the graphic patterns it delivers. To begin, select a simple pattern you feel provides an overall expression of the music. Use the computer's controls to vary pattern, speed and color until you achieve a desired effect.

You must proceed carefully, now. Whatever you record will be final—you cannot go back and revise. If you want to make changes, you must re-record the entire effort from the beginning.

Record an overall basic pattern. Then, overlay additional patterns, each one synchronized with a beat, a rhythmic pattern or a melodic figure in the music.

Using the PLAY control, roll your tape forward to a point just before your music begins. Stop at that point. Place your camera on PAUSE. Press

RECORD on your VCR. Activate the computer pattern on your TV set. Release PAUSE on your camera and fade up the picture on the TV set using the FADE control on your camera.

Record the basic pattern for the entire length of the music. Stop recording when the music finishes. You now have a single, moving graphic color picture to accompany your music.

Adjust the computer to another color pattern for synchronization with the music. Timing is critical now, so you must be very precise about where you want the new pattern to begin and where to end. Use a stopwatch or the footage counter on your VCR to determine in advance the beginning and ending of each effect.

When you're ready, rewind the tape. Play it forward to the point in the music where you want the new pattern to begin. Use the PLAY control, not the RECORD control, for this. Stop your VCR at the selected point. Then place your VCR on PAUSE. Release PAUSE to record the new pattern. Stop your VCR at the point in the music where you wish the new pattern to end.

If you want to continue the same configuration with a second verse, roll forward to that point—again using the PLAY control—and repeat the procedure.

Continue in this manner until you're satisfied with the combination of pattern variations and music. As a further refinement, you can add titles using your camera's built-in character generator, if it offers that capability. Include suitable graphic patterns at the desired places.

Index